The Interior Designer's Guide

to PRICING, ESTIMATING, *and* BUDGETING

Theo Stephan Williams

ALLWORTH PRESS
NEW YORK

09 08 07 06 05 5 4 3 2 1

Published by Allworth Press
An imprint of Allworth Communications
10 East 23rd Street, New York, NY 10010

Cover design by Derek Bacchus
Page composition/typography by SR Desktop Services, Ridge, NY

ISBN: 1-58115-403-8

Library of Congress Cataloging-in-Publication Data
Williams, Theo Stephan, 1960–
 The interior designer's guide to pricing, estimating, and budgeting /
Theo Stephan Williams.
 p. cm.
 Includes bibliographical references.
 1. Interior decoration—Practice—Economic aspects—Handbooks,
manuals, etc. 2. Interior decoration firms—Management—
Handbooks, manuals, etc. 3. Interior decoration—Marketing—
Handbooks, manuals, etc. I. Title.

NK2116.2.W55 2005
747'.068'1—dc22
 2005001838

Printed in Canada

Contents

Acknowledgments

This book is dedicated to my dad, whose spirited love for his own work and entrepreneurship—long before anyone knew what that meant—paved the way for my own independence.

My mother's endless supply of hugs and her constant reminder to me as a young girl that I could do *anything* I put my mind to are two of my greatest rewards.

A special thanks to Tad Crawford, who believed that I would one day finish the manuscript for this book—and I finally did!

Why Me?

You're probably wondering why you picked up this book in the first place. In our industry, pricing, estimating, budgeting, and everything that revolves around those three things, are more than a royal pain—and everyone knows it.

You've had the highs of that corporate client who had to get it done and never balked once at your pricing. You didn't even give him a written estimate. He begged you to just give it to him over the phone. The day of your presentation, he got so excited, he called some of his colleagues in to show off your ideas. You even got paid two weeks after you submitted your invoice. Now, isn't *this* how every interior design project turns out? Wrong.

Sure, it might happen every once in a while. But, realistically, this isn't going to be the norm, even if you are one of those design-firm names seen in every awards annual, industry magazine, and big trade show. Even the award winners and big-name designers have to get down to basics—pricing, estimating, and budgeting.

When I started my own design business in 1983, I truly expected the worst. I sold my car so that I wouldn't have car payments. I paid off all of my credit cards before quitting my job in anticipation of not being able to make minimum monthly payments. I even went so far as to lie to my parents, telling them that I had gotten laid off so they would feel sorry for me and lend me money if I couldn't scrape up enough work to feed myself. I moved a twin bed into my bedroom to allow room for a desk, drafting table (this was in the prehistoric pre-computer days), and supplies; a two-bedroom apartment just would have been too expensive.

Well, doomsday never arrived. In fact, business was so good that after two short months of paying towing bills due to my "new" used car's constant breakdowns, I bought a new car. My zero-balance credit cards were once again activated, to the

delight of my wardrobe. Exactly one year after breaking free from the entanglements of the corporate ball-and-chain, I bought my own home and created a comfortable studio space to welcome clients and vendors. And I did it all with profit. You can profit too, by establishing guidelines and simple disciplines for yourself that will soon begin ticking like clockwork.

Profit—you've got to have it to survive. Sure, you can get by for a while breaking even on jobs. But it won't be long before you burn out, shrivel up, and change careers. Interior design can and should be a lucrative industry. Just how profitable you are depends on the basics: What are your rates? Are your estimates comprehensive yet concise? Do you have an efficient method of project management? This book will help you answer these questions and give you ways to accomplish the feat of profitability.

Profiting from your interior design business is essential not only for you but also for the entire industry. There are three reasons your business can fail: 1) You don't have enough sales, 2) You are not charging enough for your services, or 3) You are mismanaging budgets. You are doing a great disservice not only to yourself but also to your colleagues across the nation by not charging your clients enough money for your work in order to be profitable.

Why you? Because you love being an interior designer, you want to be successful, and you know that to achieve the ultimate successes of it all, you've got to be a savvy businessperson. And if you're not the master of the issues detailed in this book, you can forget any business dreams in interior design . . . I hear there's a burger joint down the street looking for a few good flippers!

The Quintessential Rose-Colored Glasses

I can promise you that the three hardest things you'll ever do in the business of interior design is figure out how much to charge for your services, how to do an estimate, and how to manage project budgets completely and efficiently. We designers tend to walk around wearing rose-colored glasses, sporting the latest in designer frames, and never even *thinking* about how much we should charge for our work. Why should we? Our work is cool, and getting into colors and textures is so much fun—*someone* will pay for it.

There is a stigma in the design world surrounding money issues. Having to deal with them can seem worse than anything you have ever imagined for yourself. But wait! It's not so bad—really! You can even delegate a lot of it. The truth of the matter is that once you find out how

to successfully perform the tasks of pricing, estimating, and managing budgets, you'll probably want to perform them yourself. There is no greater feeling than taking complete ownership of a project—and that means administratively as well as creatively.

This book is written by the ultimate wearer of those aforementioned rose-colored glasses. So it's really true—you can have your rosy glasses and your financial acumen, too. Once you are the master of your pricing, budgeting, and estimating destiny, others will want to talk to you about it, they'll want you to lecture at design conferences, even write books. Because, you see, we're all so afraid of the subject.

At a recent international design conference, I, along with almost two thousand other designers, sat in a packed conference room listening to three top-notch design-firm owners discuss "the business of interior design." They all showed their work and discussed, in panel style, how they had obtained the projects and what types of awards they eventually won with them. I found myself getting agitated, because this wasn't about "business" at all.

Finally, during the Q&A, an astute designer in the audience asked my favorite guy up there (a popular speaker at these conventions), "How much did you charge for the XYZ [not its real name] museum project?" Well, ladies and gentlemen, my favorite Mr. Guru blew it big time. He stuttered and faltered, and from the fortieth row I saw those telltale signs of stress bead onto his forehead. His answer was that "it was proprietary information." We were all there in that room to learn about the business, and this guy let two thousand people down. During the conference the same person who had asked the question happened to be in my pricing seminar. I had hoped she would be. I answered her question. Of course, I didn't know for sure how much my colleague had charged his client . . . but I knew how much he *should have* charged.

I believe that I can draw a pretty unanimous conclusion about interior designers. I have interviewed over a hundred design-firm owners for various articles, books, and other projects, and if my Mr. Guru is any example—as the other interviewees were—we all like making money. We like to spend money. We like to have nice living spaces that look like a photographer could come in at a moment's notice and take a shot for a home interiors magazine. We like nice clothes and we wear trendy (rose-colored optional) glasses.

But another unanimous conclusion to make is that we don't like managing and pricing the projects we are lucky enough to obtain. And yet it is absolutely necessary to have a systematic and fearless approach to these tasks. The solution is in these pages. You will find different

types of forms, checklists, and tips prescribed from a compilation of ongoing research over the course of my twenty-one-plus years of owning a design business.

Use the appendix of this book as a detailed reference for suggested forms that will help you achieve organizational and administrative efficiency. You will find specific types of forms, such as invoices, estimates, and time sheets, and discover those pages that contain the information you want to study and modify for your own use. This appendix was written by Tad Crawford, author of *Business and Legal Forms for Interior Designers*. That book contains more substantive, specific forms and includes ready-to-use formats on CD-ROM for your use and personal enhancement (see the selected bibliography).

So, lighten up about the money issues already. Relax, sit back, and enjoy the fruits of your labor even more by learning about new ways to price, estimate, and manage the plethora of projects that are cascading in your direction. Equip yourself now with a highlighter or notepad to create an edited version of this book for your future reference.

Making Your Mark

Your decision about how much to charge for the services you provide is a most significant one. Establishing rates presents many challenges and raises many questions: What is the economy like in your area? What are the average rates now being charged for the services you will provide? Do you want to be on the low end, high end, or in the middle? Ultimately, you will want to set a price that's high enough to cover your expenses and earn you a profit, and low enough to be competitive for the work you do.

Always think about pricing in direct connection with profit—they really do go hand in hand. Also, be business-minded when you approach this decision. Study your individual situation using the guidelines provided in this chapter. Establish your pricing with self-confidence, and know that this is one area of your business that deserves a little science, math, and introspection. I promise, it's not as hard as you think.

You've heard words like *overhead* and *profit* a million times, but when you personally decide to go solo—either by freelancing, setting up a small studio, or hiring a staff—suddenly, these words fall squarely from the skies above onto your vulnerable shoulders. Wouldn't it be easier if you could look up, see the words coming down, and catch them with ease as they fell your way? Now you can!

Overhead is defined in *Webster's* as "of or pertaining to the operating expenses of a business concern." Many designers refer to it as a myste-

rious journey into the unknown. Fortunately, you're not one of those designers. Just being aware of the existence of overhead is enough to get you started thinking a bit differently. Overhead is truly something to embrace with understanding and openness—not to run from in fright or denial. It is the difference between knowing whether you are able to afford the huge loft studio that perfectly reflects the city's colors beneath you or the small-but-quaint efficiency office with no windows and a copy machine down the hall. More importantly, understanding your own overhead will help you immensely in establishing correct pricing, estimating, and projecting budgets that will make you more profitable!

Making your mark means setting your course, understanding your process and your personal motivations. Maybe money isn't your number-one goal . . . it seldom is for interior designers. Just know that, in order to maintain a strong professional status in not only your community but also in the global design community, you must develop a process for your business. I hate to use terms like *system* and *business culture*, because most people will tell me, "Look, I started my own firm so I wouldn't have to follow any rules or have any corporate culture."

My reply is, "Good luck." Why not create your own unique corporate culture instead?

Understanding Some Accounting Terms

Do yourself a magnanimous favor right now and learn some basic accounting terms. You should have a tax accountant do your taxes for you; if you have employees, you should have a certified public accountant (CPA) or full-service accounting firm helping you. Take your accountant to lunch. Boring? No. For the mere price of a plate of chicken lo mein or pesto vegetarian pizza, your accountant would love to coach you on the basics . . . and the basics are all you need. Words like *overhead*, *assets*, *liabilities*, *credits*, *debits*, and *depreciation* are all important for your knowledge bank. You may understand what they mean generally, but learn to apply their meaning directly to your business.

Use the list provided on page 7 as a guide to learning your own overhead. Notice that the list is split into two categories: fixed and unfixed (or variable) expenses. No, this is *not* Accounting 101. It's plain and simple list making, which is virtually foolproof. It will be easier for you to complete these lists by determining monthly cost figures and then multiplying by twelve to obtain an annual figure.

Fixed expenses are just that—expenses that are the same every month, like rent and equipment loan payments. Remember that when you buy a new car or update to the latest in computer technology, your

fixed list will change—and your pricing may need to reflect the new rise in overhead. The total of your monthly fixed-expenses list is the amount of gross revenue (income) that you need to generate in order to break even.

As you are preparing your fixed list, other items will quickly come to mind that belong in your unfixed-expenses list (it's like playing word association). Begin a separate column for unfixed items while you make your fixed list, because you will need both lists when you are figuring your ideal hourly rate. (More of this is covered in chapter 2.)

Your unfixed list will include expenditures that fluctuate monthly, like temporary subcontractors and delivery services. Most of your unfixed expenses will directly correlate to how busy you are during a given period. The unfixed list is somewhat of a challenge because it is not consistent like your fixed list. If you are just starting your business, call some typical subcontractors you are interested in using and ask them to help you establish a monthly average by comparing accounts that resemble your own potential usage. After you get a few months of business under your belt, you will be more knowledgeable about what to expect from your unfixed category. Many unfixed costs come as startling surprises that, if left off your list, will certainly end up costing you money.

Assessing the reality of your fixed and unfixed lists is the absolute cornerstone of your business. Take the time to review these lists with a fresh mind a day or two after you complete them. If possible, share them with a mentor or colleague to make sure you haven't forgotten anything that may not be listed in the guide provided (like snow removal from your parking space if you live in Minneapolis, for example). These expenses are your foundation for determining a fee structure that will work positively for your individual business needs. Review this list twice a year (mark your calendar to remind yourself), because as your business grows or changes, this list will need to be adjusted accordingly. The outcome of this list making will be a clearer picture of the level of income you need to generate, not only to break even but to live on as well.

Fixed Expenses	**Unfixed Expenses**
Salaries	Freelance Help
Studio Rent	Subcontractor Fees
Studio Insurance	Customer Delivery and/or
Workers' Comp Insurance	Setup Fees
(requirements vary by state)	Professional Education
Car Payment/Maintenance	Presentation/Art Supplies
Health Insurance	Photography Fees (for before-
Equipment Loan/Lease Payment	and-after shots)
Business Contents Insurance	Travel
Accounting Fees	Meals/Entertainment
Telephone Bill	Office Supplies
Heating Bill	Resource Material
Electric Bill	Postage
Professional Industry Dues	Delivery Services
Subscriptions to Trade Publications	Sales Taxes
Payroll Taxes	Self-Promotion
City/State Taxes	Bank Charges
Social Security (FICA)	Legal Fees
Personal Property Taxes	Printing Costs
	Color Separations Costs
	Maintenance/Repairs

Don't let the various tax items listed above send you over the edge. Instead, pay a tax accountant a small monthly fee (your accountant's monthly fee is already on your fixed list) to monitor these tax issues and prepare your tax forms for you.

Now, take a break from the list making and begin a quest to define an income for yourself. Be objective with your ego in determining what you think you are worth from a salary standpoint. Face the facts of your geographical environment. Are freelancers a dime a dozen in your area? Are you establishing a small firm with employees? Are you a consistent award-winning designer in your region or a relatively unknown and inexperienced entrepreneur? Most of us begin working in this industry as the latter—skilled and eager, yet basically lacking in business expertise and awards on the wall. That's okay. Use this to your advantage; the payoff is in the big picture.

It's time to fully assess your fixed list. Make certain that all expenditures that remain the same from month to month are included. Total your monthly expenditures and multiply by twelve to obtain a yearly figure. Now, add your desired, objective salary amount. If you are having difficulty establishing this amount, begin with the average salary for interior designers in your region; obviously, if you have years of experience as a designer, your salary should be commensurate with your experience. Web sites such as Monster.com and the U.S. Bureau of Labor Statistics (*www.bls.gov/bls/blswage.htm*) can help you with some current figures.

The grand total of your annual fixed list (expense) dollars plus your desired salary is the income you need to generate from the services portion of your business. Unfixed expenses are usually directly attributable to your projects. That list will be used to help you determine appropriate rates to cover those variable expenses.

Burn Out or Burn On

There's nothing like starting a new business, and motoring along on the latest razor scooter of a dynamite project that you can't believe you landed. This baby is huge! They even gave *you* the budget. You'll make so much money you don't even need an hourly rate; they never asked. You go buy the latest computer, the latest handheld PDA, the coolest sound system, and an Armani suit for the presentation. You're flying high for sure. So, the big job gets done, and it's a beauty, and then you're back to Mr. Client, who nickels and dimes you until you feel like day-old toast. The bills pile up. Maybe your credit card company calls you to see if you've forgotten this month's payment. You'll be lucky if you can pay it *next* month.

Don't burn out this way; there is simply no excuse for it. Learning how to determine the right hourly rate—and sticking to it consistently—will get you through the toaster and back out into the "fresh today" section.

Obviously, the higher your overhead, the higher your rates will be. But this doesn't mean that you can increase your prices every time you purchase a new piece of equipment or hire a new staff member. First, I'd like to share some of my experiences and thoughts on how to view those big expenses—like salaries and rent. In the next chapter, I'll give you a couple of really good formulas for setting your own hourly rates.

Recently, I saw my profits go *up* by hiring a summer intern from the local university. (To see the relative importance of this move, keep in mind that salaries are going to be your single biggest expense, unless you

are working strictly on your own. Note my list of fixed expenses on page 7. Prior to hiring this intern, I had been paying $50 to $75 per hour for freelance help that always seemed problematic; we were using a good freelancer, but our client was quite particular about many quirky little things. Without having the freelancer at our beck and call all day long, we found ourselves spending a substantial amount of time correcting work that she had accomplished. Having a summer intern in our office meant that we paid him much less than a full-time designer, plus other staff saved the time because he was more available to fix or change his work. We saved money and he got some fantastic projects for his portfolio!

Something else that goes hand in hand with determining your rates is your studio or office rent—another fixed expense. Working from home keeps this figure low, but it can quickly drive you crazy, with the distractions created by the neighbor's barking dog and your mom who calls to chat every day because she knows you're "home." On the other hand, a more elaborate studio space comes with a high monthly price tag and its own set of utility and maintenance bills.

Since your rent will be one of your biggest single expenses after salaries and taxes, you might think that finding a cheap workspace will keep your rates down substantially. But in the overall scheme of things, it doesn't improve your rates by more than a few dollars an hour. You can easily prove this by plugging different rental amounts into your fixed list as you use the master formula given on page 13.

The U.S. Bureau of Labor Statistics publishes salary rates and averages by geographic location, updated every four years. More detailed data on the survey instrument itself and the composition of respondents is available on its Web site. Doing a recent keyword search for "interior designers salaries" resulted in over 32,000 hits, with the first three Web pages containing pertinent information. You can also get information from your local chamber of commerce, job-placement services, or university-degree program offices specializing in interior design.

The American Society of Interior Designers (ASID), the largest and oldest professional organization for interior designers, shares a plethora of information on salaries, including benefit information ranging from costs for typical medical coverage, types of retirement plans offered, retirement plan contribution statistics, opportunities for group coverage, networking, and much, much more (visit their Web site at *www.asid.org*).

How to Determine
Your Hourly Rate

Before getting into the actual processes of determining rates, you will need to make some important decisions regarding whether or not you should be an interior-design business owner.

Things to Consider Before Starting Out on Your Own

- Do you crave independence and a lack of routine?
- Are you self-motivated?
- Do you like to take risks?
- Do you enjoy talking about your work and "selling" your portfolio and history of completed projects?
- Do you want to freelance for other firms or architects? If not, do you have enough contacts who could support your endeavors by hiring you directly?
- Do you like wearing different hats?
- Are you generally optimistic and outgoing?

If some of the above questions are difficult to answer affirmatively, think twice about striking out on your own just yet. Take part in some small-business workshops and start searching for a mentor or two who can help you decide when the time is right.

Assuming you feel good about the last set of questions you answered, move to this next set to determine if your strengths will lie in going it alone as a freelancer or establishing yourself as a full-service firm.

Do You Want to Be Full Service?

- Do you like being completely in charge?
- Are you a team player?
- Do you enjoy doing many things at one time?

- Do you have an extensive knowledge of not only interior design but also rough and finished construction and the actual craft of painting?
- Do you enjoy sourcing contractors?
- Do you like troubleshooting?
- Are you familiar with several respected copywriters?
- Do you feel comfortable with spelling, grammar, and punctuation?
- Do you like to negotiate?
- Do you like to establish schedules for different people and follow through with them?

Answer yes to at least eight of the above ten questions and you can count yourself a great candidate for supplying full service to your clients. Six or seven positive responses will find you a great freelance candidate, but as a full-service supplier you might have some serious challenges ahead. Any questions having a no answer should be looked at as deficiencies and corrected to a yes answer as soon as possible if you want to survive in the fun, yet challenging, full-service market.

Any fewer than six yes answers—forget it! Sorry.

Pricing

Now you're ready to pick the right pricing formula for your business. After getting through this chapter, don't stop reading the book and think you know it all. There are some great pricing options in chapter 7 that you will refer to—and use—often. The important thing to remember is that no one formula is perfect for every project. This is a starting point. Often, pricing for projects is determined by your flexibility and your knowledge of different approaches to pricing. And don't forget the most important part of this: profitability!

Many formulas exist to assist you in establishing an hourly rate. The simplest formula is to multiply all the salaries you're paying out—don't forget to include your own—by three. The theory here is that one-third of your expenses represents the actual outlay of salaries, one-third represents the overhead, and the final one-third is left over for profit. Pretty easy, huh? Actually, the smaller you are—and especially if your studio is in your home—the better this down-and-dirty formula can work.

The Master Formula

A much better and more comprehensive formula follows. Albeit more complex, it works a lot more efficiently and makes more sense logistically

as you are computing it. So, get some paper, a calculator, and a pencil with an eraser, and you'll have the perfect hourly rate in less than fifteen minutes.

Remember the fixed list? You'll need this detailed list of all your fixed expenses for its important totals. I'm using the following example for matters of simplicity.

THE BEST DESIGN FIRM, INC.
Annual Fixed Costs List

Salaries (owner + three people— one senior designer, one junior designer, one administrative assistant)	$188,000
Studio Rent and Maintenance	37,000
Company Car—Maintenance and Insurance	8,100
Health Insurance	6,480
Equipment Loan/Lease Payments	6,000
Business Insurance	1,200
Accounting Fees	4,000
Telephone	2,200
Heating/Air Conditioning	2,400
Electricity	1,000
Dues/Subscriptions/Awards Entry Fees	2,500
Payroll Taxes, City/State Taxes, Social Security Taxes (FICA) [Multiply total salaries by .25 (25 percent)]	47,000
Personal Property Taxes	2,000
Grand Total	**$307,880**

Now, look realistically at the total billable hours you can obtain from your salaried staff. First, we'll divide your total salaries by those billable hours, and that will give you a rate to charge just to cover salaries. Next, we'll add a percentage based on the rest of your expenses to cover overhead. Finally, we'll add a percentage so that the business itself can actually make a profit for all this work.

Billable hours are simply those hours that you can directly bill to a client. Nonbillable hours reflect time that cannot be attributed to any specific client's job. These are hours spent on general things like cleaning up, backing up your computer, or peeling bananas. My office manager/receptionist often performs nonbillable tasks—answering the telephone, ordering supplies, general accounting tasks, etc. Her hours are mostly nonbillable.

So, out of a total year's worth of hours for four people—52 weeks x 40 hours x 4 people = 8,320 hours—suddenly, The Best Design Firm, Inc., needs to deduct 2,080 hours for their office manager/receptionist. That leaves them three billable people and 6,240 hours. Everybody gets two weeks vacation, so three billable people times eighty hours subtracts 240 hours from the company's total. Typically, allow five days for each person to have as sick days or personal days off, so that's another 120 hours. I give my staff one week of paid vacation as part of their holiday bonus between Christmas and New Year's. If The Best Design Firm wants to offer this bonus, subtract another 120 hours. Don't forget our seven legal holidays—it's typical (due to the incredible deadline and burnout associated with the industry) to extend these into an additional day off for four-day weekends—so 14 days x 8 hours x 3 billable people is another 336 hours to subtract. The subtotal currently stands at 5,424 billable annual hours.

Last but not least, no designer is in any way billable for an actual forty hours per week. Time-consuming tasks such as surfing the Internet on company time (!?), cleaning up for that important client visit, running errands, and backing up your system can quickly add up to about an hour a day per billable person. That's a painful subtraction of 690 hours of downtime (five hours per week per billable person for forty-six total weeks of actual work) for a realistic grand total of just 4,734 *possible* billable work hours. That's if everything runs smoothly *all* the time.

Now, add the total salaries and related tax expenditures, for a total of $235,000, divide by 4,734 possible billable hours, and get an hourly rate of $49.64. For the sake of simplicity, let's round that figure up to $50 per hour. But remember, this rate does not yet include total overhead. So far, you've only covered the salaries portion of the fixed expenses list.

To determine what percentage to add to cover your other fixed expenses, divide their total by the total salary and taxes amount. In The Best Design Firm's case, the total fixed expenses ($307,880) minus salary and taxes ($235,000) leaves remaining expenses of $72,880. This remaining amount, $72,880, divided by the salary and taxes amount of $235,000 equals 31.02 percent.

Again, we'll just round this off and make it 31 percent. (Okay, okay, this is a bit like algebra, but at least I'm giving you the answers—just fill in the blanks with your own totals, and you'll get your percentage.) Now, take the hourly rate that you computed to cover salaries (in The Best Design Firm's case, $50 per hour) and multiply it by the percentage you've just established to cover your overhead (in this case, 31 percent).

The $50 hourly rate multiplied by 31 percent equals an additional $15.50 per hour Best needs to charge to break even on additional fixed annual expenses. So, $50 per hour to cover salaries plus $15.50 to cover all those other expenses establishes that The Best Design Firm needs to charge at least $65.50 per hour (let's just say $66) to *break even* on everything.

For you algebra whizzes out there, sure, you can arrive at your hourly rate simply by taking your total overhead number—in The Best Design Firm's case, $307,880—and dividing it by total billable hours for a quick hourly rate. It comes out the same, right? Correct, but it is very important as you grow to know what percentage of your business overhead is salary-based versus other fixed expenses. It is typical for salary overhead to be about 50 percent of total fixed costs.

You might think that making a profit over and above your total fixed expenses is simply icing on the cake: nice, but not really necessary. If so, you're not alone. A lot of people think that everything left over at the end of these calculations is theirs to keep. Don't make that grave mistake of not having anything left over for a rainy day or to cover the occasional slow-paying client. Small businesses close their doors every day because of these far-too-frequent dilemmas.

Remember, we've made no allowances here for slow periods, downtime, equipment failure, scheduled pay raises, or the kind gesture of distributing bonuses for jobs well done. Peruse the contents of your unfixed expenses list. Costs for things like postage, maintenance, and education (design conventions and furniture shows are wonderful) that are seldom attributable to a particular job need to come from somewhere—your bottom line. You could easily go in the hole if your hourly rates are not bumped up enough to cover these variables.

A common percentage of profit in the industry begins at 15 percent and can go up to 25 percent; I average about 19 percent. Adding 19 percent to The Best Design Firm's $66 hourly rate equals an additional $13, making their base rate $79 per hour. (I actually charge up to $250 per hour for certain tasks, which will be discussed later in this chapter.)

Enough already with the calculator! Just remember one thing: The hourly rate that you originally established (before adding a profitability percentage) covers only the itemized subjects on your overhead lists. Each job you produce will have contingencies that you must not forget to include in your budget planning and estimating execution. Details do matter; every day, every project is different.

There are other formulas to determine hourly rates, of course. I find this particular formula the most comprehensive, reliable, and easiest to

compute. Your *average* hourly rate should remain very close to your base rate—The Best Design Firm's being $79 per hour. Once this base rate has been established, it's easy to go in and refine it or to try other rate methods.

Hourly rates reflect not only the end product that a client receives, but also the years of experience, skills, and intuitive talent that a creative team offers. Ultimately, your clients expect and deserve an enhancement to their image, offering ergonomics, integrity, and functionality.

Interestingly enough, and to my surprise, the geographic locations of design firms I have interviewed in the past did not have a great effect on hourly rates. I thought New York City or San Francisco rates would certainly be higher, but found that not to be true at all. Rather, rates changed according to the size and experience level of the firm and the success and notoriety level of the principal.

Having originally founded a graphic design firm in the early eighties, I relied on that industry's *Handbook of Pricing and Ethical Guidelines* published by the Graphic Artists Guild for help in establishing rates; an updated edition is published every two years or so. This handbook, while focusing on graphic design, does contain valuable business management tips and current discussions of ethical issues that face the design industry in general. Use it like a recipe book—you may need to change some of the "ingredients" (such as the graphic design terminology) to make it suit your personal taste—but there is a plethora of insightful information for interior designers. Plus, it will give you good information regarding many aspects of design that will cross over into many of your projects, such as environmental graphics, signage design, illustration, and photography.

Per-Task Hourly Rates

Not to complicate things further, but it is common for many firms to use their base rate to establish per-task hourly rates. This simply means that for research time or time spent entering data into the computer a typical charge might be only $40 per hour, while actual design and presentation time are billed starting at $125 per hour. A principal might bill at $250 per hour.

Determining per-task rates is essential when a one- or two-person studio grows into a multiperson firm. This rating process enhances the billable efficiency of senior people within the firm; it provides for their not doing menial tasks when they could be more profitable and better appreciated doing something that reflects their experience level and strengths.

Check out the per-task rate list I have provided from my textile design business. Notice that the tasks requiring more technical experience are billed out at higher hourly fees. Also note that these rates were established to be used as a comparison factor when pricing certain task-heavy projects—for example, multiple space designs for a large home or commercial entity. First, I usually price a project using the master formula's hourly rate. I then check that result against our per-task hourly rates to help us refine our estimates. The following rates are beginning rates. Depending on the style of design required, the research necessitated, travel, and overall scope of the project size, the rates may go higher than those shown.

T'S TEXTILES
Per-Task Hourly Rates

Meeting time	$85
Research	$85
Design	$250
Illustration	$125
Travel	$500/day
Documentation	$85
Installation	$85
Quality Control	$85
Revisions	$85
Clerical	$85
Client Service	$85
Proposal Prep (commercial only)	$85

Value Rating Versus Hourly Rate

While design firms have an established base hourly rate, most of us also put a great deal of emphasis on "value" rating. Value rating means that after you determine how much time an assignment will take to design and produce and multiply that time factor by your hourly rate to get a project total, you objectively think about what the project itself is actually *worth*.

A great example of this is with custom carpet design. Some design solutions come to me in a flash, while others seem to drone on into oblivion. Many times I've sat down and literally designed a carpet in an hour's time, and a custom carpet design is worth far more than $250, right? If I billed a Fortune 500 company $250 for a custom carpet

design, the client would 1) expect to get original designs any time for that mere pittance; 2) have no idea where I am coming from when my next bill charges them $2,500 to simply reformat the design to a new dimension or color palette; and 3) begin a downhill slide of losing respect for me, because any designer who has a twenty-plus-year history would be selling herself and her colleagues short by offering to take on such a significant project for such a minimal fee.

So what is a customized design worth? Well, you can check the competition, price things on the Internet, and look at high-end designs being produced in limited edition, for a start. But the most important thing any of this will *not* tell you is what the project is worth to *you*.

Maybe the client is an energetic entrepreneur who is fun to work with and is giving me carte blanche on design. In this case, I can't charge him $5,000 for a foyer carpet design, but I can charge him a minimal amount, do a great award-winning design, and agree that I will be paid an additional $1,000 per quarter for a year after the company gets on its feet. Or I might agree to be more fairly compensated for future customized textile pieces that the company will require in its growth mode. This is value rating.

On the other hand, if a huge Fortune 500 company asks me to design a corporate collection of textiles, from the executive offices all the way down to their retail store applications, I am obligated to first discuss the

Resources for Help in Establishing Rates

The following organizations can help you research and establish rates and assess the competition in your local market:

- *American Society for Interior Designers* (ASID), *www.asid.org*, represents the interests of more than 30,000 members including interior design practitioners, students, and industry and retail partners.
- *Interior Design Society* (IDS), *www.interiordesignsociety.org*, an affiliate organization of the National Home Furnishings Association, is a guiding force for professional residential designers and design-oriented retailers.
- Your local *American Marketing Association* (AMA) chapter, *www.ama.org*. AMA National address: 250 South Wacker Drive, Suite 200, Chicago, IL 60606-5819.

budget constraints directly with my client, and then take a quiet moment in my studio to look at the value this immense project will bring. With the scope of the project in mind and an idea of the client's budget expectations (if they have been shared with me) it is easier to assess for myself what projects are worth to me and any of my subcontractors.

This pricing method is also great when a client is gaining a benefit far beyond what a normal hourly rate would reflect. For example, an original design for a new carpet I recently designed and developed for a high-end client took my office/production team and me a combined hourly total of 136 hours to create, present, and execute. One hundred thirty six hours at The Best Design Firm's hourly rate of $79 would only equal $10,744 for this significant project, which is actually valued at around $25,000. Plus, value pricing not only allows me to be flexible with people I want to work with, it also allows me to triple my normal rates when I perceive that a client will be difficult to work with.

Chapter 5 goes into more detail about value rating and what it can and can't do for you. And don't forget to check out chapter 7 for more great pricing options.

Residential Versus Commercial

Typically, it's a smart move to choose your niche—residential versus commercial. But when you are starting out you might want to do a bit

- Your local *Chamber of Commerce, www.chamberofcommerce.org.* In many regions, the local chamber of commerce goes by a name that connotes their services. In Cleveland, for example, the chamber of commerce is called the Greater Cleveland Growth Association.

Memberships in any or all of the above organizations offer many additional benefits. All of these groups offer newsletters and Web sites that share vital business information and tips regarding the topics in this book, as well as hundreds of other business issues that will become increasingly important to you. If you have trouble finding any of these organizations in your area, ask your colleagues. Some regional chapters of the above organizations are located only in larger metropolitan areas but would be glad to include you on their mailing list if you are out of range.

of both to test the synergy you have with either type of client (or neither!). A colleague of mine was a very well known residential interior designer in south-central Ohio. She and her partner seemed to own the entire high-end clientele of the region. Then, seemingly overnight, they split up; she is now independent, working solely with an administrative assistant, specializing in large commercial buildings. She never, *ever*, let anyone talk her down on price. She was known as being "expensive but great."

Making a start where you have the most contacts is the perfect approach to creating cash flow and profitability. Just don't make the mistake of starting out "cheap" to get the work. Your pricing should reflect one of the structures we have reviewed so far whether or not you are producing design solutions for residential or commercial clients—or else you will be selling yourself short and rising to the top of the disappointment pyramid. Never tell clients they are your "first customer." Always ask for their budget and determine whether or not you can make it work within a value-pricing structure. If the budget is not shared with you, or you are asked to develop one for the client, be forever persevering *not* to sell yourself short. Using this practice of pricing, you will win in the not-too-distant future, much sooner than you think.

Compare and Contrast

You've read the formulas and some other procedures for establishing pricing. How close are you now to establishing your own rates? An important question you have hopefully answered for yourself at this point is whether you want to be known as a freelancer, a one- or two-person small studio, or a full-service interior design firm. The services you provide and the number of staff people you have to provide those services greatly affects the way you will value upcoming projects.

What's Right for You?

A *one- to two-person studio* typically services its own accounts. Some are full-service, and some aren't. Ongoing client lists are usually very short with studios of this size, and they generally produce a lot of one-time projects.

Being a *design firm* basically means that you have some sort of staff—a group of people who support your efforts in one way or another. Team players in a design firm generally include the owner, who acts as the lead creative principal, at least one or two designers, and an office manager. Larger design firms have account representatives, administrative assistants who handle everything from bookkeeping to scheduling subcontractors, a graphic designer for presentations, purchasing managers, installation experts, many designers, quality control personnel, and often more than one owner.

Freelancing quite simply means that you work on an "as-needed" basis for other design firms or large corporate interior design departments. Basically, you are a can-do-it individual and end up filling in during a company's busiest periods or when their own designers are on vacation or out ill. Many freelancers specialize in a few niches or styles so that their work becomes recognizable, and thus popular, in a particular region. Freelancers often work in-house at a particular agency or design firm. The

latest trend is for freelancers to work from their own home offices, since many times their employer won't have extra equipment on hand for them to use. Increasingly popular is the capability for freelancers to post their progress on a job on the Internet for a client to review, either directly onto a Web site or by using a file transfer protocol (FTP). This saves a lot of driving time in larger cities and meeting time in general.

The next big question you've answered by now is whether or not you want to offer full service. It's like going to the soft-touch car wash: Do you want only the outside of your car washed? Maybe add the wheel cleaner and the rust-inhibiting underspray? Or do you want the works, including the deluxe vacuum, special rain-repelling coating, and the squirt of fragrance that will always remind you of sipping piña coladas in Bora-Bora?

Full service can be accomplished best when you have established yourself with a credible client list and portfolio. Many smaller studios still can provide a wide range—yet not full—set of services. It is almost always impossible for freelancers to be full service because they typically don't have established credit with subcontractors, manufacturers, or suppliers, nor do they want to handle the paperwork and responsibilities (or the substantial amount of coordination) required.

Full service means that you are responsible not only for the interior design itself, but also resourcing all of the finished fixtures and subcontractors who will install furniture, lighting, flooring, environmental graphics, signage, etc. Realistically, you and your staff cannot personally fulfill all of these obligations (how many design firms do you know that build furniture and manufacture lighting?), but your expertise in coordinating all the details of a project is paid for by your client.

When determining value rating and per-task rating, full-service firms have a longer list of extras that they are able to provide to their clients and can be reimbursed accordingly for those assets. Full-service firms charge a higher rate for their projects because they are providing more services. Most of the time, this rate is reflected in the estimate as charges for the various itemized services. A higher percentage of average profit is also expected by being a full-service firm. Freelancers or studios not providing full service will have a more difficult time acquiring larger projects, even when their rates are comparable to full-service teams.

Other factors that might affect your rates when starting out are:

■ *The quality of the pieces in your portfolio and integrity of your client list.* If you aren't established in the area, have won few awards, and know that you can do better work, but have not yet had the opportunity

to prove yourself, it will be important to set a fair rate that will attract clients and give you a chance to show what you can do. In this case, a *slightly* lower "introductory" rate may be implemented until you have achieved a few successes.

- *How much equipment you have.* This becomes part of how high your overhead is, which is directly reflected in your hourly rate equation.
- *Networking opportunities in your area.* How many people do you know, or how many friends could give you names of friends that would be potential buyers of your services? Even if you are a great interior designer, way ahead of your time, it might be difficult getting started if people in your job market don't know you. Networking is simply a way of avoiding the cold calling that most of us dread. Networking doesn't get you the project, but it does help you get in the door to present your portfolio and give onsite introductory consultation.

Now that you have absorbed all there is to know about setting your rates, just do it! You've done your homework and deserve to go forward with confidence that the rate you've established for yourself is the right rate for you. In the long run, clients will respect you more if your rates are objective and if you feel good enough about them to quote them as being your own.

Comparing Your Rates

The easiest way to discover that your rates are too high is to find yourself losing jobs to other firms offering a better price. Still, make sure that you're not *too* hasty to lower your rates before considering the old adage about apples and oranges—are you comparing apples to apples? Lots of times, my firm will lose a job to a smaller studio whose overhead is obviously much lower than mine. I've gotten into the habit of informing clients in a positive way that if they are asking smaller studios for bids, ours is seldom the lowest one they will receive, then proceeding to explain the many reasons why. I also inform them that we will not enter a bid if they are shopping only for the lowest price. To me, this is a waste of time. Who needs it?

 The best way to discover if your rates are competitive is simply by asking. Talk to your existing and prospective clients about other firms they use. Make sure they are firms that provide services comparable to yours. Have this conversation with someone you trust, with whom you can share a frank discussion about rates. Sometimes, this is more easily done in a casual atmosphere, like over lunch. But I can guarantee that

you won't offend anyone by being directly concerned and receptive to your client regarding rates if, for example, the subject comes up in a business meeting while reviewing a specific project.

I can also promise you that as time goes on, you will gain more confidence and competence being your own businessperson in the design industry, becoming less and less rate sensitive. You can trust that established firms will endorse my practice of first determining the value of a job before even thinking about dropping rates to accommodate a budget. We'll discuss this in depth later in chapter 4.

The more time you spend in the business, the more likely you are to come across a client or two who will complain about how high your rates are, no matter what you charge them. I have a client who always reminds me that my prices are so incredibly high, as high and sometimes higher than his legal and accounting fees. How can I charge him so much? I usually respond to him by laughing, as though he is making a joke. I do think it's pretty funny. He is actually one of my favorite clients to do business with because he gets so excited about the creative process. When his conversation turns to pricing, I have learned to say "yeah, yeah" to myself, smile outwardly, and move directly into the creative part of our meeting. I have realized that it simply is his process to nag about pricing. His rhetoric used to make me very defensive, and when I asked him what he *would* like to pay for a project, I would say to his answer, "You can't be serious" with a good chuckle. After all, he *does* keep coming back for more.

If you can't stop obsessing about how your rates compare, do a simple questionnaire in the form of a mailer to clients, vendors, and other people associated with your industry. Ask them to respond to questions regarding pricing issues. Make it user-friendly, with just a few yes or no boxes to fill in, and perhaps one question that requires a written answer. Use some visual design skills to make it an attractive direct-mail sample itself—you never know where your next client may come from. Give them an incentive to respond to you; design and produce a cool gift for just a few dollars. Count on getting a 5 to 10 percent response rate if you're giving something away, and write off the expenses as self-promotion.

It's interesting to note that most firms charge a higher hourly rate for the principal or owner(s) of the firm. For several years after starting my own firm, my hourly rates were the same across the board. Basically, if our cleaning woman delivered a set of revised drawings to the client on her way home, the charge was the same as if I had done it. As the business has grown, I find myself needing to be very selective about my time, and this

is reflected in a higher hourly rate for my work. Many clients prefer and even ask for me to be present during all phases of our projects together; but this simply is not humanly possible. What I have found is that I need to expose my capable staff to clients more often. Upon doing so, other people on my staff become more credible to my clients, making it much easier to justify our hourly rates and also saving me some sanity.

Very seldom will a client actually ask you what your hourly rates are. When they do ask, simply share your per-task hourly rate *range* with them. In my case, I don't hesitate at all to offer the fact that our rates *start* at $75 per hour—but I am quick to offer a short aside on my "value theory" and on the fact that we use our hourly rates to back up our original estimates, mostly for internal purposes of monitoring productivity. This conversation has appeased every client who has questioned me about rates.

The following are summaries of the roles of principals of design firms, senior designers, junior designers, and freelancers, as well as the national-average billable hourly rates they charge:

- *Principal.* Typically acts as creative director. Usually has well over five years of specific design experience. Shares a lot of diverse design, resources, and contractor expertise with clients. Manages entire staff. Average hourly billable rate: $200.
- *Senior Designer.* Has two to five years of experience. Often interacts with clients. Delegates some work to others. Average hourly billable rate: $125.
- *Junior Designer.* Entry-level position. College or design school graduate. Minimal prior experience. Average hourly billable rate: $85.
- *Freelancer.* Works independently. Usually has minimum of three years prior design firm experience. Has flexibility and usually a computer with appropriate software at his own office. Average hourly billable rate: $40–75 (depends on experience and market).

The rates listed above are averages based on my personal informal inquiry of my national client base as well as other design-firm owners. As I mentioned before, I believe that the more experience an interior designer has, the higher his or her rates can be. Typically, design firms do not want to be singled out with published rates because of the confidential nature of the subject matter. My true belief is that their reason is fear and paranoia of disclosing rates to clients. Trust me, they know anyway!

When to Raise Your Rates

Raising your rates is not nearly as difficult in practice as you might imagine, and the same rules apply for freelancers, small studios, and full-service firms. Obtaining an affluent client list, completing a new home or building in your area, or achieving recognition by designing community spaces will all help your business volume grow and result in a reevaluation of your rate structure. By "affluent client list" I mean clients who are respected—businesses that are prominent in your area, like Fortune 500 companies, or even the city itself. Many small firms have grown by doing public design work for local theater, dance, opera, and other arts organizations.

Changing from a one- to two-person studio to a full-service firm with more employees can mean charging higher rates. Providing new services is another factor. For example, the computer revolution has aided design by giving us greater ability to present even more concepts, textures, and color solutions. This makes it evident that better in-house printers, which require more ink, better paper, etc., may result in a ton of additional expenses, gigabytes, more software, and a new assortment of pricey hardware. Your pricing structure needs to be reevaluated *before* you make these purchases (whether or not they are leases) to determine their worth to your organization.

As your business grows, so does the caliber of your clientele and the types of projects you are asked to work on. Rate increases can usually be passed along to your new clients without any discussion at all, because they have no previous history with your billing procedures. If clients do think we're expensive, I always respond with an analogy they can relate to. For example, when a retail boutique client recently whined about our design rates, I asked her if she was the cheapest retailer in the city. She was offended; I had counted on that. I then asked her if she didn't think her hand-chosen, imported merchandise was worth the extra money to her clients because of its unique origin, heirloom, and finished quality. Of course, came the answer. Suddenly my pricing became a moot point.

With any business growth comes the need for new staff members and additional, often expensive, equipment. Reviewing your fixed list twice a year will help you determine whether or not you need to increase your rates. Rework your hourly-rate formula at this time as well. If your cost of doing business has jumped dramatically, it may mean having a face-to-face discussion with your long-term clients about why you need to raise your rates. The goal is to inform them of your growth and what this means to them in terms of new capabilities with your

updated equipment, access to world markets, and more. Always point out the benefit to the client when you are announcing any change in rates. Significant growth always deserves to be discussed and promoted.

Send an upbeat letter to your entire client list announcing the new additions—with perhaps a sample of your latest, hottest piece—as an ice-breaker. Always share the new benefits and services that your client will receive. Make it seem as though your new services and staff are worth way more than your minimal price increase. Also in the letter, promise to follow up with a personal call and never send out more letters than you can properly follow through on. You can start the conversation by asking something like, "Did you get our letter about our new capabilities?" Once again, never apologize for your increase in rates; simply justify them factually. Clients like to work with winners, and your rate increase can be turned into good news for them in the long run.

Save the in-depth discussion of the rate increase until the face-to-face meeting. That meeting will invariably turn into a sales call, and you will take home an armload of projects that need pricing, estimating, or budgeting.

If you've started out with a healthy hourly rate from the beginning, you shouldn't have to raise your rates very often. Raising rates by just a few dollars an hour to cover new capabilities will probably never be noticed by your clients. Many times, the addition of new equipment will happen after your original equipment is paid off. If you keep that monthly dollar allotment for equipment on your fixed list at all times, your rates won't be affected at all.

My friend and business partner, Chris Wire, uses a phrase for which we cannot find an origin or author: "Quality is long remembered after price is forgotten." It's a really beautiful saying that could transfer to just about every business on earth.

Case Study Interview

Angi Ma Wong, Feng Shui Master, Palos Verdes, California

Angi Ma Wong is an internationally recognized intercultural and feng shui expert and consultant and the bestselling author of twenty-one titles, including the popular *Feng Shui Dos and Taboos*® series. She has appeared on *Oprah*, *Regis*, *CNN Headline News*, Discovery and Learning channels, and in *Time* magazine.

Q. Angi, you have done interior design for a wide variety of clients— from celebrities to your next-door neighbor. Do you change your approach to fee structure with different levels of clients, or is it always the same?

A. Basically, I charge by the hour, increasing or charging extra for travel days, distance traveled, expenses for out-of-town appointments, and so on, with separate scales for residential and commercial properties. For large-scale projects, which may take much longer to complete, I charge on a different fee structure by stages of work completed—for example, the design phase, community outreach, marketing, and the sales phase— plus expenses, depending on a fair estimate of how many hours, meetings, etc., the project may require.

Q. What and when was your first feng shui project and how did you establish the fees for it?

A. When I first began providing feng shui consulting services more than fifteen years ago, they originated from referrals from builders and their salespeople who were looking for a consultant who was knowledgeable and could communicate well in English (many speak only Chinese, with heavy accents, or act like fortune tellers or oracles). Now 90 percent of my consultations come by word of mouth. Sorry, I'm experiencing a Baby Boomer moment and truly do not remember my first feng shui consultation. But I did begin feng shui consulting with builders to create more feng shui–compliant homes for the untapped Asian market between 1989 and 1993, during the California real estate boom, and shortly after took on individual residential and commercial clients.

I knew when I began conducting private residential assessments that I was one of the very first and few feng shui consultants during that time. (There were about six of us and we all knew each other's work. Now there are hundreds in Southern California.) I had more cultural

knowledge and expertise than the average friend or neighbor who had read a few books or taken a class and charged $25 an hour, so I started out at $75 an hour.

Through the years, as my experience, expertise, professional training, and celebrity grew, I raised my rates considerably. After all, the client is getting a bestselling author and celebrity feng shui consultant!

Q. Do you find that technology has changed your business in any way? Are potential customers now doing it themselves with interior design software? If yes, how?

A. Technology has changed my business in that more people are finding and contacting me for consultations through my Web site (*www.FengShuiLady.com*), after reading or purchasing one of my books, kits, or calendars, or through a feature in the media. Most folks who are practicing feng shui are doing so for personal reasons and not to become practitioners. After doing some feng shui on their own, they get to the point when they realize, very wisely, that there is a time to call in a pro for more fine-tuning, just as you and I can add gas, water, or windshield-wiper fluid to our cars, but we're smart enough not to start working on the engine or the electronics on our own.

Also, there are many forms of feng shui and it is not easy to know how to go about choosing the right forms for oneself. I personally practice eight different forms, but basically I am a traditional, classical feng shui practitioner who uses the Chinese *luopan* (compass) in my work.

Q. Do you worry about competitors, specifically with regard to the pricing structure of other firms?

A. No. Feng shui consultants usually work independently and I do not know how they consult or charge. I want to help as many people as possible, while at the same time know what my value is, and charge what the market can bear, e.g., more affordable consultations versus fewer at higher fees. However, I was interviewed about a year ago by a person who wanted to bring consultants together to "standardize" feng shui compliancy, with regard to a clothing line he wanted to start. In his interviews with thirty "top" consultants nationwide, he revealed that I was in the low to middle range and suggested I immediately raise my rates. About a third [of the consultants] earned more than six figures a year, and I was one of them.

Q. Do you provide everything from concept to installation? Why or why not?

A. No. Typically I work with individual clients by just providing the consultation with the architect and/or interior designer present, especially with remodeling or new-home design. Sometimes, my services are engaged for a day or more and I am shopping with the client or assisting in selecting or deciding on furnishings, colors, accessories, etc., from catalogs. When I work with commercial or real estate developers, I am a presenter to the entire design team—the architect, developer, interior designer, landscape designer—and they are all taking notes so as to integrate the feng shui principles into their concepts. Afterwards, I am accessible to all team members to answer any questions they have. This works well because the entire group hears exactly the same information and responses to any challenges, concerns, or clarification about any aspect of the design. I am not involved in fabrication or installation, as these are not my areas of expertise or training. But I do review and pass judgments on elevations, plans, color boards, and renderings for accuracy.

Q. What do your presentations consist of?

A. Included are always the basics of feng shui: colors; numbers; elements; plants; signage; names, such as street, development, and model; symbols; and any other pertinent information related to the project room by room from the site, floor, and landscaping plans. I help to choose fabrics and wallpaper; architectural features; colors of stucco and tile; roofing, exterior and interior paint colors; hard and soft scapes; and more that are presented by the interior and landscape designers. When the architectural design is conceptualized, I point out any feng shui concerns so they can be addressed and mitigated in the earliest stages of the preliminary design, before they get incorporated or too far along to be corrected. Early "intervention" is infinitely more cost effective than trying to fix bad feng shui after the product has been through several plan checks or is completed! It saves time and money in the long run for my clients.

Q. Have you had a good, ongoing client with whom you have had to change your fee structure? If so, how did you handle that change?

A. Yes. In the past, many of my developer clients have contacted me to consult on their various current projects and developments anywhere from one to ten years later, as they remember the work that I have conducted for them in the past. As my fees have increased incrementally, often the management has changed or former fees are not kept on record from the last time I did work for them, so my fees are just accepted.

The Client's Budget

Many factors can affect the way you price various projects. Some of those factors relate to what you might gain from doing the project (other than money!), some relate to what your client can afford, and then there are factors that you just can't control, like changes in the overall economy or the particular economic climate of your region. Do some homework before sharing your pricing. Can the project elevate your standing as an interior designer within your community? Is your client a smaller businessperson who has a lot of growth potential resulting in good networking opportunities for you? Is the economy in your area a little slow? These are all reasons to think strategically about how you can and should price a project.

First, Do Your Homework

Why does the word *budget* seem to reverberate from the darkest, meanest corners of the world, ricochet from the earth's highest cloud ceiling, and come back to hit us all in the head? Really, someone should come up with a better word. More often than not, I've found that the most dreaded budget—the one that some executives sat up all night establishing, subtracting from, adding to, and pulling their hair out over months ago—is not as bad as it seems after all.

The most important thing to know about budgets is that it's okay to talk about them. Many designers choose to ignore budgets when indeed a budget can become your best friend. (Well, maybe not, but certainly a worthy ally!)

The second most important thing to know is that your client is just as intimidated by the *B* word as you are. The sooner you break the budget barrier down, the better for both of you.

It's simple: Ask. If the client has a budget in mind and shares it with you, the outcome can only be one of two possibilities—

there's either enough money set aside for your specific project or there isn't—and either way, you can show your professionalism by jumping into the driver's seat and making everybody, including yourself, happy!

Taking the lead on the matter gives your client confidence in your capabilities. If not enough moneys are set aside, it's your responsibility to educate your client as to why the amounts are insufficient for the desired end result. And on the rare occasion when the budget is higher than you expected (those occasions do indeed exist), use it to create a high-end, awesome environment that you and your client can be proud of.

Established commercial real estate companies, architects, and developers who are experienced in buying design services generally understand fee structures and are most often prepared and forthcoming with monetary information. Often, these clients are required, by company policy or sometimes even by law (if it is a public entity), to obtain three bids for the same project. Rarely are they obligated to take the lowest bid. This is not the case with government or nonprofit organizations. When they ask for multiple bids, they are usually shopping for the lowest price. Ask. It is typical to discuss what the pricing or bidding parameters are before you get started.

Many times, smaller clients will ask you to assist in the budget-making process. This is a great sign of their trust in you, and often they will use your estimate as their budget. Know that you are doing *their* homework in this case; make sure that you carefully review each element of the project, and don't try to go for the high dollar. This isn't a gambling casino; it's your career. I'm always reticent, however, to help clients establish a budget if they are then going to go out and get bids from other firms. If this will be their modus operandi, I ask for at least a modest fee covering my time in order to establish the budget for them.

Establishing trust between you and your client is imperative for you to offer competitive pricing and budgeting—and also for you to create dynamic, creative end results. It's a sad day when your client asks you to establish a budget, and then, after several weeks pass by without a return phone call, you finally get him at his desk, and he announces that he's given the project to someone else. The Terminator? Might as well be. You've been duped, and it's a discouraging and crushing feeling. It happens to the best of us, and it will happen to you, too.

Just make sure that you've learned what to do the next time you're faced with this type of situation. I spend a lot of time role-playing critical communication issues like this. It's tough to think on your toes when

a client delivers information that you were not expecting. Get yourself one of those little handheld voice-activated recorders, and talk to yourself. I do it all the time while I'm driving the highways (more often getting stuck in gridlock) in Los Angeles. Sure, people look at me strangely, but who cares? I'm role-playing. What could be more important? Play the tape back, and really listen to yourself. Do you sound apprehensive or self-confident? Do you stumble around with ums and ohs while you're trying to get your message across, or do you make sense? Is your vocabulary weak or concise and intelligent-sounding? You are your worst critic. If you're anything like the typical perfectionist designer, keep on talking until you feel like you're ready to make the call or appointment. You'll be glad you finished your homework!

When the Budget Is Too Small

There will be occasions when there simply isn't enough money in the client's domain to pay your rates or to produce the project to the height of design and finishes you originally had in mind. One of the hardest things to learn is how to gracefully, but emphatically, say "No, thank you." Saying no will probably close the door to future endeavors with this particular client, but it comes with its own set of advantages—it shows that you are serious about your rates and the services you provide, and it also gives you the opportunity to refer a friend in the industry who might have lower rates and be an excellent fit with this client's needs. What goes around always tends to come around, you know.

If you stay within your current community for a long period of time and are committed to business growth and image, clients whom you turned down often roll back around to your starting gate. Your client will either grow his business, thus moving to a new space in need of design, or change career tracks and go to work for another company you are either already servicing or, better yet, one that requires your services. You could end up working on a civic project together or some other nonprofit community endeavor. You never know where Mr. or Ms. Client will show his or her face. So, if you bow out of a project because a budget is too low, make sure you don't burn any bridges. Your "cheap client" today could be your stepping-stone to bigger and better projects tomorrow.

Your other option when a budget appears to be too low is to say yes because the project offers you the potential for a great portfolio piece, or because this may be a new type of client who will enhance your firm's flexibility by adding diversity to your growing client list. If you decide to proceed with a budget that you know is not high enough, it

is very important that you set parameters with your client up front. You may decide to produce the design solution in your firm's downtime—thus taking a longer period of time than normal to complete the project. Or you may suggest that the clients become more involved in providing elements of the project, such as hiring subcontractors or doing some of the painting themselves.

The important thing in dealing with an under-budget job is not to build resentment because of the money you are not being paid. After all, you did say yes, and it wasn't because Bruno was twisting your arm. Take responsibility for your actions, and be as professional and efficient with the matter as you would with a big-budget job. The payoff is in the end product: the smile on your client's face and the next job you get as a result of this one!

Building Strong Allies

Taking on an under-budget assignment may also be an opportunity to work with a new, perhaps smaller subcontractor or craftsperson. Perhaps you have had a new furniture maker or lighting manufacturer calling on you whose work looks nice and who you really want to try, but you haven't had the right project until now. Be very honest with new resources when you ask them to work with you. Don't use them unless you sincerely want to establish an ongoing relationship. You don't want the reputation of being a carrot dangler.

Maybe an established resource has a new line that it might be willing to invoice at a lower rate. I saw this happen, for example, when a popular textile manufacturer introduced a new line of lighting into the marketplace. The company wanted a comprehensive project that would show off their textile and lighting line together. It just so happened that a small but good client of mine had decided to open a small but all-new office in a large city and needed a prestigious-looking space for this new endeavor, but the budget was extremely limited. The result was an environment that made everyone—manufacturer, client, and me—very happy!

There are some beautiful, majestic public spaces, like museums, university libraries, concert halls, and places for art gatherings in your region, right? You know, those phenomenal buildings always sporting the latest eye candy lusciously designed using all the latest trends—and you'd just do anything to get that tasty, lip-smacking job for your portfolio. Well, they usually don't pay you enough to go out and buy a case of candy bars. Truly.

If the client is a nonprofit entity, many subcontractors will price their participation in the project accordingly. Some subcontractors will even

donate their services if asked or if given a generous lead-time in which to turn the project around. It is wise to have your client do the asking for favors such as donated services. Encourage them to tell subcontractors that they will receive credits on printed advertisements or program pieces for services or items they donate. Once again, your reputation is at stake; and you don't want to be known as the design firm from the freebie-asking kingdom. Save your favor-asking for the times when you will need those favors to cover yourself. Manufacturers and subcontractors will have a harder time saying no to a nonprofit client that is producing a job for a worthy cause than they would have saying no to you.

Wants Versus Needs

A major factor to consider when dealing with an unrealistic budget is the matter of what the client may want versus your professional opinion of what the client really needs. Many times, I have met with clients who think they need a full-blown remodeled space, when in actuality they may just need some fresh paint, some well-watered plants instead of the withering ferns crouched in the corner, and a few new pieces of art on the walls. Another typical example of clients' wants versus needs may be a brand-new company that moves into a new space wanting all the latest Eames and Herman Miller furniture when Ikea might do just as well for the time being.

A healthy alternative in these types of situations is to offer to tier a program for your client. Perhaps you work on some smart temporary solutions now with a strong color and foundational design concept, leaving plenty of open spaces working with modulars, instead of building walls that will require artwork immediately. This way, you don't overwhelm your client with one big invoice it may not be able to pay. Setting priorities in this manner shows your clients that you care, that you understand budget constraints, that you are interested in teaming up with them to better their image, and that you want a long-term relationship. It also puts you in that omni-desirable driver's seat.

Don't forget that different-sized businesses will require you to think in different ways about pricing. For example, a new environment for the new corner deli cannot possibly cost as much as an executive dining room at Universal Studios. At first, the thought of charging different rates for different clients may seem unethical, but this is not the case. Think of this practice as being a close companion to the value-rating method discussed in chapter 2. The larger corporate clients are simply going to have more layers of work and approval processes, ultimately requiring more time and higher fees.

Consider the following scenario: When a large local developer recently asked a firm to design the interiors of seven different model homes for a new neighborhood of 244 condominium houses, it also asked for a budget, including printed materials for new homeowners showing finished design options, several different pricing tiers of fixture, lighting, and appliance selections, and four different comprehensive interior color palettes from which its customers could choose. The estimate requested $12,000 for the lighting option selection alone, while just a few weeks prior to that, an entire real estate office was designed for only $2,500.

The developer's project required countless meetings, extensive research about the specific target audience, strategic environmental analysis, ADA research and requirement fulfillment, and the development of printed collateral for a simultaneous public-relations campaign. On the other hand, the new real estate office was relatively simple—one initial client meeting with only two principals who were very organized and knew what they wanted, virtually no research—plus an additional incentive: the realtor was a new neighbor to the designer's studio. You never know when you might need to borrow your neighbor's snow blower, and, in this case, when you might need to sell or relocate your business.

Again, as with budget-driven pricing, think about what's in it for your firm when establishing rates for smaller clients versus larger, more-established ones. Consider the visibility for your business of smaller-budget projects. Also, possible barter situations or extended payment arrangements may once again surface with the smaller client. We'll go into detail on more pricing options in chapter 7.

While you should be careful not to interrupt important cash flow by adjusting your rates downward for smaller businesses, these types of projects might actually be scheduled for production during slower periods, which could help you in the long run. And don't forget the potential for that small start-up business to become a full-fledged corporation . . . sooner than you think.

Work Now, Get Paid Later . . . *Not*

I don't think there's a designer or design firm out there today who hasn't gotten burned yet by a seemingly promising, up-and-coming company of one type or another. This happened very frequently during the dot-com boom. These guys seemed to be just about everywhere, needing everything and demanding the latest in hi-tech-looking interiors. Unfortunately for many, the nonpaying dot-coms became stereotypical

clients for interior designers and their subcontractors. At first, they appeared very attractive. Cash was flowing from capital investors, young entrepreneurs wanted the latest colors, textures, and the most contemporary, exciting design solutions. So when a dot-com sprouted up in a neighborhood, competition was fierce for the designing.

After producing a couple of designs in the Midwest for some supposedly high-tech dot-com start-ups—and never receiving payment—I was asked by a client of mine at Universal Studios to meet a friend of his who was starting a "very high-end dot-com." These people were just getting their funding, and everything was hunky-dory, howdy-doody, or whatever the phrase might be. You get the picture. I took the time to meet one of the new owners, who had impressed my credible client enough to impress me. This dot-com was on the West Coast after all, and that was where all of them with the big money were, right?

Turns out, I really liked the president and founder of this new dot-com. He was very sharp, well dressed, incredibly articulate, and already had a decent list of clients. His funding was just around the corner. His career history had attracted plenty of new clients to his business. He needed beautiful custom textiles for his office environment, and he needed them yesterday. Now *this* was a project with which I could be exceedingly creative and proficient.

I was immediately brought in to meet the other owners. We all clicked right away. The president was very honest. They had less than $10,000 in cash, more likely $8,000. But he was willing to rent furnishings and art initially to allow me time to create the best solution for the new space, which was in a high-rent, high-profile district and was certain to open new client opportunities for me. I literally ended up spending several hours (unheard of for such a low-budget project) in the initial meeting with these people.

I created fantastic design solutions for this company. The first clue that something was going wrong was that, after revising the designs to the decision makers' likings, I didn't hear from them for a couple weeks. Repeated efforts to call and e-mail went unanswered. Even my big client from Universal tried to call on our behalf. He was supposed to be on their newly forming board of directors, and he was embarrassed that he had introduced us. Everyone was perplexed, but still gave the new start-up the benefit of the doubt. They just seemed so credible—how could all of us be so wrong?

It turned out we weren't really wrong. After two months passed, the president finally called to inform me that the company was going under. The interesting factor here was that the company players were still

credible business people. They were astoundingly creative and had an excellent business concept. The plain and simple fact was that they had never landed their big financing support. Every day, grassroots companies obtain their operational licenses, hoping and crossing their toes, working their butts off until they get so burnt out they just can't go anymore. The dot-com's idea was still great. They just couldn't sell it to venture capitalists.

Shame on me for letting this waste my time and energy. I should have been very systematic about requesting credit information from this company—their banker's name and phone number and the names of companies who were already extending credit. Even new businesses have established credit with phone companies, power and light companies, and other basic-needs support services. I could have—and should have—taken the time to ask the right questions and check out their wherewithal before moving forward. I have no excuse. All the intuition in the world on all of our parts did not pay off. I even have a full-time (nonbillable) office manager to whom I can delegate the types of administrative tasks required for background and credit checks. Geez.

Consider Your Options

If you do accept a job at a lower fee, it is not unusual to ask clients if you can install promotional signage in front of their entity while the work is in progress, or even print a simple brochure, highlighting before-and-after shots with some promotional information about your firm. Many times, distributing this promotional literature (via postal mail or e-mail) to your mailing list can enhance and expand your client's visibility to your specific audience, thus adding some possible residual benefits for both sides.

There are always more options to consider when the client's budget isn't big enough. Use your intuition. I know this sounds ethereal to a lot of readers, but we all have intuition inherent to ourselves. Go out and buy a book on how to tap into yours if you think you don't have any— you do. Check your gut, and ask it if this client is worth going out on a limb for. After your gut says yes, ask the client for some credit references if they're a small business or start-up.

Then, roll up your sleeves and have a brainstorming session with the client and figure things out. Set up a payment plan for your client that you feel comfortable with—perhaps on an ongoing monthly basis. This could help both you and your client's cash flow. Eliminate costly presentations; provide them in an informal manner, maybe even on your laptop, having bookmarked, for example, furnishings you selected from

Internet catalogs. Technology has rewarded the industry with the ability to provide beautiful, brilliant, comprehensive presentations for the cost of some printer ink and nice paper. You can even try going with some sketches and a verbal walk-through of your concept, using simple idea-boards showing your designs. Make sure you get the client's buy-in on the initial concepts before you jump into the costly act of hiring subcontractors and making purchases you don't want to redo or return, with costly restocking fees.

Try replacing original artwork with quality poster prints, use linoleum or marmoleum instead of wood or tiles. Rely on basic, functional interior design for a change. Design a great black-and-white space—or simple open spaces with classic colors. Less *can* truly be more. You might also choose lesser-grade woods or counter finishes; ask your suppliers to help you reduce costs. With imported pieces flooding the marketplace and new flooring and finishing options permeating our senses daily, opportunities abound to be creatively—and beautifully—cost efficient.

Use budgets as a stepping-stone to better client relations, to increase your own knowledge, and as a reference for future projects. The more input you bring to your client regarding a budget, the better for both of you. The most important thing to remember about budgets is not to be intimidated by them, but to embrace and accept them for what they are.

More on Value Rating

I introduced value rating in chapter 2 of this book, and like the prior chapter on the client's budget, value rating deserves a lot more discussion and in greater detail. There can actually be a considerable amount of appreciation for you in value rating—even from a profitability standpoint. Most of the pricing I do for my textile design projects is based on value rating. After I assign a value to a project, however, I always go back and divide the value rate by the amount of hours I believe the project will take, to determine whether or not I am close to my computed hourly rate described in my master formula. Invariably, I am ahead of the game when I do value rating, but until you get a very clear idea of what a project can, and should, go for pricing-wise, it is smarter to stay with your master formula.

Prepare for the Unexpected

Current events play an extremely significant role in fee structuring. During our latest national economic downturn, many interior design and service support firms went out of business because they were not flexible enough to respond to the dramatic drop in workflow.

Keeping up with national news is vital to every business, but keep in mind that professionals in the creative industries often suffer the most when times are tight. Why? More often than not, large companies sever their moving, furniture-purchasing, and design budgets, making their existing spaces and furnishings do until financial times turn around. If you keep informed on the latest happenings, you can tighten the belt buckle on things like overhead, new equipment purchases, and employee hirings while bracing for the storm. Eventually, the weather clears, and you find yourself busier than ever. Everything's a cycle, after all.

Something that you can never fully be prepared for—resulting in possible cascades of unmanageable workflows for

interior designers—is a natural disaster. While the economy may be doing its own thing as per usual, and you have stacks of local and national newspapers to prove your willingness to stay informed, an unexpected new situation can happen in a matter of seconds. If a hurricane, earthquake, or other natural disaster hits your area, you can be assured that it *will* affect your business in some way.

Unfortunately, even personal accidents occur. I was driving to the golf course to play a round of golf one early-spring day. Business was great, I was laughing with my best girlfriend about some type of nonsense, and seconds later found myself with only a memory of crunching metal and breaking glass. Our car had been hit from behind, leaving me with a bulging disk in my neck, over a hundred days off work for physical therapy, two years of working in pain, and a newfound litigation attorney I was forced to hire to settle the matter and recoup losses.

The economy had nothing to do with the resulting business loss. However, I was forced to face some pretty heavy overhead issues that resulted in the restructuring of rates and the way business was done in my absence. Until the accident, I was our primary salesperson. Not so smart. If you are the sole salesperson and income driver for your firm, make sure you have a good disability policy that will cover your personal income in case you are temporarily—or worse, permanently—unable to work because of an accident or catastrophic illness. If you run a business with a partner, "key-man" insurance is advised to cover either one of you on the other's behalf. These issues are not pleasant to think about, but they are sound business investments all in the cause of basic business survival.

Self-Promotional Value

Another reason you might decide to try value pricing is because the project has the potential to reward you with some self-promotional value. Perhaps it's selecting the color palette, finishes, seating, and lighting for a prominent historical theater renovation in your region. These projects are usually very high profile and make great portfolio pieces—but they're generally low in budgetary allotment because they are funded by grants and public and private donations. Deciding whether or not there is any real self-promotion value in a project is pretty easy. Always stay focused on your big career picture when you are making this decision, not allowing yourself to get caught up in "should I do this, but they need me to do this, or what if I don't do this" types of scenarios.

What's in It for *Me?*

- *Does the project allow any kind of growth for you?* If you are new to your community or if you are a new business start-up, this may be a great way to make yourself known.
- *Is it a new, possibly ongoing client opportunity?* Keeping with my example of a local arts organization—for example, a ballet or opera company—many times these organizations have some funds set aside for their annual redesigns of certain areas or satellite locations.
- *Does it involve the potential of a new design, material, or finish that you have wanted to try?* Perhaps there is a chance for you to try something you've never done before, and thus an opportunity for experimentation on a real process, while simultaneously getting educated. Sound like a win-win?
- *Does it provide any networking opportunities for future sales potential within your client's organization?* Translation: Are there important members on your local opera's board of directors who could be potential corporate clients?
- *Will it open new doors for you because this is a new type of client that you have never serviced before?* I don't know how many times I've shown my portfolio to a client in an industry I have never serviced before, and they won't consider me only because I have never done work for the widget-crafting industry—or whatever business they happen to be in. You and I know that good interior design is just that—it doesn't matter what the business is. But the uneducated creative-services buyer doesn't have a clue and wants to see something pertaining to his industry in your book.
- *Will the end result be portfolio quality?* It would be great if every job could be a portfolio job (and there is no reason not to strive for this) but, realistically, we all know that not every job is. So if you want to sink your keyboard into a specific project, this might be your magic moment.
- *Is the client willing to give you credit for the design and agree to print this credit on any printed promotional pieces highlighting his company (and thus your work)?* If the client allows you to print a mouse-size credit on the piece, you're golden. Ask the printer for extra samples to send to your own mailing list. You might have to pay a minimal amount for overruns . . . but it will be worth it.

Answering yes to any of the above questions can be sufficient for your affirmative decision to design a value-rated piece, possibly at a lesser rate than you might normally charge. However, only you can make the final decision, which will usually depend on just how busy you are (or aren't) when such an opportunity arises.

Pro Bono Work

If you thought pro bono only applied to law firms, think again—and think hard! Once you've opened your doors as a businessperson, the favor-asking follows close behind. Accepting jobs for no fee needs to be done selectively, while making sure that doing so does not disrupt your cash flow or place too great a significance on pro bono jobs over paying clients. Finding the right balance of when to say yes to such projects can be difficult—especially if you're one of those types who never say no.

If you know that you are indeed one of those people who can never say no, you're probably giving way too much work to many outstretched hands for the wrong reasons. Know that this can possibly result in great, ongoing grief for you with your peers. It's tough to give something for nothing. You must be a master at finessing creative control, talking and presenting (typically) to a powerful board of directors, and savvy at obtaining constructive criticism from a group such as this. Doesn't sound like much fun, does it? Most established interior design firms stay far away from this practice, leaving some space for those starting out to take the reigns and ride into the night.

Requests for pro bono work should *always* come from *nonprofit* entities. I cannot stress the significance of my last sentence enough. Small businesses starting out, or other "needy" companies or clubs, will not—I promise you—respect your process if you are going to give away your goods for free. They will dime and dollar you to your creative demise, and you will ultimately regret your generosity—even if you think you're doing yourself a favor to get some great samples into your portfolio. You will also certainly set a precedent for being a "cheap" designer, and when you go to charge your real hourly or value rates, you'll be questioned and ridiculed because "you didn't charge us that much on the last job we did."

In my opinion, pro bono is a necessary evil for the design community to embrace and accept. How many times have you been on an airplane and the flight attendant asks if there is a doctor on board? Designers are the communications doctors for organizations like your local performing arts groups or disease-research fundraiser parties. They all need well-designed, functional, aesthetic environments. Many of these projects are things like special events, trade shows, museums, and theaters—the fun stuff we all love to design. Ironically, these projects are usually big attention-getters in our industry because it is typically understood—and if not understood, it is up to you to make the fact

known—that if you are not going to charge for your fees, the creative direction of the project (within reason) is yours. Next should come the press photos of opening night or even a feature article in regional or national publications.

There are a number of nonmonetary benefits to providing your services at no cost. Consider some of the following issues when you make your decision:

- *Giving something back to your community.* We all want to give something back that we can feel good about. Good intentions of donating cash to causes we feel are worthy don't always translate into action—there never seems to be enough left over after the bills are paid. Pro bono work is a way to share your expertise by creating results-oriented design, thus providing actual value to causes near and dear to your heart.

- *Portfolio potential.* Most pro bono clients should agree to give you free rein creatively (while providing them with good design to fulfill their needs within their operating budget, of course). It would be unethical for them to ask you to do something for free and then tell you exactly how to do it. Unethical, yes, but believe me, they'll try. Make sure to lay at least the groundwork for your creative freedom before entering into any agreement, and know that with larger nonprofit organizations, you will be presenting to a board of directors with varied opinions, tastes, and attitudes toward design.

- *Networking.* All nonprofit groups I have worked with have influential businesspeople on their boards of directors. When word of your generosity reaches them, they will most likely be inclined to meet with you and help you make contacts within their own companies, which could mean new sales opportunities for your firm. This opportunity will present itself as your project unfolds. You will probably meet certain "committee" (that is, the marketing or design committee) board members who will influence the entire board's final decision as to whether or not to accept your work.

- *Ask to be the presenter at the "big" board meeting.* This is an invaluable experience for you and the right time to make yourself known. If you are unaccustomed to presenting to large groups, what better format with which to gain the experience than one with a lot of decision makers, earnest to learn from your presentation? You can't

make a mistake; you're there for free. It might help you, as you introduce yourself to this group, to thank them for the opportunity to provide your services (it's the perfect time to crack a joke about their lack of budget). You might even say that this experience is a win-win for all of you, because you are gaining some valuable practice from it yourself, such as presenting to a large group, presenting with a microphone, and so on. Use this time to educate the audience on your design sense; you're the expert—that's why you're up there. Make sure they know it by the time you're done.

■ *Self-promotion.* Since your pro bono designs will be portfolio quality, ask them to include your name on any press releases or printed information that goes out to the press or general public. If printed material is produced, ask for samples to distribute to your own mailing list. On more than one occasion, pro bono work I have designed was mailed to my own mailing list as part of my agreement—at no cost to me. Most nonprofits have a healthy mailing-expense budget. If you can show them that your own firm's mailing list might include potential investors or donors, it may well be worth their while to include your mailing list in their own. As with all pro bono work, it is very common to include a printed "design by" at the bottom of the piece so that everyone who receives it will also see your name.

Alternatives to providing projects totally free include charging a discounted rate or bartering for things like season tickets or recognition as a corporate sponsor in the organization's program. In some cases, I have asked clients to pay our regular fees, then on receipt of their check I immediately write my own company check back to their organization. This way, I post my check as a promotional expense and can take the amount as a legal tax deduction because I am indeed using it for my own promotional purposes. To date, the IRS does not consider time spent (even when translated to a dollar amount or hourly rate) in providing design services to nonprofit entities as a legitimate tax deduction. By requesting that a nonprofit entity pay for your services and then immediately refunding their money with a company check for the same amount or more, you are legally allowed to take the contribution as a tax write-off (even though you must declare the income). And, more importantly, it allows you to publicly announce your donation.

Ruling the Competition

Value pricing gives you a tremendous opportunity to stand out against your competition. And not always in good ways. My favorite client always reminds me, "Your work is expensive. You charge me as much as my lawyer does." These types of comments always made me cringe in the early days of owning my business. Luckily, he usually ends his comments with something like, "but you're good, you always come up with something new, and I like that," quickly followed by, "but I can't use you for everything."

Honestly, there was a time when I wished that every client I had would use me for everything. A one-stop shopping interior design firm—yessirree. You want a new paint scheme? We'll do a new paint scheme. You want wallpaper installed in your bathrooms? I love wallpaper projects. You want a hand-carved credenza from Bali reassembled after it has been crated and shipped? Well, we don't really do assembly, but what the heck, sure, we'll do that too!

Perhaps you can get some insight here into where I'm going with this dialogue: Most interior design businesses open their doors as little-known organizations. Producing some high-visibility projects and calling on the largest potential client companies will slowly help you to become recognized. Sixteen years later, your big client at Universal Studios in Hollywood is telling you that your prices are as high as his big Los Angeles advertising agency. What's wrong with that picture? The answer is, what's *right* about that picture?

Any time a potential client asks who your competition is, try answering their question unfalteringly. "We really have no competition," should be your consistent answer. They will look at you quizzically, listening to you going on about the fact that you create work that specifically answers your clients' needs, not your own. Not only are you in the interior design business to get results from the beautiful, comfortable, and functional environment you create for your clients; you're also in the business to get the clients' repeat business and referrals. This dialogue will result in clients who are ultimately happy with your pricing structure in return for the value of work they are receiving. There is no better reward for you than a repeat client or one who is glad to extend referrals to your organization or write letters of recommendation for your larger endeavors.

I think this philosophy is important to any size firm or studio. Your "competition" might have the coolest Web site, the slickest salespeople, and the biggest expense accounts, but at the end of the day, the "right" clients for you will be the ones who like you because of your work, not because you drive a nice car or you go out to fancy lunches.

Consistency in your pricing structure is a significant priority. Especially within a large company like Universal, don't get fooled by the fact that the advertising department is in building number 1102 and the property development group is in building number 418. Everybody talks and compares—especially if you're doing your job right. You should never take the chance of pricing one way for one group and another way for another group unless you want to do some serious explaining and hula-hooping in front of a large crowd some day.

Let's face it . . . having our work featured in magazines does get us attention. I can say to our staff that our greatest reward is a repeat client—and I mean it. But the ultimate is a repeat client for whom you win recognition—in your own trade magazines or theirs! Ruling the competition also happens gradually, as the local and regional newspapers or general business magazines—as well as local and international design competitions—recognize your work. It's always a treat to *not* be one of the big kids on the block and then leave an industry awards program with a big box full of accolades and handshakes.

Entering design awards programs can be incredibly expensive. Set aside a certain amount of money within your own firm's budget every year to make sure you have the cash to enter. Look in your favorite industry magazines for competitions sponsored by manufacturing companies. Winning even an honorable mention in these types of competitions will give you generous national exposure and a somewhat different venue in which to win and be recognized than the typical local press you are likely to achieve.

Don't make the mistake of not caring about awards programs and taking an aloof attitude. Tooting your own horn may be the most difficult thing for you to do. It's really hard for some personality types to actually go up to the podium and graciously accept an award. I remember the first year I joined with my design-firm partner who is ten years my junior. He was recognized for a wonderful accomplishment and given a significant reward. On his way up to the podium, he seemed embarrassed, looked down at the ground, and practically made an excuse for himself when he accepted the reward at the microphone. The crowd is watching you at these events. Learn to say "thank you" with meaning and clarity, even if it is simple. Enjoy the moment standing before your competition; sometimes your clients are in the audience, too.

Appearing overly humble will lessen the reward or press recognition in the viewers' eyes. They might question why you received the reward if you did not believe in the work enough yourself. They will invariably make wrong assumptions about you or the project. Give everyone a reason to look up to you by showing that you believe in yourself. Everyone likes to go with a winner.

A Designer Producing an Interior Design for a Nonprofit Entity: Karen Painter, Principal, Lorenz Williams, Inc., Dayton, Ohio

Karen Painter is a principal of Lorenz Williams, where she manages the firm's interior design projects and has given twenty-five years of service to the company. She is responsible for managing multidisciplinary project teams and specializes in architectural interior environments, programming and space planning, functional determination and affinity analysis, product evaluation for lifecycle costs, and renewable aspects. She has particular experience in sustainable and environmentally responsible design.

Q. Briefly describe the scope of your most memorable project completed for a nonprofit entity.

A. The Marie S. Aull Education Center at Aullwood Audubon Center and farm was a result of Aullwood's desire to meet an increasing demand for nature education programs. The design intent of the project was to create a facility that blended with its natural surroundings and provide a stimulating, memorable learning experience for children and adults alike. The new center is a major expansion of an original eight-thousand-square-foot education center that was built around a century-old, stone and hand-hewed beam barn. The expansion includes two new wings on either side of the original structure that total thirteen thousand square feet.

Q. What were some of the specific challenges you faced during this project?

A. There were many architectural and engineering challenges—environmental concerns such as site orientation. In response to a lack of utility and gas service onsite, a geothermal heating and cooling system was incorporated. Aullwood's existing well was used, rather than creating a bigger one, by putting holding tanks in the basement and pumping from there into building areas as needed. Natural lighting is often used and promoted inside in place of electrical solutions. Operable windows are used throughout to allow ventilation and cooling. By creating both indoor and outdoor classrooms (the shape of the building creates outside classrooms, while the indoor classrooms have doors to the outside), education space was maximized.

Design-wise, there was the need to integrate the "old" with the "new" so that one would not feel a separation between the existing building and the new addition. There needed to be a recall of some

materials and elements that were favorites of longstanding members and guests of Aullwood. The redwood exterior siding that was removed from the existing structure, to allow for the expansion, was brought into the interior finishes and used as wall finish for portions of the classrooms. Several of the beloved trees on the site had to be removed. Rather than sacrifice those trees altogether, some were made into lumber used for the construction, some wood was used to create beautiful handcrafted tree motif entry doors by a local woodworker. A large boulder was unearthed during excavation and was used as part of the main reception counter. Other natural materials such as stone, cork, and bamboo were also used as interior finish materials to evoke a sense of place.

Flexibility was key for gaining the greatest utilization of space for dollars spent. Modular wall systems allow for the expansion and division of the large multipurpose room. Furniture height, as well as configuration, can be altered. Products were selected as a "family" to be interchanged as needed. Classrooms were constructed in different sizes to match the needs for various educational programs. Trails continue directly through the building toward the outside, as seen in the Hall of Wonder. The Window on Wildlife space acts as a gallery that allows the building to constantly transform itself, much as nature does.

Q. Were there any troublesome issues with regard to the budget, and how did you overcome them?
A. Aullwood supporters began raising funds for the expansion project in 1998 because the center's educational programs had outgrown the facility. They ran a very successful campaign in the course of two years, raising $3.7 million through donations from 645 individuals, foundations, and organizations. Lorenz Williams provided a number of graphic visuals that assisted in the campaign in addition to numerous events attended by the project and design architect John Fabelo and various members of the project team. Some value engineering did occur in the construction phase of the project, but none impacted the vision of the project.

Q. Were there any residual benefits, such as press coverage or new client opportunities that resulted from your endeavors?
A. Lorenz Williams received coverage in newspapers, press coverage, and continues their relationship with the client. The director, Charity Krueger, is quoted in a publication as saying, "We're so fortunate that Lorenz Williams were our architects on this, because they really caught the heart of what Aullwood stands for." Charity and the uniqueness of the building continue to promote Lorenz Williams as

each new organization attends. It is also considered to be a model for other Audubon Centers. The best compliment is that our team is now working on the expansion and renovation of the farm portion of the center that will include classrooms, offices for the farm administration, a teaching and commercial kitchen, and a three-hundred-seat multipurpose room, all surrounded by the farm pastures, outbuildings, and barn. This project also advanced our firm in "green" sustainable architecture, interior design, and engineering, now being requested by many of our clients.

Q. Would you do another project for a nonprofit entity?

A. Yes. We have done other projects to date as well, including the Carillon Historic Park and the National Aviation Hall of Fame, to name a couple.

Fatal Errors

Some clients are notorious for changing their minds for all the wrong reasons and at all the wrong times. You *can* charge clients for changing their minds a million times. A first round of changes to an original design concept just after the initial presentation is acceptable, at no additional charge to your client; build this into your quote and just count on it. Sometimes, a second, third, or—horrifyingly—a fourth round is required. The industry is inundated with change orders, and it is an absolute must for you to include a "revisions allowance" in your quotes or to specify "change order" hourly fees. Generally, any changes after a third round mean that either you are not communicating with your client effectively, your client has multiple personalities (and many of them do), or your client is making its decision by committee and the committee is too big to agree on anything.

The Changelings

If you have the unfortunate history of most of your clients constantly making changes, then a personal assessment is certainly due. More often than not, however, if a client is given carte blanche to make changes, he or she will do so. Set the rules up front. An absolute requirement to your project-acceptance repertoire will be the ubiquitous change order form. This form might be a simple confirmation of the client's desired changes, along with a new cost for this revision and a place on the form for the client to sign off. It could be as simple as setting up a template that can be printed on your letterhead. Review this form and procedure with your clients before starting projects, thus warding off their desire to make alterations.

Clients, justifiably, are allowed to change their minds. What we as designers need to realize is that, most of the time, client changes are not meant to bruise our egos or to point out that we

are uncreative or totally off-base with our selections. Remember that many times client changes come not directly from your client but indirectly from your client's boss. When changes come from a higher echelon, which can seem as invisible as the Wizard of Oz, it is important to remember that eventually the Wizard surfaces, and, just like in the movies, he may not be such a bad guy after all.

The truth of the matter is that the client—unless he has extensive experience choosing colors, finishes, and textures—most often *does not* know if he is going to like something until he sees it. Keep in mind that there is a time and place for client changes, and it is up to you to set those ground rules proactively while you are establishing the schedule for the project at your initial master meeting. Discuss up front the issue of possible changes that your client may want to make. Be specific about what these changes could possibly be. Give your client reassurance once again that while his or her involvement is key to the success of the finished piece, revisions should be made only at certain incremental stages of the project, which you establish and agree upon together. Changes at any other stage of the game (after furniture is ordered or walls torn out, for example) will wreak havoc on your estimate.

Don't let unreasonable revision charges build up until they become a towering inferno of disaster. You cannot absorb these charges, and your client must acknowledge them if they are to be made at all. Many times, when clients are informed of the costs they will incur to make a significant change at the wrong stage of their project, they will change their mind (again) and leave the project alone.

For as many times as a client may think he wants to change his mind, there are as many occasions where a simple dialogue with you might convince him otherwise. Acknowledge the concern, but point out how such a change might be costly beyond any possible value to be derived from it (if this is actually the case) and, more important to you, how the change may actually be undesirable from a design, ergonomic, or aesthetic standpoint. Sometimes, clients want reassurance that they have made the right choices along the creative way. Often, they are charting unexplored areas, and their decisions are being scrutinized not only by their customers, but usually by superiors as well. Your sensitivity to these issues, along with an ultra-significant patience factor that has been deemed necessary for your survival in this industry, is vital to your success.

A great example is when a client sees the new color scheme painted in its lobby or office area and suddenly isn't sure that you've chosen the right combination—only a few days after he said he loved it and it was perfect. Your answer should sound something like, "You know, I had the

same concern about that shade of green myself when I saw the first coat; but then I realized it was the best choice because of the way the light floods this room all day, making it a perfectly tranquil solution for a waiting space. I can promise you this is the best color to use here; and you chose the right color last Monday. Good job!"

Most of the time, your client simply wants acknowledgment and validation of his concern. Your explanation then gives him ammunition if someone else (perhaps his superior) decides to challenge him regarding the same issue. Plus you are reaffirming the decision he made when he said he loved it a few days before.

Your delivery of these dialogues will get better and better with practice. Once you have the satisfaction of experiencing a client go from constantly wanting to change the course of things to seeing it your way, you'll know that you can achieve your desired creative results—you just can't expect to do it all the time.

The following are some ideas for how to handle a client's unreasonable change requests:

- Make certain that you establish a protocol for change orders with your client before a project actually begins.
- Listen very carefully to what your client is saying; it may not be as bad as you think.
- Be objective. Review your proposal (if you did one) for an outline of the project's goals and objectives. Do the client's changes concur with those goals and objectives?
- Validate your client's concerns by simply acknowledging them. This does not necessarily mean that you have to agree with them.
- Discuss the issue and endeavor to mutually agree on what the next step should be. Most often, the next step will be for you to research additional costs and discuss them with your client as soon as possible.
- Communicate additional costs in writing to clients, and have them sign a change-order form that acts as an agreement to cover the surcharges.

Billing Protocol

Providing services that you can't charge your client for is sure to dishearten you. Your efficiency, and that of the staff members and subcontractors you have chosen to slurp at your overhead, is of constant, utmost importance. Everyone makes mistakes. Just don't make the same mistake more than once and you'll be on the road to more profitable, enjoyable

self-employment. Taboos that you cannot ethically charge your client for are things like ordering the wrong paint colors or finishes; making item-number errors from catalogs or price lists when ordering furniture, lighting, or materials; using unauthorized copies of software programs or poorly maintained computer systems that create problems; suffering the dreaded "fatal error" computer bomb; not backing up or saving your computer work; and misdirecting a subcontractor, supplier, or freelancer you have hired to help you complete the job.

A very difficult task is to train your staff members to take personal responsibility for their mistakes. The advent of the computer as a design/production/spreadsheet planning tool in our industry has added a significant amount of responsibility to the designer's already heavy load of multitasking; thus, the opportunity arises for more mistakes on the technical side. Employees should constantly be updated on new ways of doing things, and also be monitored for costly errors that reduce the firm's profitability.

I have found that biting the bullet and paying for employees' mistakes without disclosing the monetary amounts to said employees results in even more errors. A staff member can quickly prove his or her loyalty, efficiency, and worth to the firm by reducing the frequency of mistakes once he has been enlightened about the occurrence and how much it has cost the firm. A practice I have recently put into place is to reward employees with a small bonus every month that goes by without their making errors that cost the firm time and money.

The old adage that hindsight is 20/20 comes into play in yet another arena: You have a hunch that adding more to the project will please the client and pay off. Often, you'll be right, but your thinking will be wrong in some of those cases, and you really can't charge the clients for things they didn't ask for or agree to.

But it can be great when you *do* take the risk and it *does* pay off! There have been several occasions in which I quoted a client a price for a specific project and decided on my own accord to enhance the project by adding time and, on occasion, even money to make that project better.

A perfect example is a textile design I recently created for a new client whom I have known personally for years but never worked with professionally. This woman is quite well known in our region because she is married to a legendary actor and she herself is quite philanthropic and community-oriented. However, she is very sensitive to people wanting to work with her just because she is wealthy, and she is almost paranoid about wondering if she is being taken advantage of where fees are concerned.

Upon her request, I designed a carpet for her family room. While I was designing, and with the rich mahogany details prevailing in the beams and bookcases in the room, I couldn't help but think of a contrasting pattern that would work well for pillows, as well as a smaller carpet for the entry area to the room. I took the time to create the designs and had a service bureau print them out to scale—which was costly. When I showed her the final carpet design I surprised her with the other patterns, and her resulting delight is now in my profit margin. I was right! In this case, producing the extra patterns was not a stark risk because I did know the woman personally and had her trust. Use your intuition to decide when to take the extra gamble of spending your time to increase not only your bottom line but your portfolio and, probably most importantly, customer satisfaction.

Another example is a program I am creating for a local museum that has a national audience. My original quote and presentation were to create a reproduction of an original antique textile that cannot be repaired and one the museum wants to archive. The cost of doing an original textile can be overwhelming at times—especially one of this size and detail—and add to that the fact that this client is a nonprofit entity. My solution was to turn the project into a fundraiser for the organization. We will produce a series of one hundred signed reproductions and offer them to the museum's benefactors. Not only will the needed reproduction be paid for, the resulting funds collected will benefit the museum and be lasting heirloom purchases for the patrons.

I will add a high-profile museum to my portfolio base and hopefully meet some new clients through the benefactors' promotion—two big payoffs. Plus, it will be fun to follow the fundraising as it continues, attend the installation premiere, and interact with an entirely new group of acquaintances I wouldn't have had the opportunity to meet otherwise.

There is a tendency in our industry for egos to get in the way of practicality and reality. The introduction of technology as a design and production tool presents a perplexing problem. The incessant, looming question is, how much will we use technology to design and in what format should we show things to our clients? Most clients have the comical perception that if you have a computer you can just "change this and that and move this here and change this color there and try moving this wall to see what happens," on and on into oblivion.

Theoretically, this may be true, but the real world comes back with a bucket of cold water in the face, reminding us that we can't be everything to everybody, as we sometimes imagine we can in those

omnipresent rose-colored glasses! The answer is simple: Don't make it hard on yourself. Do what you do best, and do it all the time. If your strong point is interior wall coverings and only interior wall coverings, provide your client with *only* that service. Talk to vendors about your weaknesses, and at least educate yourself enough to offer a referral service to clients who need to buy services that you don't provide. Refer to the full-service concept earlier in this book, make your decision about what services you do and don't want to provide, and move on. You can always add services to your list; it's harder to take them away. Realizing your strengths will reward you not only with profitability but also with a great reputation within your chosen niche.

There are five common faux pas that you should take responsibility for and never charge your client:

1. Purchasing the wrong color, finish, or pattern from a vendor. Make sure you understand restocking fees and proofread, proofread, proofread your *written, detailed* purchase orders.

2. Forgetting to change the color of something (usually paint) that your client specifically requested.

3. Ordering too much fabric, wallpaper, paint, or floor covering. You might pad your estimates for supplies of this type by 15 percent to cover overages. Exact measurements are sometimes difficult to determine and it's better to have too much than not enough—especially when it is possible for a manufacturer to discontinue a color or pattern in the middle of a project.

4. Miscommunicating change-order status to your subcontractors. Make sure that if you are responsible for your subcontractors' productivity (and bills) that you are on the job frequently to explain changes, anticipate problems, etc.

5. Having the finishing materials or furnishings delivered to the wrong address. Don't laugh—this happens often. To avoid arguments and incurring additional freight costs, have your client confirm the delivery location(s) in writing.

You Gotta Be You

Owning your own interior design business and developing your personal ethics systems are huge challenges in their own right. Don't be too hard on yourself, but always be true to yourself. Living under false pretenses is very stressful and can literally make you sick. You must know your own process and that of your staff members to be truly productive and profitable. Dealing with money and issues regarding

pricing is delicate subject matter. Money is a weird figment of our society. It's intimate, and everyone handles it differently and has different concepts of right and wrong. The process is an individual one, and this book has been designed to broaden your own awareness of what might work for you.

When a client says, "I spoke with such-and-such design firm, and it can do my project for $3,000 less than the estimate you gave me," your first response should be to ask whether your client is comparing apples to apples. If you are a multiperson firm and you are being quoted out against a freelancer or small studio, your rates will obviously be higher, and you can't be expected to compete in such an arena. If your firm was quoted out against another multiperson firm, comparably talented, and you feel that you properly assessed the requirements of the project before submitting your estimate, then tell the client they have a good deal going with the other firm, and you'd like to see how the project comes out, thank you very much!

You are setting a dangerous precedent if you lower your price point-blank. You will always be expected to lower your prices with that particular client, and you will get a reputation all over the place for doing so—clients talk, you know. Protect yourself. Don't feel like you have to get every job you estimate.

It comes down to the simple matter of who the client really wants to work with and your ability to look at the matter in a strictly professional way. Never put yourself in a defensive position or frame of mind. Don't ever take these situations personally—if you do, you will be committing yourself to straitjacket city in a matter of months.

Time Management: The Key to Your Survival

Another mandatory aspect of a successful business that makes you and every right-brainer cringe is accepting the concept of time management. That's for accountants, you say? I used to think so too. I'm not going to frustrate you with loads of information that you probably won't take the time to read anyway. Just please know that time management goes hand in hand with project management and with the "discipline" thing that's so difficult for us designers to commit to.

I finally found the one time management tool that totally changed my life—I mean totally—when my dear employee Kathy Madden forced me to buy one of those day planners. Before I joined the multitude of day-planner users, I had piles of papers on, shoved in, and stacked knee-high around my desk. I thought those planners were for geeks—certainly not for designers. And why would I want to spend over

$30 for some notebook pages that I would never use anyway, and another $100 for a leather-bound carrier that I didn't like the look of? Dear Kathy practically bound and gagged me as she ever so patiently showed me my new apparatus and how to use it.

Ten years later, I am a reformed and better-organized woman. I go *everywhere* with my day planner. They come in many different sizes and name brands—and you'll find that one name brand's carrier is not compatible with the holes punched in the other name brand's calendar pages. Getting over this initial frustration will be easy once you are able to open yourself up to the wonderful world of *pre*-organization.

That's right—someone else has already figured it out for you! There, before your very eyes, are sectioned-off pages that include every hour of the day for your appointment reminders, plenty of space to take notes (and draw pictures), other goodies like last month's and this month's calendars in full view, and any month within a five-year period at your fingertips.

What about the infamous electronic PDAs (personal data assistants) that are everywhere, which people use to beam each other mega-information, games, stock quotes, and e-mail messages? I think they're great. As a matter of fact, I have used one before and plan to get one of the latest models as soon as I have enough time to research the one that suits my needs.

I can promise you that a planner will change the way you do (or don't) organize yourself, your clients, your vendors, and so on. It will be a tremendous aid to use at your master meeting and while determining project and personal schedules. Everyone on my staff now has a planner, and it has made a big difference—everybody knows what is expected and when. Ultimately, putting these deadlines and other details in writing in the planner's calendar format—especially if you actually take it to planning and creative sessions—opens up your own creativity. You're not bogged down with all that left-brain stuff, because it's all in your book!

Know Your Work Process!

In the world of organization, knowing your work process—how you get things done—is another significant factor. If you know your own methods and can use them to your advantage, organizing yourself and others will be substantially easier. A lot of our work processes were taught to us in design school or college by professors who set up class assignments with schedules that suited *their* work processes. You may not have given it a second thought until now, but do so with me, and you'll see what I mean.

Answer the questions below as specifically as possible.

- Do you like to do a lot of thumbnails before you begin a project? If so, how many, and how much time do you like to spend on each one?
- Do you like to do research before you begin designing to get a true and accurate sense of every possibility?
- After you have been assigned a project, do you like to let it swirl around in your head for several days before you begin?
- Do you want to be part of every innuendo of the architectural layout, elevations, and cornice details?

Or:

- Do you like to start a project right away, spending little time on thumbnails?
- Do you get frustrated when a client asks you to show more than one concept?
- Do you find that you have an intuitive sense regarding many different kinds of client tastes and what will appeal to each of them?
- Do you like to have the architectural elevations already finished so you can fill in with colors and textures right away?

There is no right or wrong answer. These questions are simply a way to pinpoint the methods that appeal to *your* sense of how to be productive.

Answering affirmatively to the first four questions shows that you come at design from a more practical, fact-oriented basis. You're the type who likes to turn over every stone before you pick one up and hold it for a while. The methods suggested by the last four questions appeal to design types who get frustrated with a lot of preliminary tasks and who like to dive into a project right away.

Realistically acknowledging your answers to the sidebar questions above will be a great help in setting up your project schedules in the future. Using what you have just learned, you will know yourself better and can therefore establish with your clients the sequence of necessary events for your work to be timely and effective. If you have a staff, ask them these questions as well. Know that if you are going to require someone's help to complete a project, you may have to set up the schedule to fit a very different work process (or style) than your own.

This whole work process thing came to me while teaching design theory at the University of Dayton several years ago. My own work process is mostly that of diving right in and creating a visual theme right away. So, when I assigned a portfolio-type project to a group of seniors, requiring only five thumbnails before moving on to the design enhancement and production phases, I heard this huge resounding sigh of relief from about half of the class. I thought five thumbnails sounded like a lot. It turned out that my colleague down the hall, who taught another portfolio-level design class, required a minimum of thirty thumbnails on his projects.

My first inclination was to panic; I had never taught this level of design students, and I felt that maybe I was not pushing them enough. What I soon learned was that the students who needed to do more than five thumbnails did so on their own before they could move on. About half of the students did just fine with only five thumbnail concepts. Grades and the quality level of the finished projects were not affected by how much planning or "predesign" work went into a piece. My colleague's students' projects were no better than my students' projects. It simply boiled down to two different methods—or work processes—of performing the same tasks.

You'd think that this teaching experience would have shown me something about scheduling projects for my own staff. But I hadn't really learned my lesson. Very shortly afterward, I had the great fortune of being able to hire a very talented illustrator-designer who had recently graduated on an art scholarship from a well-known university. I had seen his portfolio about six months previously but did not have any job openings. A significant growth in accounts offered me the opportunity to seek out this young man and offer him a job.

About two months after my art director and I had enthusiastically agreed that this young man was the perfect member to add to our team, we began to have second thoughts. He seemed to have trouble meeting deadlines and all of a sudden seemed unsure of himself. The quality level in his once-incredible illustrations and designs seemed to drop way off. We were frustrated, and so was he. The straw that finally broke the camel's back was when we gave him the opportunity to draw some illustrations for a new client's capabilities brochure. He worked solidly for one week and then over a weekend, with very little to show for his time. We met him on a Sunday (the project was due for the client's review on Tuesday) and couldn't believe how little we saw. I frantically called in two freelancers, who responded appropriately, and we got the job done on time.

This employee was really depressed, and so were we. When my anger and disappointment had subsided enough for me to talk with him about what had happened, the skies suddenly parted and light shone down into my blinded eyes. We were all relieved to realize that it was a simple matter of his having a different work process. While my art director and I have a quick-go-to-it process, this staff member likes to plan his work with a lot of pre-concepts and a comprehensive idea of what the final project is going to look like before he can really get started.

This story is a great example of just how important it is for design employers to understand the vast differences in their individual employees' needs in order to get the most creative output from them. When you look at interior design as you would a manufacturing process, it's easy to see how different methods of operation will affect not only the end product but the efficiency within the implementation process as well.

Project management, from a creativity and organizational standpoint, can benefit greatly when the principal (or principals) of a firm oversees all projects. This doesn't mean that you will have to over-encumber yourself with work tasks—quite the contrary. By overseeing projects, I mean that you should approve each project at every significant stage of the growth process. Study any thumbnails or pre-concepts with the "heavy planners" on your staff. Review and approve all elevations whether your firm or an architectural firm is producing them. Approve all presentation materials and the theme for the project. Every phase will need your affirmative nod, including approving color palettes, textures, finishes and furnishings, artwork, and so on, making any suggestions for improvement to your junior and senior designers (or to your clients), before purchase orders are prepared.

By overseeing projects in this way, you will better understand what endeavors went into each phase of the design from a time-creativity, problem-and-solution standpoint. You will be more respected by your associates and your clients if you have a general overall knowledge of each element of a project. If you're the principal of a firm or studio, your capabilities for discernment are more developed than those of your support staff. If you become out of touch with a project, you will also lose control of it, and the end result may be something that is not up to your standards.

As your firm grows, it will be exceedingly difficult for you to oversee each and every project produced by your firm. The challenge will be to find that special senior designer you trust enough to give him or her authority similar to your own. To this day, the most difficult task I have

ever faced as the owner of a firm was to find just the right person to help me take on the most significant task of overseeing projects.

It's like a marriage: you trust your partner to make important decisions in your absence. You learn immediately that if your partner doesn't do things just like you do, it will be hard to accept her decisions, and you learn how to stand up to clients in situations in which you personally had nothing to do with the issue at hand. I know that some principals never find the right person to accomplish the ultra-important tasks. After running my firm for *nine* years, I had the great fortune of meeting the person who became my trusted partner and creative comrade.

Either Chris or I approved every project that came into our studios. It got really crazy at times, but we both knew that it was imperative for one of us to approve projects internally before our clients saw them. The result was that each project benefited from critique by more than one creative eye (that is, by the designer who created the work and by either Chris or me), and perhaps more importantly, it was organized and managed within the discipline of the internal system we had created. Consistency in how we produced and presented our projects was the key to our firm's "signature" within the market.

Your Client *Is* Your Partner

Treating your client somewhat as you might a business partner will help both of you create successful projects. None of us likes to feel that we are being controlled by someone else. Simply offering comments like, "I'd really like to know how you visualize this place before we get started," or, "Your input is really important to the success of this space," psychologically makes your client feel like a significant contributor to your design solution.

Even if you don't really like the client's ideas, make sure you listen carefully without interrupting when your client is voicing an opinion or presenting an idea. You will make your client feel great whenever you *can* offer, "That's a great idea!" If you would like to change or add to their idea, or offer an alternative, try to add something like "And it would also be great to blah, blah, blah." Words like *and*, *also*, and *in addition to* are inclusive of the client's ideas. Don't use words like *but*, *only*, or *just*; these are negative. Your message will be more readily accepted if you use positive words.

Develop a System That Works for You

Knowing yourself and your staff's processes will be the foundation for the type of project management system you need, and will also depend

heavily on the size and complexity of your business. If it's just you, or you and one or two other people, it's easiest to implement a simple system; I recommend the "job-jacket" system. For a larger group of people, you'll want to involve everyone in devising and implementing a system that works for all the individuals involved. (*Why* group involvement is much more important than the details of the system you eventually decide to adopt is discussed below.

The best system I've found for small groups—which I define as you working alone or with one or two other people—is the *job-jacket system*. A job jacket is simply an oversized envelope that holds every element belonging to that particular project. The external job jacket itself can be reused many times until it falls apart—your clients will never see it.

The outside of the job jacket usually has a clear pocket of some type that you can use for the job's log number, the project name, a list of everything that's inside, and client information, such as name, address, and phone number. Or this information can be written directly on the envelope itself. Inside the job jacket you should keep pre-concepts; thumbnails; color, fabric and finish swatches; all photos and illustrations; purchase orders; time sheets; and anything else that your client originally gave to you when you accepted the project.

Job jackets should always be kept in a central location where everyone can access them. At the end of the day, all items should be put back into their specified job jackets. The next morning's work is then started without employees wondering where certain project elements are. This simple but effective system works great and is the most common organizational system used by small studios.

Seldom does a firm open its doors with a huge, award-winning staff, crème de la crème clientele, and an overflow of working capital in the bank. If you decide to start a studio, and it grows until you need to hire several full-time support-staff members and then several more, you'll need more than the job-jacket system to keep things organized and flowing comfortably.

This may sound odd, but the best way to create a strong project management system for a larger group of people is to get everyone involved in both the creation and the establishment of the system. This is at least as important as what kind of system you eventually establish! By getting everyone involved, everyone takes ownership of the system, and everyone has a say in its development. Work processes of all types will be acknowledged when a group makes a team effort in putting together a project management policy in which every member will participate.

When the boss tries to put the so-called perfect system in place, the support staff tends to hold grudges or find excuses for why they aren't working. But when the support staff team up with their leader in a joint effort, a clear winner emerges—the group itself as a whole.

Once you and your group have established a project management system that everyone can assume some level of ownership for, it should pretty much be left to run on autopilot. You should have checks and balances set up along the way so that you or another key authoritative person will be overseeing and approving projects as they pass through the phases you have deemed necessary for such review and approval.

Ongoing clients will become a part of your project management system through osmosis. They will know from experience when and how to expect things from your firm. You will have developed a consistency that you, your staff, and your clients will become familiar with. And high staff morale will ensue because you have allowed everyone to be a part of building the machine that will drive the team's organization and ultimately its creativity. Learn to tie those two thoughts together repeatedly, and make them your mantra: "organization, creativity."

I know it all seems like a lot of work, especially when you can't possibly see yourself being this detailed or this organized. I totally understand. But trust that your professional and personal lives will be much better for it all. Picture this monster inside of you that is the bad, disorganized, and out-of-control person. Then, picture the calmer, more productive, in-control person. You might not even be the slightest bit aware of this second option. Now you have the tools to meet that awareness face to face.

Five Time- and Project-Management Tips

1. Consistently maintain time sheets.
2. Plan your days so that you can spend at least two hours at a time focusing on design and production tasks. Fragmented time is counterproductive.
3. Make and return your phone calls at the same time every day; try initiating calls first thing in the morning for an hour and then returning calls between 1:30 and 2:30 in the afternoon. You'll find greater success in reaching your parties at these hours, resulting in some nice blocks of time for planning or productive sessions. Don't set up appointments for yourself during these periods, and inform your staff that you are not to be interrupted at these times.
4. Be aware that job burnout occurs very often in your industry—both with designers and subcontractors. Encourage staff to take planned vacation days, consider giving an extra day off on holiday weekends, and think about closing your office or studio for at least a week (or two) between Christmas and New Year's.
5. Set realistic schedules for projects, and stick to them. Hire freelancers or approve overtime hours to keep projects on track. Falling behind will result in a domino effect of being behind all of the time and becoming notorious for missing deadlines with clients and vendors—a really big no-no in our industry!

Case Study Interview

A True-Life Lesson in Error Management: Shawn Taddey, Principal, Senior and Junior Designer, Administrator

Shawn Taddey is the sole principal at Taddey + Karlin. She focuses on in-depth, full-service residential interior design in Beverly Hills, California, employing a senior and junior designer along with one administrative person.

Q. Do you develop "partnerships" with your client in any way? How does that work to your benefit—or not?

A. It depends on the client, because some like to keep things strictly professional and a lot of clients make you their new best friends and you hear about every bit of their life and more than you would ever want to know!

We are very sensitive to what type of relationship makes the client feel comfortable; that, in essence, is the true art of being a designer—assessing what the clients want and how to make them feel taken care of. It's just like dating—you figure out what they like and what turns them on.

My firm also ends up lots of times being their personal manager (because our firm is so obviously efficient). We sometimes manage their entire lives; I've hired shrinks and weight trainers for clients! I've even done Christmas shopping for clients. We interview and hire maids, then we groom them and teach the maids how to take care of the clients' house. Some clients really get addicted to it. It's kind of hard to wean them off when our project is done but it works out very nicely because they get an entire package from start to finish and there is a lot of trust established which gives us more freedom to do good work.

Q. Do you have an established protocol for change orders?

A. Yes, absolutely. We document everything constantly and in great detail, but not only internally. We also demand it from our subcontractors. When a client wants to make a change, we review it with the client and the contractor together to make sure everyone is on the same page.

Designers need to go to business school. I see so many designers fail because they simply do not know how to handle these situations with a firm hand. They can have the most beautiful taste in the world and then lose money because they do not know how to execute changes and issues like this that arise in our business every day.

If we disagree with a change a client wants to make, we show him the end result on paper to make sure he knows what he's thinking and saying. One of my great assets is that I can draw; it has been a major factor in my career success. I mean—designers who can't draw—goodbye! If I start talking to a client about a room I can draw it for him in a minute on a piece of paper and he can see it and choose it. If he wants to make a change I show it to him instantly. Art Center was the best education I could have had because it taught me the drawing and painting and full design theory that I use every day. Designers simply have to take drawing classes, in my opinion!

Q. What special time management techniques do you use to keep projects on track—both from a completion deadline standpoint and your own profitability standpoint? Does your staff also use this system?
A. All of us use a project status report format and a daily time sheet to log every detail down to every five minutes of our projects. Again, I cannot stress enough the fact that designers must have business skills and be very diligent about the details with regard to how they and their staff members use their time, making sure their clients are charged for all of it.

We are very critical in how we present the scope of our interior and architectural design services initially to our clients. We specify every minute detail of our services, the purchases we will be making and what we can and cannot be responsible for throughout the duration of the project.

Q. Is there a particular system you use to bring projects in and then track them throughout their duration?
A. The most important part of our system is doing our homework up-front to make sure we have everything outlined, costs are detailed, and fees and markups are explained thoroughly from day one. Clients do not like surprises. Our initial contract is very intense and I like to personally review every aspect of the contract with the clients to make sure they are on board with everything and understand it all. I do not assume anything about my clients even if they have worked with other designers. I even explain, for example, that fabrics have varying degrees of fading over a period of time and [from] exposure to sun or light. I make sure they initial every page of the contract as we review it. Our projects are very large and even a "small" mistake can be very costly to me if there is a misunderstanding; so we get the nitty-gritty done up front and then we can move in and change their lives—in a good way!

Q. You have a lot of experience in the design industry. Has your own work process changed—through personal awareness, using technology, or both? How does your own understanding of that process make you more efficient?

A. We are pretty conventional in our approach to design. Like I mentioned earlier, drawing has been critical to my success and being able to think fast and produce solutions immediately. Designers will ultimately have their biggest successes if they can do this and if they make sure they are confident with their business management skills. If they are all creative and have no business knowledge they really need to take some business administration courses; and it's so easy to do this now with community colleges offering so many alternatives.

Pricing Options

I know you have spent a lot of time and energy in establishing your hourly rate and learning about value pricing. But when it comes to operating your own business, creativity in your pricing structures can be just as important as the creativity in your portfolio.

Brokering

I'll never forget exactly when and how the idea of "brokering" came to fruition in my business. After my car accident and the subsequent restructuring of my business, my soon-to-be husband Joel and I were brainstorming on my recent lack of profitability. Since I was the primary salesperson at the time, reducing my overhead because of lack of volume was mandatory.

Joel's closer scrutiny of my books showed some months with huge sales and other months with less than 10 percent of those sales. I explained to my pragmatic, number-crunching, attorney-guru-fiancé that the huge sales reflected jobs that resulted in equally huge subcontractor services. "Well, that's simple," he replied unnervingly. "Why don't you act as a broker for those services?"

I began to wonder why I had ever agreed to marry such an uncreative, left-brained kind of guy. Not only had I never heard of brokering in our industry, it sounded like a dirty word that was filled with pinpoint oxford cloth shirts shouting indiscernible words on Wall Street. Little did I know that it was soon to be one of the most creative ways to generate consistent profitability and peace of mind.

Joel encouraged me to call a close friend of mine who was also a general contractor and discuss the possibilities of brokering. The idea was to work like this: I would continue to offer full service to my clients by providing design management,

coordination, and quality control (which was very important to me). I would still obtain quotes from subcontractors and include their prices in my client's estimate, with my normal markup fee (we'll go over this on the next page).

The only difference was that the subcontractors would bill my client directly, include my markup fee, and then send me a check for my marked-up amount after my client paid him. The beauty of this plan is that all at once, your subcontractors owe *you* money! Suddenly, your books are consistent every month, reflecting your actual billing performance more realistically. And you don't have to worry about your client paying you on time so that you can pay your printer on time. You can also use this system for purchasing materials and furnishings from vendors; simply have the vendors bill your client directly with your markup fee.

This system also leaves you absolutely no opportunity for the occasional temptation to spend the money collected from your client for your huge subcontracting bills on something other than what they were intended for. Too often, businesses of all types get into "robbing Peter to pay Paul" and fall dangerously behind in their obligations to Mary, even though they had every intention to make up the difference through increased revenues or better cash-flow management. Don't ever let this happen to you.

Of course, there are certain clients and situations for which you will want to absorb the paperwork and details of significant outside costs. Some large companies issue only one blanket purchase order for a project, and if you claim to be full service, you may need to be responsible for the entire project, including hefty printing charges. But at least 50 percent of the time, the brokerage concept has worked *very* successfully for me.

Quite surprisingly, our vendors love it, too, and most of them are now encouraging other firms and agencies to operate in the same manner. It's an efficient way to handle large amounts of money and be able to look at your business volume more realistically. Vendor trust is an absolute must, but to this day—seven years later—I have never had even the smallest problem with the implementation of this system.

Most clients will welcome receiving the subcontractors' invoices separately from their design services invoice. Subcontractors usually bill two to three times during the project, and in many cases this will extend the payment period for your client, because your own invoice should be in their hands just after your initial design concepts are approved, and then weekly thereafter. Typically, I tell clients that we prefer billing them

for our services while asking the subcontractors to do the same. I explain to them that we do quote two to three comparable subcontractors and always choose the best one for the project depending upon price and quality. Disclosing the actual brokerage procedure is usually not necessary. If clients ask, I certainly tell them that the subcontractor discounts the work and uses us as a broker—which is true—and it has never created a problem. Generally, the client wants and appreciates the full service.

If the client wants us to bill everything and carry complete administrative and supervisory management of all outside services, we add a project-management fee to cover our production manager's billable hourly rate as well as the typical markups.

Markups

Everyone knows the concept of retail markup. The corner grocery store buys lemons for a dime a piece and sells them three for a dollar. Your favorite department store buys Levi's for $16 and sells them to you for the everyday low price of $34.99, and so on. Well, every business has its markup standards, and the interior design business is no exception.

Consider the substantial cost of supplies required for a presentation, for example. Many times, FedEx charges are incurred for obtaining samples, expensive and large color printouts, presentation boards, and so on. Or, if you are buying furnishings for a client, you need to be aware that there is a universal standard of marking up these costs. I had been running my design firm for almost two years before I came to this heightened level of awareness one day while having lunch with a business mentor. Hopefully, you're finding out about this earlier in the process than I did!

The most common markup in the interior design world is 20 percent; every firm I interviewed used that amount as a base and went up or down from there. On smaller projects, many firms charge a 25-percent markup to their clients for outside costs. This simply makes it all worthwhile and recoups some of your nonbillable office manager's time for all the work, like invoicing and purchase-order management for the necessary supplies and vendors required to complete the job.

Usually, the only time markups go down is when the quantity of furnishings and finishes is so large that it is totally unreasonable to charge 20 percent, because it places the entire project in jeopardy of being monstrously over budget. The perfect examples of this are projects like entire floors of offices for a specific company, large homes where multiple rooms are being designed, new homes, or businesses. Project sizes

that exceed finished costs of around $100,000 typically see a lower range in markup amounts. Once again, the value theory comes to light, and it is necessary for you to make the final decision. Sometimes, putting even a 1-percent markup on a project can increase your profitability substantially without taking the client over budget on their unit cost.

Markups are a great way to make a nice, ethical profit margin, on things like furnishings in particular—especially when you have pre-negotiated a lower retail price than other designers might obtain because you have established a high-volume relationship with a manufacturer. Use the following checklist to remind yourself of typical things to mark up while you're doing your estimate or projected budget:

☑ Supplies needed to complete a job—special presentation boards, colored papers, and laminating
☑ Any outside, service bureau fees—high-resolution output, color lasers, color copies, and oversized outputs
☑ Laser copies from in-house equipment
☑ CDs or other hardware required for backup of client files
☑ Photography required before and after the project
☑ Supplies and materials needed for photo props
☑ Subcontractor fees
☑ All design/building materials
☑ Furnishings, lighting, window coverings, accessories, etc.

In essence, it's anything that you are buying to complete a project.

Management Fees

There are pros and cons to letting your client be the one to manage the painters and other large outside suppliers. Sometimes, clients want to manage things like who will paint their walls, who will build their credenzas, who will provide the flooring, and who will perform the actual, major tasks that bring a project to its final peak (or demise). While some clients really *do* know how to buy these services, others know just enough to cause real trouble. Your job is to discern among the multitude and decide accordingly.

Since some clients will be adamant about managing these matters, your challenge is to decide whether or not this control scenario is agreeable with your own process. If the contractors the client wants to use are part of your own pool of known subcontractors, then there is typically no problem. Sometimes, clients who buy their own services will even respect your suggestions and referrals. In any case, you should ask for a management fee to go through the punchlisting (a simple checklist of issues and problems that need correcting by the contractors) and quality-control phases of your project. After all, if your clients respect you enough to hire your design services, they should want your blessing along the way to ensure integrity of the project.

If you're full service, don't be afraid to say no to a client's project that won't pay you a management fee to go on the job site or allow your input on color choices or contractor details. Both you and the client are asking for trouble when it comes to important quality issues in the final phases. Many good designs rely on finishing techniques, such as varnishes, paints, installation, and other industry craftsmanship that simply cannot be judged until the final stages of a job. If an alteration needs to be made during these last moments of your projects, and you are not present to help make the decisions of what gets improved upon and how, chances are your design will be sacrificed unnecessarily, to your total chagrin.

Square-Footage Rates

Quite often, clients might ask you to quote projects based on square footage. This is a dangerous request because it shows that this particular client is probably accustomed to "canned" design and doesn't really want or understand customization. Perhaps he would prefer the services of someone else. If you were *really* efficient and kept using the same types of finishes, wall and floor coverings, and furniture manufacturers, you might be able to pull this off. You could also agree to such a fee structure if you were responsible, for example, for a group of condominiums with the same floor plan within the same development.

While the "square footage" term won't be heard on a daily basis, clients who prefer this pricing method might expect you to respond to it—and you can, if you educate yourself up front. Take the last six projects you have completed that are in the same category from a

services and quality standpoint, add up the total costs for all six (this will include furnishings, markups, etc.), then divide that amount by the total square footage of all six projects. Make sure to compare the right projects to the quality level of design this particular client is asking you for.

Working on a volume project that has a square footage fee attached to it can be quite profitable and rewarding. Since this appears to be the age of condo development and condo conversions (every baby boomer retirement city in the nation is converting apartment buildings to condos), getting a few square-footage pricing projects under your belt as examples will give prospective clients the green light to hire your services. These production-style projects can be a good way to keep cash flowing and staff people consistently busy.

The easiest way to determine your square-footage rate is to ask clients what they are used to paying. I have found that 75 percent of the time, clients in this category are willing to pay more than I would have asked—so, in that case, you've got a win-win situation and everybody's happy!

If a client is hesitant to give you a rate, you'll need Intuition 101 once again. First, decide on the value of the job. Then, using your newly found algebra skills, try to determine how long the project will take you to produce, and multiply that by your hourly rate. Divide your totaled amount by the square footage of the project. How does it compare to your preferred rate methodology? It is not unusual to charge a square-footage rate separately from the supplies, subcontractor, and furnishings pricing, plus markup.

If the client thinks your square-footage rate is too high, share your difficulty in establishing this rate with him or her and see if you can come to an agreement that you both feel good about. Don't let yourself get backed into a corner; but the sooner you can find a comfort level for discussing money issues with your clients, the better for both of you.

Painters, wall finishers, and flooring experts will most typically quote in square-footage terms, and this is probably the reason for your client asking you to quote projects this way in the first place. Don't hesitate to give combined quotes for square-footage design work included with other associated fees that simply do not fit this structure. Hardly any project in the interior design domain can be thought of as canned, and you can explain the difference openly to your client. Asking the right

questions up front will gain you more respect, long-term confidence, and integrity.

Knowing the different possibilities for square-footage pricing, even in approximate ranges, will be an asset in initial client meetings, where you might be asked to discuss rates on the spot. Figure on at least three different quality levels, do the math, and keep these numbers under your friendly cap. The last thing you want is to be asked a question that leaves you looking like a deer caught in headlights.

Retainers

Retainer pricing means that a client pays you a straight monthly fee for services you provide. In actuality, the client is retaining your services for a consistent fee based on your annual volume of work production for them.

Retainers were primarily devised for full-service design firms by clients, such as real estate developers who would buy design, finishes, and furnishings on an ongoing basis using an annual budget. The retainer fee would be used essentially like a revolving credit card for the firm to make purchase orders and expedite the project. On a monthly, quarterly, or annual basis, the entire account required an intense review to determine whether the firm was overpaid or underpaid, what exact services were performed at what rate, what projects the client had added unexpectedly, and so on.

Many large firms and even some large design firms still use this billing procedure for large, ongoing accounts, but its feasibility and popularity is quickly waning. The biggest problem is that many times the firm ends up owing the client money. Most firms simply don't have the cash flow to pay back money that they've already used for something else. *Every* client I have spoken to about retainers over the last ten years has been burned by them.

Another problem with retainers is the legal descriptions, contracts, and attorney fees that ensue with such an entanglement before you can even get started working with the client. Not to mention the paperwork and accounting nightmares that suddenly face your office manager (or you). If a client suggests a retainer program to you, however, don't cower in abject fear. That suggestion means there's lots of work coming your way.

A great advantage of retainers is certainly the consistent cash flow that will prevail, as well as a guaranteed level of work. Retainers are a

great way to grow your firm because you can assign a staff member to "manage" the retainer account while hiring new staff members to either dedicate to that account or work on new projects. Make certain to have a contract stating that the payments are not refundable and that the account will be reviewed quarterly by both you and your client (to make sure that you don't "owe" your client too much work, or to bill additional fees to your client that were not covered in your original retainer agreement).

The biggest negative thing about retainers is that they *are* contractually binding, usually for at least a year, if not longer. This can be a good thing for you if all is peaceful and smooth. On the other hand, it can be a living nightmare if, for example, all of a sudden you lose rapport with your client or the person with whom you work directly gets replaced by someone with whom you can't work too well. Make succession plans for your business for the impending loss of cash flow if either of these things happens, forcing you not to renew the contract when it expires.

Quick Billing

A creative alternative exists to the monetary tracking hassles that retainers require. Why not suggest a simple pay-as-you-go concept to your client instead? Billing can be done on a weekly, biweekly, or monthly basis (depending on volume) for the work done within that period; the client could agree to pay you within a week of receiving your invoice.

You might even give a 2-percent discount as an incentive if payment is received within ten days, five days, or whatever you decide is fair. Involving your client in this process shows your business acumen and also shows that you are serious about proficient service.

If you and your client agree to a quick-pay or other creative billing program versus a retainer, also ask for a ninety-day-out agreement. This could be a simple letter of agreement outlining your request for ninety days' advance notice should your client decide to terminate your ongoing services. Outline these ongoing services as explicitly as possible so that the volume of work is apparent. Your signature and your client's signature on your letterhead outlining your agreement quite simply suffices for a legally binding document. The ninety-day agreement will give you time to plan when a client does terminate your services and will also remind your client of his or her commitment to you.

Per-Project Pricing

Countless times I've been asked questions by clients like, "How much would you charge me for a sixteen-color, five-by-eight-foot carpet?"

Or, "How much would you charge to do two rooms of flooring design?" These types of questions are frequently asked by new clients trying to get a feel for your rates.

As previously discussed regarding square-footage rates, you should have some idea of how to answer these questions. You don't want to be intimidated into quoting a lower price because you're being asked to think on your toes. If you're not sure what you would like your answer to be, simply respond that you need more specifics, that each job is certainly different, and that you will provide a rate that afternoon or tomorrow or whatever, to make it clear that you are not simply skirting the pricing issue. Self-confidence is key here in your communicative rapport. People can pick up on your weaknesses quickly and use them to their advantage if you're not prepared with an answer.

Again, using a range of fees is always safe in these circumstances—your answer can be, "anywhere from $10,000 to $100,000"—and in many instances will prove to the client that you simply need more information to be more accurate. Being able to quote a range of fees is the perfect segue to *your* next question, which is, "Do you have a specific design project coming up that I could quote on?"

After you have completed several similar projects, you will have a good idea of what these types of projects entail cost-wise. This type of pricing simply will not work on full-service pricing but it is fairly simple on textile design projects and condo/development projects if they are of similar scope to projects you have done in the past or if they are "cookie-cutter" projects with a simple change of color palette, lighting, or hardware style.

Bartering for Profit

Bartering is indeed a way to make a nice profit of a different sort. Surely, you remember your *Weekly Reader* as a kid—it often described exciting trade journeys from the far corners of the world. *Bartering* is just the slang word used for *trade*, usually referring to trade on a somewhat less grand scale—that is, between individuals or small groups.

I have designed many fun and creatively rewarding projects for clients who didn't have a lot of money but had something to offer in return. A very popular local restaurant in my old hometown is a great example of this. The Winds Cafe & Bakery is owned by a couple of friends who work hard and get rave reviews from critics all around the state of Ohio. I happen to enjoy eating their unique Mediterranean-style and nouvelle cuisine dishes. Back in my graphic design days, the Winds

needed a logo—and sub-logos for their carryout bakery, coffee beans, and wines—but they didn't want to spend thousands of dollars for design and production. We agreed that they would pay for their fixed costs—the money required to print new menus, letterheads, business cards, envelopes, matches, and T-shirts, for example. Fees for design services and production would be bartered. So, everybody was happy—I ate great meals once a week and entertained friends and clients at no actual dollar cost, and the Winds got nicely designed promotional items and signage, many of which have won design awards and continue to be used today.

Another example of a successful bartering arrangement concerns a very talented furniture builder whose display window I marveled at on countless occasions. Through an unusual chain of events, I was introduced to this man, who immediately discussed his need for some design services. Business was brisk for Glen, but he wanted to be doing more highly designed, custom pieces. The tradeoff here was a design for his showroom in exchange for an incredible conference table that playfully emulates a grand piano. Although we really needed a meeting table for our offices, we would never have been able to actually spend the money on an item as lavish as a faux grand piano. Glen and I decided that he would make the table during his down periods, and I would design his space in the same manner.

If you have a staff and are actually paying a staff member salary to work on barter accounts, you have to be very careful that you are busy enough with actual paying work to generate cash flow to compensate that particular staff member's time. Also, be very careful not to have too many barter accounts in house at any time.

The best barter situations are those that 1) specifically fit your needs when an exchange is established; 2) affirm your need for a loose schedule so that you can fit them into down times; and last but not least, 3) retain a very high level of respect from your barter client for the type of designs you produce and finishes that are installed. The last thing you want is to trade any dollars' worth of your time with someone who will make content and finish alterations that could leave you biting the bullet and unhappy with your agreement.

Flexibility in pricing options shows your clients that you care not only about the creative process but about their bottom line and budget constraints as well, and the beauty of offering these options can mean enhanced profitability for you as well.

The Details on Estimates 8

This chapter proves to you that estimates will be the bench-mark for the majority of projects you produce. Whether you are operating as a freelancer, a small studio, or a large design firm, an estimate shows your client that you are indeed a professional, that you have a good understanding of the client's expectations regarding creative needs and budget constraints, and that you know how to get the job done proficiently. An estimate is your primary starting point for good project management and for healthy client relationships. Never underestimate its importance.

What Is an Estimate?

A good estimate acts as a blueprint for a successful project and a satisfied client. This is truly the stage of a project that determines the quality of the end result. Goals for the finished project should be established and shared with your client as you review your estimate together. Your client will appreciate your thorough-ness and understanding of the project when you provide a cohe-sive, concise estimate. You will benefit by gaining a client who shares your vision of the job.

An estimate is an evaluation or appraisal of a specific project in terms of creative and technical specifications and the fees required to implement these specifications. The estimate ulti-mately places an actual value on a project—not only from a cost standpoint, but from a creative application vantage as well. Basically, there are two types of estimates: detailed, itemized esti-mates and simple, lump-sum estimates.

Your estimate will often become your contract for a specific project, so it's important to do your homework until you're comfortable with the information you're providing your client. This will also give your client the confidence to proceed with your services. Last, but not least, it will open the door to your

own creativity when you can (finally!) get started on the design, knowing in advance the parameters you will be working within.

On many occasions, clients will inquire about a project and request an estimate, only for you to find out later that the piece is stuck in a large black hole called "budget allocation." In this case, a client may be putting together a budget for an entire project that exists only conceptually in his company—and he is merely looking for an approximation of money to allocate for that specific purpose. There will also be times when clients *think* they need a project done right away, only to realize when they get estimates that they don't have enough money allocated for it.

Creating preliminary estimates will appease both you and your client in these cases. A full-blown estimate takes a long time to prepare, and most clients who are familiar with buying interior design services will understand and appreciate that fact. A preliminary estimate should be defined as such in your estimate's headline. You should then prepare it as you would a range or "not-to-exceed" estimate, which are both reviewed later in this chapter. This procedure will save you time, while giving your client the information needed for allocation of funds.

If your client has never used professional interior design services, it will be good usage of your time to qualify the client by asking if he is prepared to pay your hourly rate of, say, $100 per hour in exchange for a perfectly delightful family room, kitchen, entire home, etc. Taking some time up front to explain your fees can save you a lot of time and heartache presenting an estimate that the client is not expecting. Especially if a residential client is inexperienced with design services, it will be up to you to explain your process and what he will receive versus doing the project himself or (horrors!) with another designer. You will need to make sure that neither of you gets embarrassed or, worse yet, angry with the other because of this necessary, up-front communication.

Patience is imperative when you prepare estimates and, more importantly, when you submit those estimates for approval. As you process more and more requests for estimates, you will be better able to assess which projects are 1) actually hot prospects waiting to be produced; 2) "maybe" projects, depending on how much they are going to cost; or 3) won't be produced for months. One of the first questions you should ask while reviewing a project for estimating purposes is, "What is your time frame for having this project completed?" Once you have the answer to this inquiry, you can discuss with your client which type of estimate will best suit his immediate needs.

Let me warn you about assuming that your clients—new or existing—know how to establish realistic budgets. A few months ago, a good friend asked me to give him an estimate on a very exciting project. Since we were friends and knew a lot about each other's processes, we skipped a lot of preliminary fact-finding and dove right into his needs. This end result was to be the equivalent of the best project we had ever produced. It rang with possibilities, sang with promises, and soared beyond eagles. You get the picture.

Well, about six weeks after we submitted our estimate, my dear friend freaked out because he had set aside about $200,000 to do a project that we estimated costing $850,000. He embarrassingly had to go back to his superiors to get more money approved and explain to them why he didn't know it would cost so much to complete in the first place. This guy is a very talented corporate real estate developer, but really does not have a clue about how to buy design services or how much they should cost. He did know that he needed a highly designed, uniquely furnished 4,200-square-foot luxury condo for a huge company and a piece of real estate that will sell for millions of dollars. He also knew the target audience and all the relative information that I needed to know to price the project.

Had I been more inquisitive and perceptive, I could have helped him by providing him with my doomsday information right from the start. Had he been more inquisitive, he would have had my firm provide him with a preliminary estimate before he presented his original budget to his superiors for review. The moral of this story is, shame on both of us. Take the opportunity to be proactive with your clients about budgeting and providing them with realistic numbers for upcoming projects. Providing this service enhances your clients' perception of your business knowledge and puts you first in their minds when the time comes to assign the project. It also gives you a first foot in the door to follow through on projects you know are coming up.

Preparing an Estimate

I recommend providing your client with detailed, itemized estimates, particularly for special, one-of-a-kind projects, even after you have a long-term relationship established. The advantages of providing a more detailed estimate include protecting yourself against possible false expectations, showing a real "bottom line" or total cost, and having a "legal" document should you face the unfortunate circumstance of needing one. A signed estimate actually doubles as a legal contract and requires your client to pay you for services and products

outlined within. After working with a client on an ongoing basis, you will discover how to tailor your estimating process to achieve maximum efficiency.

Here are six main questions to ask yourself every time you prepare an estimate:

1. Who is the estimate being prepared for?
2. What is the name of the estimate? Give it a header like "Estimate for 2005 Harris & Greenburg Law Offices: A New Environment" or "Estimate for Coldwell Banker Corporate Headquarters, New York: The Future Is Now." A creative name will generate excitement for the project for you and your client and perhaps extend itself into the finished theme.
3. How is the overview of the project to be defined?
4. What are the technical specs for the project?
5. Who will do what?
6. What are the fees?

You will need to know and use terms like "in-house services," "outside costs," and "outside suppliers." In-house simply means those services your firm generates completely while using equipment, staff, and knowledge that you physically have in your studio or office. Outside costs are generated by outside suppliers, such as picture framers, painters, and floor installers—any service you require to complete a project that you don't originate from under your own roof.

Use the list of questions and the following, more detailed checklist to help you devise an appropriate format for your estimates. Also, consider using an estimating worksheet so that you don't forget anything. This is a form designed for internal use only (clients never need to see this form), and is common as a guide in the estimating process. This form can include some of the questions I've outlined here as well as questions that you find to be appropriate to specific projects. The important thing is to find a format that speaks to your own sense of organization, and to cover all the relevant details. I'll review the between-the-lines information you'll need to know about preparing estimates throughout the rest of this chapter.

Here is a detailed checklist of items to include in your estimates:

- ☑ A concise description of the project
- ☑ Overview of project phases
- ☑ Assignment of responsibilities (i.e., yours versus your client's versus the subcontractor's)
- ☑ A list of what you will provide and subsequent fees. I call this "creative development," and list research, design, resourcing, presentation, palette, and finishing materials
- ☑ Supplies and materials required and their costs
- ☑ Photography required and subsequent fees, including your art direction
- ☑ Any special circumstances such as ADA requirements, design adaptation for seniors or persons with special needs, etc.
- ☑ Walls/ceiling treatment
- ☑ Floor treatment(s)
- ☑ Wall treatment
- ☑ Millwork required
- ☑ Window treatment(s)
- ☑ Furnishings
- ☑ Accessories
- ☑ Travel expenses
- ☑ Delivery or freight expenses
- ☑ Installation
- ☑ Payment terms
- ☑ Your signature and a line for your client's signature

You may use "TBD" (to be determined) if the exact specs have not been decided yet. Make sure that when you have a conclusion on any loose ends, you do a revised and detailed estimate to obtain sign-off on any TBD items.

Preparing an accurate, thorough estimate depends on your ability to obtain the essential information required. Never be intimidated by your client or feel like you are asking too many questions. When a client informs you of a project, set up a meeting so you can go over the project elements face to face. As mentioned earlier, you may find simpler ways of accomplishing the estimating task as rapport is established with a client; but initially, face-to-face contact is important in gaining trust and perceiving expectations.

This important initial discussion with the client will set the precedent for all future client rapport. Be ultra-organized for this meeting, and be on time! Take a calendar, and after you have the necessary information, plan a schedule with the client that you will confirm in writing after the estimate is approved. Discuss the project's process with your client: what happens first, next, and so on, step by step, to make sure the client understands the significant role he plays.

This first meeting is the "master" meeting, where you must gain your client's confidence and have him relinquish control of the project to you willingly. You will have great success if you keep your client *involved* throughout this process; everyone likes to feel needed and important. I have found clients to be far less meddlesome in the design and implementation phases if I involve them heavily in the planning phase and maintain our agreed-upon schedule.

Use this meeting to review exactly what services you will provide and specifically what the client will be providing for you to accomplish your great feat. If the client is providing certain elements, like furnishings or lighting, ask to see samples. Will they provide items compatible with the design you are envisioning? Are you expected to create a design using their provided items as a platform? Are important family heirlooms to be included and featured in certain ways? Assessing the quality of materials and finishes required of your completed project is of utmost significance now; if you're talking Ferrari and your client is talking Hyundai, you're both in trouble! Educating your client may be very necessary in this meeting. (See chapter 11 for more on educating your client.)

Don't be afraid to ask for what you want. If your client is providing some of the project elements and you are not pleased with their quality, ask if you can include within your estimate the fees required for their *possible* updating. All a client can do is say no and offer an explanation of why not. I've found that, for the most part, clients are very open to constructive comments and generally receptive to receiving an education of sorts, after you have gained sufficient confidence to present these matters objectively and are sure that you won't be putting anyone on the defensive. There's always the case where a client's daughter designed the urn that goes in the foyer or the eldest son who made the nightstand lamp in a workshop. And there is a time and a place for everything!

Taking time to understand your new assignment and client is of maximum importance. Be very aware of the underlying factors that influence successful projects. You may need to take some time before your initial client meeting to read up about the client, especially if it is

a new one. If the client is a corporation, get your hands on its annual report or any self-promotional material it may have, and be knowledgeable about who you're dealing with. If your client is an individual, try looking him or her up on an Internet search engine. Diving design-first into projects without knowing more about your clients—their history and expectations—is a serious waste of time if you want repeat clientele.

If the client is a start-up business, or he or she doesn't have promotional materials to share with you, ask about any related information you could read, like industry trade magazines or competitors' brochures. This shows that your attentiveness and detail-oriented manner are more than skin deep, and that you are truly committed to being *prepared*. Clients always appreciate this level of preparation and will ultimately reward it with coveted projects.

In addition to reading up on the client, you may need to become knowledgeable about the client's target audience, who will be visiting the space(s), as well as how and when it will be used. Usually, this research should be done before your estimate is approved; don't forget to allow sufficient fee structure within your creative development fees to do the proper investigation and get paid for it. Clients will appreciate your acknowledgment of the research task as an important contribution. If a significant amount of time is required to do it properly, add it as a separate line item on your estimate. Cutting corners on research time is certain to simultaneously cut the level of respect you will get from your clients.

Range and "Not-to-Exceed" Estimates

Sometimes a client simply won't take the time to meet with you long enough, thus resulting in you not having enough information to provide a thorough estimate. In this case, you might provide an estimate range, which would include an overview of how you perceive the finished project, brief specifications, and then a realistic price range (like $100,000 to $125,000). You also want to spell out terms of payment and get an authorized signature on the range, just as you would for any other estimate. Estimates provided in ranges tend to get the client's attention, and in the case that such an estimate is approved (and they sometimes are), it protects you by being vague in itemizations but inclusive of any possible, necessary fees.

The other option for providing an estimate when you don't have enough information is to develop a "not-to-exceed" estimate. In this case, you again provide a brief project description and specifications while virtually guaranteeing to do the project for a price not to exceed the amount you are stipulating. Some clients will be amenable to this

arrangement; others will be shocked to their senses and agree to give you more information and get more involved.

Providing range and not-to-exceed estimates saves you time because you don't have to sweat over the details. You also save time by more-or-less assuming the specifications. It is imperative, however, that you pad your outside costs substantially to cover the many yet-unturned stones.

An omnipresent number of variables hover above your estimate-in-the-making. Think of your estimate as the framework for all things to come: When a builder builds a home, he can't set up the framing without first looking at a plan, and only after the framework is built can the plumbing, electricity, windows, walls, flooring, and trim be added. Only then, after those tasks are finally accomplished, do you get to move your furniture in! Learn to moderate by carefully taking one step at a time.

The Estimating Process

When your initial discussion with your client regarding the scope of the project is behind you, the road is paved for you to begin your estimating process. Find a comfortable place, close your eyes, and take yourself on an imaginary journey through the creation of the entire project from start to finish. Now, either with a notepad or a mini-recorder, document this scenario in detail. By doing this task you will achieve two things: The first accomplishment will be to perceive the less-obvious tasks and possible variables you will encounter throughout the project's evolution. The second will be to have an image in your mind of how the project will flow. This exercise is the first step toward organized, creative project management.

Planning for things like travel expenses, long-distance telephone charges, and freight charges will provide you and your client with the most comprehensive estimate. No client likes to be surprised with such charges at the end of a project, long after the charges have been incurred. Remember: It's very important to involve your clients in the process, so they know what it will take for you to get the job done right.

As mentioned earlier, your own mistakes and technical blunders (such as fatal errors on your computer like entering the wrong measurements) are not billable; however, you may want to plan now for the extra time you will no doubt need to cover or fix some of your faux pas. Knowing just how much to pad for these variables is a tough call, and it's best to remain conservative, especially if your rates are under scrutiny.

Client revisions and the mistakes they may make *are* billable and should be called out as such within your estimate. Since you can't really plan for these particular variables and client whims in your original

estimate, it is important that you allow for their occurrence as part of your billable time. Stating something like "Client revisions to be billed at $75 per hour" at the end of your estimate is totally acceptable and very common. You can count on many clients getting nervous about this note; however, it does encourage the client to give you the right information and authorization the first time around. Also, after your explanation that a typical design change or two will only take a half hour (assuming hammers have not been lifted yet), a client is reassured. And in the case where a client wants to make substantial design revisions after the project is well underway, you are indeed covered.

Add the time of preparing the estimate itself into your project fees. Even a simple project requires a lot of phone calls to outside suppliers, and every hour of billable time you incur should be included in your costs. You will probably want to include the estimate preparation time in your creative development fees. This will avoid any attention being brought to the matter, since it will be a small amount of time compared to the total hours spent on creative development.

Another often-forgotten variable is adding an allowance for rush charges you may incur from outside suppliers, especially if you are busy with other projects when you take on a new one. Many suppliers will charge incredible handling fees for expediting samples, furnishings, or other items through their warehouse and outside of their normal turnaround time. Rush charges can very quickly skim significant percentages from your profit margin.

While variables can truly cost you money, proper planning and comprehensive estimating are the real keys to profitability. Believe me, after only one project that ends up *costing* you money to produce, you'll learn the lesson that haste truly makes waste. Unfortunately, it eventually happens to all of us. But if you're really smart, it will only happen once.

It is not uncommon to charge your client overtime fees if the schedule is extremely tight—to the point where lots of overtime will be *required*. If, for example, your client wants a new office space designed before a particular corporate event, within anything less than a typical three- or four-month period, you and your support vendors will most certainly spend many late nights accomplishing this task. As you become more familiar with how much time certain tasks require, you will also become more confident establishing ground rules for how much time you need to produce the job properly. A client will assume that he or she is totally in line if you don't bring the issue to the forefront. Also, you will be setting a dangerous example for how much time will be allowed for you to do future projects if you don't charge properly for your overtime.

During busy periods, even accepting a job with a normal turn-around schedule can suddenly become a crazy overtime venture—but one that your client cannot be responsible for. It's a great idea to plan for these occasions: meet capable freelancers and set up a strong support network for yourself in anticipation of this eventual occurrence. Burnout for you and your staff members is truly devastating and can be avoided with proper planning.

Accepting a project with a tight schedule—whether your client or your own busy schedule created it—is a commitment of many sorts. At all costs, don't get into the habit of missing deadlines. Our industry is notorious for being full of pressure to meet deadlines. If you think about it, there is a huge domino effect that you immediately become involved in upon a project's initiation. You are the middleman between your client and the other vendors required to complete the project—whether you hire them or not. Passing the buck to outside suppliers when you start to run behind on your schedule is strictly taboo. When missing a deadline really *is* another vendor's fault, you should insist that he write a letter to your client admitting that fact.

I think the most important element where meeting deadlines is concerned is to keep your client informed of extenuating circumstances. For example, if a project requires a lot of outdoor construction, and this in turn depends on good weather, your schedule could quickly go down the proverbial drain in a matter of hours. Don't become known to your clients or vendors for always being behind schedule. Sure, you're going to miss some deadlines eventually. But it is very important that you know how to diplomatically repair unfavorable results that will occur in these situations. If you're an infrequent offender on the running-out-of-time scene, you'll probably be able to negotiate your way out of it. Unfortunately, clients are sometimes lost because of it.

At the end of my own firm's estimates, we have a disclaimer that simply states: Final costs may fluctuate 15 to 20 percent due to actual expenses and time logged. Very seldom have clients asked me about this. The only exception, perhaps, is when I have provided not-to-exceed estimates. In this case, the client usually expects and deserves not to be billed for overages, assuming that they are already built in.

We've already discussed the fact that you must build in a little extra time for unforeseeable situations. Once again, as you gain experience producing similar projects or projects for specific clients, a pattern of time requirements will most certainly emerge. Certain computer programs also allow you the luxury of comparing projects and the actual time logged on them at the touch of a button. As you develop a track

record for yourself, the guessing game will turn into an actual target that is more consistently achievable.

Additional Variables

Some possible variables often overlooked in the estimating process include:

- Time needed for research, outside vendor coordination, and those moments when you're in a creative slump
- Postage, freight, and delivery costs—not just for the final product, but for all the things that transpire along the way to a project's completion
- Proofreading time for purchase-order product numbers, delivery addresses, etc.
- Client meeting time—especially if you will be working with a committee
- Long-distance and/or mobile telephone charges
- Travel expenses—not only for you, but perhaps for your assistant(s)
- Markups—often these fees added onto outside vendor charges become your lifesaver when you've miscalculated time requirements or other charges

Creating good estimates is a challenging task because it establishes the entire foundation of a project. Many times, after starting a project, you will get an idea that might enhance the project. Know that pursuing this idea will cost you money, since it does not appear on your original estimate. If you are notorious for changing your mind and coming up with ideas after the estimate has been approved, ask for "design revision allowances" on your estimate and explain your creative process to your client.

Proposals 9

I have fondly nicknamed the official Request for Proposal (RFP) a "cattle call." This must go back to my childhood, watching a farmer friend of my dad's calling in his dairy cattle. The analogy seems quite accurate when you study the specifics.

RFPs or RIPs?

An RFP is certain to hit your mailbox one of these days. The RFP is most commonly a multipage document that an organization will send out detailing its need for designed and printed material regarding a specific subject. Certain organizations even have forms you can fill out to get on their RFP list. Usually, you will be informed of the technical specifications in the initial document—the scope of the project, square footage, who supplies what, finished quality, and so on. Sometimes, the RFP will include a budget or a "final price not to exceed" rate, but most often the RFP will be asking you for a budget. Many times, the RFP will require your presence at a particular meeting, where you will take notes on the extensive requirements and see your colleagues who are "mooing" for the same project. But wait, it gets even more desirable. . . .

RFPs are undeniably a drag. The most hateful thing about them is that the proposed project is usually really cool and something you want for your portfolio. You never know when and where to read between the lines, though: Are they looking for the lowest bid? Are they looking just for a budget on a project that they will plug into their next fiscal year? Some RFPs even have the audacity to ask you to include a creative concept, finishing prototypes, or idea board with your estimate—all on spec, of course. Just how much time should you put into this nonsense? These questions can only be answered on an individual basis.

A Case Study

Quite coincidentally, I am right this minute sitting on the edge of my seat waiting for an answer from a small city nearby that recently sent out an RFP. It's a beautiful project that I would love to get my hands on. The dreaded RFP came as they always do—regular mail, with details, details, and more details. There was a request for creative "sketches," a request for a budget, a ten-day deadline for submission of the proposal package, and a contact name.

What, in this day and age, are "creative sketches," and how does one go about acquiring a high-end job—or even being properly considered—by providing "sketches"? I phoned the contact person to first verify that indeed this job did not have a predetermined design-firm destination (this happens often; some RFPs, especially those issued by governmental institutions, must be issued for formality purposes, to follow the "rules" of certain organizations). Next, I confirmed that they were not looking for the lowest bid. Then, I got as much information as I could about the qualities that they were looking for, not only in the piece itself but also in the services to be provided.

As soon as I had enough information, my senior designer and I sat down to work up our presentation. Even though his billable time is higher than the other designers on our team, I knew that his capabilities and efficiency would be more cost-effective for me in the long run. The outcome was a great presentation, along with voluminous hopes that we will be granted this coveted project.

In this case, the client was forthcoming with information, familiar with my firm, and strongly encouraged our participation. I shared with the client that it is not our general practice to do work on spec but that we were very interested in the project and would proceed on his recommendation. The deciding factors for me were his openness and the generous amount of time he spent on the telephone reviewing the project with me.

Since the RFP was issued by a governmental organization, I knew from experience they would not have any presentation money. I have gotten into the habit of asking quite vocally at the aforementioned information sessions if some limited funds have been set aside for presentations, simply to cover costs. This always generates clapping from the audience and probably a red circle with a slash through it in the presenter's notebook with regard to my firm's selection. At that point I don't really care. It is indeed our duty to educate organizations that

consistently ask for spec work to, at the very least, offer minimum budgets for presentations. I think word is getting around; most recently, I've noticed that fair budgets for presentations are typically assigned to the final three firms making the cut for a certain project. *Then* the client can objectively make comparisons on different firms' creative approaches.

Your decision on whether or not to participate in a particular RFP will depend on the circumstances: how busy you are when you receive the RFP, how much you've learned from Intuition 101, and what the prospective project means to your firm, not just in terms of money but in increased recognition, prestige, and other factors.

Use the following checklist to help you decide when to answer the cattle call:

☑ Is there a contact name or a phone number to call for further information?
☑ Are you familiar with the organization?
☑ Do they *not* have a firm or agency they seem to consistently choose?
☑ Is this *not* a lowest-bid situation?
☑ Does the scope of the project lie within your realm of expertise?

Make sure you answer all five items affirmatively before going for it; otherwise, you're certain to turn your next RFP reply into a big rip.

Proposals Versus Estimates

Don't confuse proposals with estimates. A proposal is always necessary for larger projects and is often presented before the estimate to confirm that you and your client are on the same wavelength regarding pertinent matters specific to the project. In some cases, the proposal is included as a prelude to the estimate, or the proposal and estimate may be presented together.

Basically, the proposal outlines the goals of a project, states the objective, target audience, assignment of responsibilities, and so on. Ideally, a proposal will include all aspects of the project and may even include "sell" information about you and your staff. For example, you

may want to give credentials and other qualifications of your team, such as a brief history, client list, and a list of industry acknowledgements received.

The proposal is a document in which you can outline your entire approach to the project, so the client is very clear about everything you will be doing. This is the place to put your client's objectives (as you have interpreted them) into writing. It's also the place to address your methodology or strategies, including any phases such as research, creative development, refinement of craftsmanship, and project implementation. Take this opportunity to outline client responsibilities during your work together. What will the client provide, if anything? What deadlines is the client responsible for, so the project can be kept on schedule? How will revisions and additions be charged? What terms will apply if the project is terminated after work has begun? All of these topics can be dealt with in the proposal.

Often, the estimate is included as part of the proposal. This is logical: Since the proposal is supplying information about each phase—and even each step—in the project, why not also provide an estimated dollar cost for each of these steps as they are outlined? This way, the client has all applicable information at once.

An important note: When you receive a coveted Request for Proposal, you'll want to read it carefully and respond in the exact format that specific client is requesting. Most of the time, an RFP is requesting

Use the following as a checklist of possible items to include in a proposal:

☑ A clearly defined project objective
☑ Goals that the end product might achieve
☑ Strategies as to how those goals may be realized
☑ Target audience review (for commercial projects only)
☑ Any market research findings
☑ A list of any research that needs to be done
☑ Assignment of responsibilities—what you will provide and what the client will provide
☑ An overview of the team players, your company history, your client list, or any other sell information you can provide that will reinforce the client's confidence in choosing you

your proposal and estimate, but many times, it is requesting a proposal only. As mentioned earlier, your proposal may include a creative prototype or sketches as well.

Going for the Ultimate

Nowadays, it's pretty simple to do an awesome proposal. We have a format we've recently created that is easy to produce and revise for different clients. We have historically had the good fortune of being awarded several projects based strictly on our proposals—without providing estimates. Honestly, I can hardly believe it myself, but it's true. I believe the reason this can happen is that, currently, new housing construction and development is at an all-time high in my region. Clients seem so increasingly demanding with regard to turnaround times, deadlines, and unreasonable expectations that if they find someone willing, they'll hire them. While I know that both of these reasons can be true, I'm mentally ready for an economic downturn at any given moment. Read: Never take situations like these for granted!

But let's spend some time thinking about this "ultimate" situation for a few minutes. Take some time to brainstorm the possibilities with your own staff. If you work alone, consider hiring a short-term intern from your local design school, community college, or university. Excellent students dying to sponge up your knowledge can work for you, often for little or no pay. Many college requirements include a mandatory internship that students must fulfill before graduation. Using a fresh eye and a fresh ear can really bring life to your proposals—especially if you've never done one. Great references exist for your brainstorm session. See how the award winners are doing it by buying some industry books on proposals and marketing your firm.

If you do not have professional portfolio pictures, use a digital camera to take photos of your portfolio projects. Have fun with setting up the shots, and use props like fresh flowers and wonderful artwork to display the projects favorably. Print the images onto high-quality paper, and include a brief description of the project near the photo. Use these pages at the end of your proposal, selecting previously completed projects that convey your expertise in the type of project you are proposing. Remember that in our industry, quality always translates into price. The more "buttoned-up" you look, the easier it will be for you to justify a higher price for your work.

Choose an interesting paper and binding method for the outside cover of the proposal. Options are all over the place. Even if you live in a remote or rural area (I do, so I know!), paper distributors and printers

in your nearest big city will be glad to keep you advised of new papers and binding methods available. This is their job, and how they sell their products and services. Take the time to ask for your inclusion on mailing lists and promos. Paper reps are happy to set up an appointment and meet with you to show you the latest goodies on the market. Ask lots of questions. Ask for samples, and you can make your proposal covers with different paper samples until you find the paper that works for you. Quick-print outlets like Kinko's can also be a good source for creativity—just know that anybody can go to Kinko's, and a bit of ingenuity on your own part by sleuthing papers and finishes yourself might make you stand apart from your competition.

Within the framework of your proposal, if you do not include an estimate for pricing, be sure to include your entire process. Perhaps you might share how you will price the project—by using an hourly rate per task, per person, or whatever. This entire proposal-instead-of-estimate ideology comes from the large, full-service architectural/design firms we so often find ourselves competing with. Larger corporate clients are especially accustomed to receiving a voluminous amount of paperwork when they are in the process of deciding which firm to hire. Help them to make their decision by showing that you are the be-all of your clients' dreams. It's easy and fun, like writing a book about why you want the project, how you're going to go about doing it, who you'll be working with, and so on.

Reviewing your proposal in person with your clients is a smart way to make sure they don't receive your life's work and store it away for lavatory reading or the coffee table. I never read the copy within the text aloud—but I do review the information therein by going through the subheads and verbally telling the client what they contain. This is my opportunity to show my firm's competence to the client. The end of my proposal presentation includes a more detailed explanation of our portfolio pages.

More often than not, the person you're presenting to will need to go to a superior or authority group of people and reiterate to them what you've just reviewed. While frustrating for you, this is typical. Many corporate clients are paranoid about their co-workers' involvement and want to project a sense of being in control, therefore wishing to present your information to their own peers. It is a great day when your client will allow you to present directly to the decision-making core. Credibility for both you and your client begins here.

Instead of pricing within your proposal, try explaining the different phases within the specified project. If the client is new, tell him your

biggest reward is a satisfied, repeat client, and include testimonials or references from satisfied clients in your proposal. If you are a one-person studio, developing a strategy and a "look" for your proposals will elevate you tremendously in your customers' eyes. If writing and self-marketing are not your strengths, hire a freelance public-relations person or a professional writer to help you establish a template for this new endeavor. Use your newfound bartering skills to trade these talented individuals for work you both need to have accomplished, yet don't have the cash, time, or patience to complete.

Troubleshooting Estimates and Proposals

Now that you're an expert at pricing and estimating, it's time to get comfortable with how you manage projects and budgets. The estimate that you provide to your client actually doubles as a project budget; it includes your rates, calculations, and determinations. Now you have to produce what you said you could produce for the amount of money you said it would take!

Throughout this book, we have reviewed some subjects that will affect project management. The most common trauma you will experience throughout your course of owning and managing your own firm are unexpected changes—in other words, charges that either you or your client will need to absorb. These issues will arise time and time again throughout the estimating and project-management phases of your jobs, and you will learn how to tailor my examples of solutions to your own particular needs.

Organizing for Productivity and Creativity

The most proactive thing you can do to ward off the evil changes–and–charges demon is to organize, organize, organize. If organizing and managing project budgets sounds like a big responsibility, it is. I can't stress enough the importance of setting up forms and a project management system that will help you to realize true and glorious profitability. Your last key to the profitability cache is to learn how to manage project budgets effectively. This, in turn, will open new doors to your creativity. Trust me, creativity comes more easily when projects and money are flowing smoothly; creative block is directly connected to stress.

Good project management saves time and money by acting as a template, embracing all disciplinary aspects of a project. *Discipline* is a word that carries us all back to our childhood; it means rules and regulations and acting in some type of

So where do you begin? Use the following checklist for creating discipline in project management—starting at the very beginning of the project:

☑ Get a signed, approved estimate; this estimate will double as your project budget

☑ Review a detailed schedule with your client, your staff, and your vendors

☑ Work out dates in the schedule as needed until everyone has agreed that it is reasonable

Next, make sure your schedule includes the following dates:

☑ All of the dates when your client will provide you with the information you will need to complete the project

controlled manner. Horrors! In general, it's not a very friendly word, but I suggest you learn to love it if you want more time to focus on creativity, design, and what you do best. Committing to disciplines of different varieties (some of which are given in this chapter) will truly save time, money, and your sanity!

After your estimate has been approved, you're ready to embark on the creative aspirations that brought you the project in the first place. In your master meeting, when you originally gathered the information needed to compile your estimate, you also discussed a typical schedule for the project with your client. This was your first step in establishing discipline with regard to the project's efficient management.

If you did not involve the client in this scheduling development, do so immediately. Put the schedule in writing and detail every event that will happen as part of the project. Include dates when you will receive pertinent information from your client as well as when your client will review everything you present for approval—from initial concepts to the approval of finishes, colors, and furnishings. Reviewing the schedule together with your client before you get started will save substantial time for both of you. Neither of you will waste time wondering what the other is doing with his or her portion of the tasks involved; nor will you waste time trying to track each other down or e-mail questions in an attempt to get what you need and expect from each other.

Substantial amounts of money are often wasted on rush charges with service bureaus or manufacturers and on same-day and overnight delivery charges. Many of these dollars can go right in your pocket if

- ☑ The date when you show your client initial design concepts for his or her approval
- ☑ A date when your client will either give you or approve the finished plans for the project
- ☑ The date when you show your client the color palette, finishes, and furnishings, either in a three-dimensional computer-generated format or in a format you have previously agreed to
- ☑ The date when the first subcontractor begins
- ☑ The date when the last subcontractor finishes
- ☑ Delivery dates for furnishings, accessories, and installations
- ☑ The date of the open house party

you discipline yourself, your staff, and your client by organizing project events carefully before you begin. People in our industry seem especially "addicted" to overnight and one-hour delivery services. Upon scrutiny of your outside expenses, I can promise you that about 50 percent of them could be eliminated with better project management.

Get Ready . . . Go!

Once all parties involved in the project—clients, staff, and vendors—agree to the important project dates listed above, you can proceed to realistically schedule your own personal time that will be required to complete the project. Information and purchase orders to service bureaus and outside vendors can now be planned by date with possible incentives built in to meet or exceed project schedules.

Reimbursing your staff for their mileage expenses (the current IRS-approved rate is 37 cents per mile) is a lot less expensive than using regional delivery services, makes the clients feel like they are personally being serviced by your staff (and they are!), and makes your staff feel trusted and more appreciated by you and your clients. If you do not have a staff, consider hiring a student intern from a local design program to do your deliveries a few times a week. Students love the experience of being around design professionals; you'll be doing them a favor and at the same time saving a lot of money otherwise allotted for delivery services. Lucky you!

Never, ever begin a job without a schedule or deadlines. We get a lot of projects from one of our favorite clients that have no tight turn-

around requirements. (That's why they're one of our favorites.) They'll say, "Well, we have a trade show about six months from now, and we'll need a new booth look by then." Usually, it's a project that could easily be designed and produced within four to six weeks. These types of projects can (and will) go on and on—with everyone perfecting and redoing little things here and there into oblivion—unless you have created a disciplined schedule. In the past, evaluating time and expenses incurred on these pseudo-eternal projects always came as a surprise—they were our *least* profitable (albeit least stressful) jobs.

The biggest roadblock to successful project management is you. Well, maybe or maybe not. But let's face it—stereotypical designers love to rock the boat and procrastinate, waiting until absolutely the last minute to get the adrenaline going to produce a dynamite concept. The only problem with this recurring scenario is that when it's all said and done, you always look at the project and say something like, "If I'd just had more time to do this," or, "If I'd just had another day, I would have tried a different color palette that might have looked better." The truth of the matter is that you often did indeed have that time (check your schedule!); you just chose to do other things.

Nobody likes to hear the self-discipline rap. I myself really hate it deep down and almost can't believe I'm preaching it. The truth is that, after all these years in the industry (twenty and counting), I really have found a balance between procrastination—with its craziness—and the real secret to creativity. You need to find a balance within every day— or at least every week to start—between the time spent adhering to your set project schedules and the time you allow yourself to run free. If you don't, you'll find yourself on a roller coaster: The highs will be incredibly creative, but the lows will wipe you out. You may find yourself getting sick too often with colds, flu, and so on, or you might even experience the total blackness of burnout.

A huge part of project management is taking the schedule you've created and following it, not only by doing the work yourself, but also by delegating to others whenever you need to and firmly requesting that staff and vendors alike adhere to the schedule. Even if you work by yourself, student interns, service bureaus, and freelancers are eager to help when you're in over your head. If you have agreed to a schedule that for the most part you have directed, you are the very last person who should have trouble sticking to it. *Get help when you need it.*

Learn to do exactly what you do best all of the time, and then find a team of support people—whether they are occasional freelancers or regular staff—who specialize in tasks that you don't do so well. For

example, if you're a great people person, you love client contact, and you love coming up with ideas for projects, find a core of support people who are great at putting your ideas on paper and creating presentations and another person or two who are great at research and resourcing so that you don't have to be it all, let alone do it all, in your peak periods.

You will be infinitely more creative, make more money, and be a lot more fulfilled once you look at project management in this way. Just remember, do what you do best all the time, every day, and find other people to do what they do best, every day, all the time. This is the key to superior project management.

The type of project management system you need will depend primarily on the size and complexity of your business. If it's just you, or you and one or two other people, it's easiest to just implement a simple system; I recommend the job-jacket system outlined in chapter 6. For a larger group of people, you'll want to include everyone in devising and implementing a system that works for all the individuals involved. (See "Develop a System That Works for You," page 64.)

The Perils of Perfectionism

As you gather information for your estimate, perhaps the most important task will be to assess the time that will be required to produce a project. From that time assessment, you will either multiply your required hours by your hourly rate or assign a value amount to the job, as described earlier. The only thing that can really throw a big whammy into your allotted time frame, or at least the only thing that you'll be able to anticipate up front, is a tendency toward perfectionism. If either you or your client are prone to perfectionism, it can really spell trouble.

If you know yourself to be the potential culprit in this case, you're halfway to changing your bad habits. Start resolving the other half by being extremely dedicated to tracking the time you spend on every task concerning your next project. When the project is finished, add up your total hours and divide that amount into the total dollar amount that the invoice gives as your fee. The resulting figure is the overall hourly rate you actually earned for that project. In many cases, you could earn more flipping burgers at you-know-where!

Now, look objectively at each task within the project and determine where you spent too much time. If this disappointing outcome happens often, you are probably the victim of perfectionism. Do you have a tendency to perform tasks over and over, or to start a project over many times before you move through it? You can only correct this problem by strictly disciplining yourself to perform certain tasks only within

reasonable pre-allotted time frames. Share your dilemmas with colleagues, and compare how much time it takes them to perform the same tasks.

If you have a client who is a perfectionist, you'll recognize it during your first meeting. Typical attributes of the perfectionist client are that he will repeat the same things over in two or three different ways, and ask you to read your notes back to him. Then, he will call you needlessly every day to see how you are coming with his project. These disturbances take unnecessary time, which you will need to log on your time sheets. Refer to the communication tips on page 82 to find ways to avoid these situations *before* you start a project. Also, it might be effective to gently remind your client that while you appreciate his need to have everything done in a certain way, his conversations are causing the project to go over budget. Remember, the name of the game is being honest and up-front with yourself and your client at all times.

I realize this concept of "letting go" of a project is a most difficult one for most of us. It's hard to watch the kids throw toys all over the house when you would like to have it ready for a location shoot at any moment. The same analogy holds true for the way we create visual design solutions. They can always be better with a color change here, a modification there, some extra cornice molding in that conference room. Vow to use what you learn after every piece is completed. Give yourself permission to establish a deadline, then maybe just a few hours of tweak time after the project is complete and you've had a chance to catch a few *z*'s on the matter. If you know that you're a tweaker, don't forget to add these "few hours" into your original estimate.

There is a way to possibly sneak in some extra billable hours if you simply can't let go. On more than one occasion, I've presented a design to a client as is, and at the table told him about my new, improved idea. If the client bites and likes your concept, it is the perfect time to ask if you can get him a revised estimate to include your new ideas. This leaves the door open for your client to have time to digest both the new idea and the fact that the new work is going to cost a little more. In this way, you don't proceed with the new idea until your client approves the extra costs; thus, you don't lose any money. Make a steadfast rule with yourself that you will not proceed with the new work unless funds are approved.

Bigger Problems than You Bargained for?

When your original estimates don't hold and completing the project entails more hours than you had presented in your budget, your ability to provide accountability and a detailed, legible paper trail will help you

tremendously. (Now would be a good time to review the information on knowing your process in chapter 6 and the sidebar of time management tips on page 67). The fact remains that good forms are necessary to build a solid foundation of accountability. You need to develop a reputation of consistently providing services for the actual fees you quote in your estimates. Occasionally, you will need to use the 15- to 20-percent fee overage provision that you have allowed for at the conclusion of your estimates, but you certainly don't want to make a habit of it. If you do, sooner or later your clients will expect the surcharges, and your estimates will be facing some tough credibility issues.

Forms create a paper trail, whether you're filing them as hard copies or within your hard drive. But proper documentation of time and expenses is imperative if you are to track the reality of your endeavors. If you are consistently forced to charge fees beyond those you quoted, you need to take a hard look at several factors. Are you allowing enough time to complete tasks? Are some members of your team slower than others, and shouldn't you be taking that into consideration when you're estimating? Do you keep forgetting certain outside costs that always seem to show up after the job is finished?

Be prepared for clients to occasionally ask you for documentation to justify your billing rates. While this won't happen very often, sometimes it will be necessary for you to review cost overages with clients. You should be able to source a time sheet and expense log of some type at any given moment throughout a job's history.

If you can't do that right now, this minute, just stop everything you're doing. I really mean it. Just *stop*. Take today, or tomorrow at the latest. Cancel all your appointments. Take a deep breath and clear your mind, and then begin a system of logging your time and expenses. Make some forms of your own that will track everything you need to track. There is never a perfect day to perform this task. If you're a procrastinator, as most designers are, you'll never get around to it unless you cancel a day and devote yourself to form production. It shouldn't take you more than a day, and you will see immediate results.

It is important for you to realize how closely interconnected pricing, estimating, and project management really are when you want to meet your budgets and make a profit. Remember: No profit, quick burnout. No self-employment, no fun!

The Passage of Time

You may find that the estimate you presented to a client is no longer realistic if a significant period of time has lapsed since its submission. On

several occasions I have had clients approve projects six months to a year after I had given them an estimate. Most of these occurrences resulted from my client's original need to receive an estimate on a project simply to plug the fees into his fiscal budget, knowing all the while that it might not be produced for quite some time. This procedure is very typical for larger Fortune 500 clients, who must plan their budgets well in advance. It is also typical in the residential sector, when an individual gets sticker shock and needs to plan cash resources to complete the project—not now, but later.

In your initial (master) meeting with a client, it is important for you to verify *when* your client expects to be in production with the job you are estimating. If you are indeed just establishing a budget and won't be producing the project for quite some time, it is very important to note possible variables that might arise. These variables include any foreseeable rate increases that you may be considering because of staff, equipment, or fixed-cost growth. Such an estimate should be labeled "for budget purposes" and include a simple disclosure of possible variables.

Quite often, a job will be postponed because your estimate is sitting on your client's desk and he hasn't had time to review it, or he needs his superior's (or spouse's) approval first. To avoid this delay, always try to review your estimate face to face with your client. At the very least, review it over the telephone and answer any questions that your client may have. Then, ask the client when you can expect approval, so you can put it into your production schedule. Be very clear that the project will not be initiated until you have a signed, approved estimate.

If the promised date of approval comes and goes with no signature or contact from the client, an informal note via fax or e-mail usually does wonders. Most of the time, the estimate has moved to the bottom of the pile on someone's desk, and the client has wrongly assumed that you have gotten started. If you still haven't achieved desired results after a couple of days, you have a good excuse to phone the client, check on your estimate's approval status, and ask if any clarification of the estimate is needed. Warning: I haven't researched Murphy's Law enough to scientifically verify this, but it seems like a project that's prolonged unnecessarily often turns into a nightmare project that goes on and on and drives everyone crazy!

Costs for items such as finishing and furnishing materials tend to fluctuate over longer periods of time, especially with the fluctuating cost of gasoline, which grossly affects freight, which in turn affects pricing for plastics and many flooring materials. Always verify your outside suppliers' quotes to determine how long their prices are good for. Make sure that, if your painter quotes you a cost that is good for only thirty

days from the date of that quote, you share that date and disclaimer on your estimate to your client. It is very common for painters and other suppliers to have a thirty-day clause in their quotes; you and your client need to be very aware of cost overages that may be incurred by the delay of a project.

Once a supplier accepts a purchase order from you detailing the services or products at set, itemized costs, he is obligated to provide the services or products at those particular costs—another good reason for the wonderful world of forms and systems.

Ensuring Good Communication

The last thing you need is to have project costs exceed your estimate because of poor communication. There is absolutely no excuse for this, because you are, after all, in the communications industry. I have students and entry-level designers stare at me in disbelief when I break the news to them that they are first and foremost communicators—*before* and even *when* they are professional designers. It's true. Your clients not only expect you to communicate with their audiences by creating good, visual, and environmental design solutions, but also expect (and deserve) you to be an excellent communicator on *all* levels. This is the biggest issue facing inexperienced designers and other individuals who want to start their own firm or studio.

There are several easy steps you can follow that will open the doors to good, effective client communication. (I have also dedicated an entire section within chapter 13 to this subject.) Remember to always be up-front, honest, and considerate in terms of your clients'—and thus *his* or *her* clients'—needs. Even before following the specific steps outlined, you should evaluate your own basic communication strengths and weaknesses by having a frank conversation about this with family members and any friends with whom you feel comfortable discussing sensitive issues. This suggestion is not made to make you feel defensive; it's just the quickest way to take a crash course in self-discovery where communication issues are concerned.

Sooner or later, you will experience the uncomfortable (and seemingly irresolvable) situation of a problem that isn't outlined, defined, or acknowledged in your estimate, resulting in costly changes for a project. When this happens, your clients will want you to absorb the additional costs, and you will think that they've truly lost their mind this time. There will be a moderate amount of finger-pointing, perhaps a voice raised beyond the decibel level regarded as normal, and a feeling in your stomach like you've just swallowed a bucket of peanut butter.

While experiencing this situation, try very hard to listen to your client's complaints without interrupting or blurting something out that you may regret later. If you are the one who is announcing the problem to your client, do so in a clear, uncritical, concise manner, and then listen carefully as just described. After the issue has been reviewed, offer your solution, if you have one. If you have not had enough time to assess who is ultimately responsible, or if you feel really angry, now is not the time to negotiate a resolution. Tell your client you will prioritize the matter today and be in contact with him later regarding the situation. Go outside, take big breaths (don't hyperventilate!), tell yourself that there really is a silver lining to all of this somewhere, and begin immediately to seek it out.

Take a good, objective look at your estimate. Does it clearly define responsibility for who does what throughout the stages of the project? Have you and any subcontractors you hired fulfilled the tasks that you agreed to perform in your estimate, and have they been performed accurately and on time? Has your client done the same with his appointed task list and approval process? Perhaps you are answering yes to the questions that involve you, and your client disagrees with you, or vice versa. The sooner you can agree on who or what is really to blame, the better. Sometimes it's best to just let go of relatively minor points, so you both can reach a conclusion and get on with your lives.

If you know in your heart of hearts that you are indeed at fault and the problem is your mistake, then admit it, correct it, pay for it, and move on. Should you decide to pass the buck to someone else or even try to prove that your client is at fault, expect that client to avoid you like the plague the next time you call on him for work or a referral. Mistakes can be costly, but after all, if they are your fault, you will truly gain client confidence and credibility (along with the probability of ensuring a long-term relationship) if you take responsibility for them, no matter what the cost might be to you. It might sound easy for me to say and be tough for you to read, but it's true. Set aside some rainy-day funds—I'd suggest something around $25,000—for this purpose. Put them into an interest-bearing account, and do something fun once a year with the interest money you've acquired (assuming you don't use the set-aside funds).

When the Client Is Wrong

Of course, there will be times when your client is actually to blame for something gone awry within the parameters of your project. If the client insists that it is your fault and you don't have the proper documentation to exonerate yourself, you only have six options:

1. *Do the obvious—quit.* Walk away from the project and the client, jump on your waiting stallion, and gallop away into the sunset. Of course, expect to look behind you and see the bridges of client rapport burning irreparably away. I only recommend this procedure when you have given significant energy to the next three options.

2. *Ask your client to split the additional costs required with you.* This is the quickest, most common, and usually the fairest approach to resolving a dispute of this type. It instantly shows that you respect your client and that you support him. Most problems that result in cost overages can be blamed on more than one party. When you know that you could have avoided this issue if you had just done this or that, you probably are somewhat to blame yourself. Thus, splitting the costs is justifiable to everyone. If the costs involve third-party vendors, they will usually give you a substantial discount for doing something the second time around. Ask.

3. *Confirm the additional charges in writing.* If you have really done your investigating, if you absolutely cannot afford to absorb any additional costs, and if the problems at hand were truly created by your client, I suggest using the utmost diplomacy in a written confirmation giving concise, accurate details of the events and circumstances that brought you to your conclusion. Most clients respond better to written explanations than to personal dialogue that puts them on the defensive. Do follow your written explanation with a timely phone call after you think your client has had enough time to digest the information. Hopefully, your client will agree with you, and you can promise to help him be more aware of such issues in the future. If the letter does not work, it will, at the very least, prepare you for the next item.

4. *Get a mediator.* Your lawyer will have a list of mediators who are used in an attempt to get both parties to sit down and come to an agreement together. I have had the opportunity to use a mediator once for a situation regarding my favorite subcontractor. I had refused to pay a bill because the contractor had made a materials change without notifying me. The process was very positive for both of us. The mediator was patient, intuitive, and knew what questions to ask in order to help us make our own decisions. The outcome resulted in a positive, ongoing, and very close relationship.

5. *Get an arbitrator.* When neither you nor your client will compromise, when you've gone around and around to no avail, consider obtaining an arbitrator you both can agree on, who will do everything to settle the matter with (and for) you. When it gets to this level of disagreement, a professional arbitrator, again located through your lawyer's

office, is necessary. Many times, it might seem logical to ask a mutually respected colleague to intervene; however, the chances of your colleague remaining mutually respected are slim. It's best to call in the services of your attorney and your client's attorney to decide specifically when, where, and how you can resolve this issue. It's common to include an arbitration clause containing this information in contracts.

6. *File a lawsuit against your client.* This should only be done after your attempts at arbitration fail to bring a resolution. Retaining the services of an attorney to file suit is costly, time-consuming, and agonizing. Only if the amount of money you are disagreeing about is staggering *and* if you are absolutely certain that you had nothing to do with the problems that occurred should you even consider filing suit. Before you know it, your business will become everybody's business, and you'll find yourself being questioned by vendors, colleagues, and possibly your local press about what happened and why. It's best not to discuss the matter at all, even if you feel a great need to clear yourself.

I have never had to sue a client. I came very close a few years ago. My firm had produced a project for a client with whom I had worked closely for over five years. The project seemed tainted from the beginning, with the client making seemingly irrational design changes every other week after he had approved them the week before. It turned out that he was getting a lot of pressure from different committees that were involved in certain phases of the project, and he kept making the changes to appease others.

When the client was presented with a bill for what I had deemed a totally unreasonable number of changes, he balked. Immediately, I admitted that my staff had not notified him properly that he was exceeding the budget we had agreed to in my original estimate. I had been out of town when many of these changes occurred and felt responsible at least for not communicating these overages to an established client. We both agreed to our mistakes and quite happily agreed to split the additional costs. Unbeknownst to both of us at that time, my client's boss would not agree to the additional charges or any explanation of why or how the sequence of events had led to their occurrence.

I personally met with my client's superior, with my client in attendance. The meeting was uncomfortable for all of us, to say the least. My client and I left the meeting with no resolution and both of us feeling pretty helpless. I was angry at what I deemed to be greatly unprofessional behavior on the superior's part. On the advice of my attorney, I wrote a detailed letter reviewing the entire project and cost overages. I

suggested hiring a mutually agreed-upon arbitrator, and received an unfriendly letter from the superior stating that my client was not at all responsible (after he had admitted that he was) and that an arbitrator was not a possibility.

Again, on the advice of my attorney, I wrote a stronger-toned letter stating that if I did not hear from my client's superior within thirty days, I would unfortunately be forced into filing a lawsuit. In my letter, I reviewed the project in its entirety, justifying overages and documenting when they had incurred. I again offered to settle the matter by splitting the overages. Within ten days, I received a check for the amount I had requested.

I have seen this client socially on many occasions, and he has always been friendly to me. We have both acknowledged our disappointment and bewilderment at his superior's final decision. We are both sorry that our long-term working relationship was brought to an end by something out of our control. Ultimately, we both learned the hard way. Hopefully, this story will help you avoid similar situations in your future.

Case Study Interview

An Independent Designer on the Perils of Perfectionism and Time Management: Lisa Schmitz, Kansas City, Missouri

Lisa Schmitz has been an independent designer for two years. She has been an interior designer in Kansas City since 1988, first working for a large firm specializing in architectural interior design, spending her first nine years there 60 percent on commercial and 40 percent on residential. Her next several years were spent with a large firm strictly providing commercial interior design solutions. As an independent designer, Lisa is now focusing primarily on residential interior design, with many of her clients now repeat clients from projects she worked on long ago. Her professional growth as an independent has come primarily by word of mouth, building upon her reputation.

Q. Lisa, you have shared with me your penchant for perfectionism. How do you organize your projects for maximum productivity and creativity (with profitability in mind, of course), knowing that you'll probably get caught up in the perils of perfectionism?

A. Certain details need to be worked out early in the project, and it is always beneficial, as the designer, to be involved in the project at the preliminary stages. As I design details, the architecture can be affected. The team can work together to incorporate these details into the design documents rather than trying to simply add them after the fact. At these early stages, I create quick sketches that show concepts. These sketches then evolve into details. Sometimes these three-dimensional sketches are more understandable than the construction documents.

Details are worked out with the contractor and architect. As a team, each person has experience and information that can lead to the details being implemented in the best manner—aesthetically, functionally, and in a cost-effective manner. I keep all of these sketches in a three-ring binder throughout the project. The binder has sections for meeting notes, correspondence, details, invoices, and design sketches. I also purchase product for the client, so I often have sections pertaining to purchase orders. I may be working on over six projects at once and it is often difficult to keep track of conversations, quotes, and daily conversations on all of these jobs. So each day, I date each sheet and use as many sheets as I need. Therefore, I have all of my daily information in one place. I can then copy the pages as needed and place them in the appropriate job file.

The perfectionism part is difficult in that it takes an enormous amount of time to research, coordinate, and relay the needed information in order to get what I envision. I rely heavily on sources that I have accumulated through the years. There are some people who have wonderful craftsmanship, and I may need to push them to create what is new to them. There is always risk in doing that, since there may not be photographs to show them what I desire. I rely on magazine images, sketches, and conversation to work out the best construction, and must listen to their input as to the feasibility.

Q. Will you share an example of a project that went "too far" either because you or your client got caught up in the spiraling vortex of not knowing when to stop? Was the project profitable for you—why or why not?

A. I am working on a project now for a client whose office I redesigned several years ago. This client is very, *very* detail oriented. He has a great design sense, and it is very demanding to meet his ideas. I don't say it negatively—I say it in that he is very meticulous in how he stores his cooking equipment and everything in his closets—so there is a huge amount of organizational detail. Every spoon and every pot and pan has to be accounted for in the kitchen; and with that he had a great design sense with regard to organization and aesthetics. The client is cognizant of his perfectionism. He and I keep track of my time and he understands that in order to get it the way that he wants it is going to take time. So I am lucky that he understands that.

Originally, I had given him a cost up front of what I assumed to be a not-to-exceed number, having bumped it up a fair amount knowing the complexity and his penchant for details. But now the project has changed completely, with my handling both the architectural and construction administration and the hiring and managing of a structural engineer. The complexity and the detail grew from the original agreement, which was supposed to be a nine-month project—and we are still in the "finishing" stages, and it will be a year next month. As he increased my scope, he understood that my original estimate was obsolete and has been very respectful about paying me a strictly hourly rate after I agreed on not gaining a profit through the products purchased.

This has worked out really well for me, because I bill him along with my detailed time sheets, and since he himself is a lawyer billing his own clients this way, he understands my invoices without challenge.

Q. What type of "paper trail" do you use to ensure good communication between you and your clients?

A. The sketches, as mentioned above, as well as construction documents, show the general concept of the project. As a project is being developed, there is a series of plans and plan revisions. It is important to date each set as to the revisions, and then copy the client. This shows the development of the project. This is also true of meeting notes. It is important to create meeting notes to document the conversations and decisions. These also should be copied to the client. E-mail is also now a wonderful way to communicate certain decisions or changes. These quick notes are easy to save in the project file.

Things have gotten a little more complicated in the area of purchasing. I usually present a quote to the client with the item description and cost. These should have a signature of approval from the client. The more detail you can list on the quote, the more you are covered.

Q. Will you give us an example of a project you were involved in when the client made a mistake, was wrong about something, and how you resolved the issue?

A. I recently had twenty-one custom pillows made for a client, all of them filled with 50 percent down and 50 percent goose. This combination of fill is ideal and presents a beautiful, fluffy pillow with perfect form. The client verbally approved the pillows, and the fill matched some of the existing pillows that the client already owned. After delivering the pillows, the client informed me that she was allergic to down and did not want the pillows if they were filled with down. I am in the process of getting synthetic fill for the pillows and trying to determine a resolution.

I have another client that needs several of the same sizes of forms, so I will sell those forms to her. The other forms I may have to stock myself and hope to sell at another date. If I had written on my quote that the fill was down, and the client had approved it as written, she would have been responsible. Since I do not have proof that I verbally stated the content of the pillows, I am responsible. The client said she would pay for the forms, but knowing that I was partially responsible, I do not want to charge her the full cost, so I plan to split it with her fifty-fifty.

Successfully Establishing and Managing Budgets

It's really important for your design skills to include a strong knowledge of finished implementation; this will help you greatly when you need to produce cost-conscious projects. There are many implementation techniques that you can use to please your clients when they want the whole world but can only afford a small U.S. state. Some spaces work better when they aren't over-designed anyway.

Learning Cost Consciousness

Finding affordable alternatives can be a fun and interesting challenge. There are lots of ways to achieve great results without sacrificing creativity. Some of the most common cost-cutting alternatives include:

- Working within the existing footprint, not removing walls or major utilities
- Creating a rich or hi-tech look with off-the-shelf furnishings from discount catalogs or places like IKEA
- Changing just accessories—like new window coverings, pillows, and area carpets, instead of lighting, windows, and doors—can completely revive a tired space
- Determining what is salvageable by plugging in existing room and furniture sizes into the outstanding design software now available
- Selecting an all-new color palette to complement what already exists and changing wall colors only

Of course, you could probably add twenty items or more to this list. The reason I've mentioned these possibilities at all is to get you to consider design or production alternatives *before* you consider compromising your rates. In addition, builders, electricians,

and other subcontractors are very credible sources for acquiring samples and, upon request, ideas for cost-conscious design. I also mentioned earlier that putting a client's needs into tiers of phases, or into a series of projects (such as implementing a portion of the project per month at a steady yet effective pace) is a great way to extend the budget and be cost conscious.

Using an appropriate format for presentations (that is, not overdoing it) might save you considerable time, and, thus, money. Back in the estimating stage of your project, you should have decided exactly what type of presentation your client would require to obtain approval for your design concepts.

As my staff and I develop client relationships and trust levels increase, the type of presentations we show tends to change as well. Our biggest client at the moment has gotten to a point of approving our design concepts based on a fax showing simple black-and-white marker drawings. This way, the client's staff usually gets to see a lot more than just one idea; they get to see them all. This is a somewhat unusual case because the decision makers in the design department are very creative individuals themselves and have the visual sense to say, "Go for it" or, "You guys are out of your minds!"

The most expensive presentation is computer-generated and/or 3D-modeled, and is presented to the client in all its finished glory. You and I know that a comprehensive presentation of this magnitude really means that the project is at least 75 percent approved at this point; and if the client hates it and you have to start over, you've got a lot tied up that gets tossed in the trash. For those occasions when the client loves it, however, and you only need to tweak a little here and there, you can go singing and dancing into the wee hours because finishing the project becomes a somewhat simple implementation task.

A compromise between the quickie black-and-white doodles and the elaborate computer comps is what I call the "idea board." These come in handy when a client isn't sure what they want or whether they want to hire my firm to produce their project. I usually charge a flat rate of $2,400 and show one or two boards with a mixture of sketched and photographed comparative elements (from magazines or other trade publications) that will give the client a very good idea of where our thoughts are headed for their project.

Clients have been very receptive to these idea boards. They don't have to invest a lot of money up front, and they have more input on the direction we're taking a project before we go too far with it. A solid 90 percent of the time, our idea boards turn into full-fledged projects. Our

next presentation after these initial boards is usually a completed presentation that is not a huge surprise to the client because he is familiar with and has approved our initial concepts and knows what to expect.

Another place to be cost-conscious is in the overrun of custom fabrication. Designer beware: Charges can be incurred by overruns of actual fabrics, specific moldings, or other detail elements—quantities over and above the exact quantity you have specified on your client's behalf. Manufacturers almost always make some overruns, often with the initial part of the manufacturing run having some flaws.

A typical overrun, which can be expected with your larger manufactured orders, is about 10 percent. The press is going so fast that, in the time it takes to shut it down, you have overruns. Negotiate overruns to be very modestly priced (about 50 percent of normal cost is standard), as they will be necessary on most large-scale custom projects (someone will make a cutting mistake on the tile or the fabric). Most larger clients will want the overruns for future use, if necessary—that is, if an installed tile cracks or a piece of upholstery is irreparably harmed. A client who is watching pennies and having you research cost-cutting alternatives, on the other hand, probably won't want any overruns or produced elements at all—much less expect to pay for them. To further complicate the matter, most vendors usually do expect to be paid for overruns, unless you specify otherwise up front.

Since overruns are a conventional, established practice for a lot of vendors, but may be news to your client, it's important to always ask your clients and your vendors *beforehand* what their expectations of overruns are and specifically how they want to handle them.

The way in which we communicate and contact our clients has a lot to do with cost-conscious design. After all, any time spent on a project means time that should be billed to that particular job, whether it's design time or client-meeting time. Clients do not need to know (at least, they don't need to be reminded with a bill for every meeting) that they are actually being billed for the time you or your staff spend with them. Remember, you budgeted time for client meetings when you prepared your estimate, so you should be covered within your total estimate amount.

I can't tell you how often clients have complained about many of my firm's competitors sending them bills for things like fifteen-minute phone calls and forty-five-minute meetings. The general thinking is how *un*thinking of designers to bill as though they were attorneys! While recouping fees for the significant amount of meeting time required before and during a project's life span is imperative, how you

obtain those fees from your client is open for interpretation. And it *can* be done in a much friendlier, more acceptable way! I lump what I refer to on my estimates as "meeting/coordination time" into one conservative amount. If I know going in that the client requires a lot of hand-holding and will not be amenable to assigning dollars for meetings, I bury the meeting costs into the creative.

Using Cost-Conscious Design

Another good point regarding cost consciousness within the design process is to think about who represents your firm at client meetings. I used to think that I personally needed to be at every single meeting, no matter how big or how small. As business has grown in other cities and states, this is no longer physically possible.

With most projects, a senior designer or staff equivalent (I hate titles, and we don't have them on our business cards) attends every initial client meeting (that is, *every* master meeting for a new client) to review the project from a creative standpoint. As our sales and customer service peoples' self-confidence grows, and as they obtain work from ongoing clients, they have gotten to a point where they can assess projects initially by themselves and properly communicate that information back to us—at least on small and medium-sized projects.

On larger projects, I have found it very helpful to include, along with me, a senior and junior designer, and, in some cases, our administration/resource manager in the master meeting. Doing this is more cost efficient for us in two ways: 1) it has saved a lot of time, since I don't have to explain the project to my support staff—they get firsthand information from the client themselves; and 2) the client and my support staff are given the opportunity to meet and interact with each other. This builds staff morale and client trust. It also gives you, your senior and junior designers, or any other executive staff great freedom from absolutely needing to be at every future meeting or from needing to be involved in every phone conversation regarding the project. This is key if you want to avoid micromanagement.

When you're talking about cost-conscious design, client involvement at several different levels can be either helpful or detrimental. Client involvement becomes most necessary when unexpected issues arise in the creative or implementation phases of a project. Some significant examples of this are 1) a new, better idea surfaces at your studio regarding placement or finishing techniques that will be more costly than your approved estimate; or 2) after the design is completed, you realize that the furnishings you specified in your original estimate are

not the best selection for the project after all, and the new items you would like to use raise the final costs beyond budget. Of course, there are many examples we could list here, but these are the two most common issues that seem to arise.

Obviously, when costs are going to go up, you need approval from your client. In the two cases described above, you won't always get it. Sometimes, clients can agree that maybe you've come up with a better idea, but the budget established is one that they need to adhere to. The same thing goes for choosing a more expensive furniture product after the original estimate is approved. There are also occasions when a client really wants to make the change but just can't because of increased costs.

Whenever possible, I discuss this matter with my subcontractors and sometimes succeed, for example, in having them reduce their costs to match my needs. We've also been known to throw in some extra time and not charge the client for it if we feel that we could profit from having a better sample for our portfolio or if the client works with us frequently and appreciates our endeavors.

The Three Big *Ds* to Cost-Conscious Design

1. *Discipline.* Stick to your schedules! Don't over-perfect, over-design, or procrastinate.
2. *Delegate.* Use support staff whenever possible. Hire an office manager and a traffic manager to make your firm more efficient.
3. *Direct.* Use your expertise to show others what to do and how to do it. Let your discerning eye decide what to improve at each design phase.

In these ever-changing, computer-driven design times, it is extremely important to keep up with what's happening in the industry. This may seem a little weird, but I'm about to get on a soapbox about spending money while we're in the midst of talking about being cost conscious. To use a cliché, sometimes you have to spend money to make money.

Things like new software (or updates for software), software seminars, trade shows, time management workshops, and other important educational opportunities do take a day or two away from actual work now and then, and they do cost money. But you need (at least sometimes) to take the time and spend the money. (That's why our discussion of fixed and unfixed expenses way back in chapter 1 includes the need for such items.)

As the owner of your firm, you will have to decide when and where to spend the extra money necessary to keep things up and running to the standards you have created and want to maintain. Essentially, you could look at such expenditures as lowering your bottom line. I know a lot of firm owners who get by with the minimum and are very negative about spending their profits to enlighten staff or expand their equipment base to include the constant stream of next-level technology.

My opinion is that spending money on things like this is really necessary for my staff and me. It helps everyone stay interested, focused, and loyal to the firm. Sure, you have to find a balance of when and how to spend the money; in tighter times, you just don't do it. After having the good fortune to be able to run my firm as long as I have, struggling as a group through the tough times (and there were, indeed, a couple of years of very tough times) only proved to me that spending money for what I like to define as "improvements" turned out to be a great investment in my firm's future. It's almost like glue to a creaky chair or plant food to a wilting plant. You can still sit on the creaky chair for a few

Recap: Five Basic Strategies for Controlling Costs

1. Before you begin a project, review the budgeted time and costs for each phase of the project. Pass this information along to any support staff involved.
2. Encourage your staff to inform you immediately when they are going over budget in any area, or if they have any problems with the allotted time you have given them to perform a task.
3. Update your client immediately if he is the source of any cost overages being incurred. Obtain approval of a revised estimate, or use a change-order form to get additional costs approved.
4. If you do underestimate your time, don't cut corners by using lower-quality subcontractors or cheaper paint brands for finishes in order to recoup your losses. You and your client will be disappointed in the outcome.
5. Make all staff members responsible for processing their own *detailed* purchase orders and time sheets within the parameters of the system you have established together. Do not be lax in enforcing this policy once it has been put into play.

years, and the plant is not going to die for a while, but both will benefit greatly from a little time and money spent on care and nourishment.

Educating Your Client

In your original master meeting you should determine your client's knowledge regarding detailed aspects of the interior design industry and how much he really understands your work process. Your estimate may contain technical jargon only understood by people in our industry, and you may be surprised at how many times you will need to explain certain processes. Many designers are fooled into thinking that a client who is hiring their services understands industry vocabulary simply by general osmosis.

Explaining technical processes in layman's terms will be the number-one way you'll need to educate your client. Try to answer all technical questions before you present your estimate. If your client is not familiar with the processes, review the finished estimate with him in person. Then, as the job is progressing, show him the processes as they occur, and invite him to experience the craftsmanship of the project firsthand so that he not only can appreciate your expertise but also feel more confident delegating these types of projects in the future.

Does your client need (or want) a crash course in technical education? Give it to him on the spot, if so. If you determine in your initial meeting with your client that he is not totally competent and wants your help, this is your cue to develop a long-term relationship. No one likes being in the position of not knowing. And if you can embrace the teaching process and not be condescending, you'll have a client for life.

A more dangerous scenario is the client who thinks he knows everything, and as you hopelessly try to explain the realities of a situation, your words fall on deaf ears. This happens way too often in large corporations, where less-experienced design buyers are intimidated, preferring to be bullies rather than eager students. When you experience these types of clients, let them blow off all the knowledge in their little brains and walk away. Choose your moment carefully to reintroduce the subject at a later date, reminding your client about it in a casual fashion, such as, "You know when we were talking the other day about roll-on versus spray painting for the molding finishes, and we disagreed? Why don't we talk to Mr. Favorite Painter to find the answer—maybe we're both wrong!?"

A few proactive ideas follow with regard to specific educational explanations I have often confronted in the industry:

■ If you need a digital copy of your client's logo in a "JPEG" or "TIFF" format and he doesn't know what that means, you probably won't even know it until you receive a differently formatted logo in your e-mail in-box. Pre-digital days called for "camera-ready" logos, which are usually on slick, high-quality paper that you can scan yourself to create a digital file. If the client is at a total loss or seems flustered by your request, ask if there is an internal graphics department that might be able to give you either a hard copy or a digital version.

■ When deciding who will manage subcontractors, you will quickly determine if your client has a clue as to what this means in total. For quality-control purposes, you will want to at least coordinate your outside suppliers. You should explain the basic reasons for your decisions to your client. For example, tell them, "Choosing a subcontractor depends on who can most proficiently produce the job from quality and economic standpoints," and describe some of the ways to judge this.

■ Ask your client how much education she would like throughout the production of her project. Some clients want to be more involved than others. Ultimately, however, you will need to involve your client at the levels that *you* feel comfortable with.

■ Invite your client to your studio so that he can see how you produce a project. It is very helpful for clients to see just how time-intensive project resolution really is. Your efforts will be more appreciated after he has a general knowledge of how the design world spins.

I realize these explanations might sound elementary, but don't ever take for granted that every client you have is aware of these common scenarios.

Fitting Pricing to the Budget

Deciding whether or not you can fit an estimate into a client's existing budget depends somewhat on what type of fee structure you've chosen to use. Fitting an estimate to a budget is easier with the value-pricing method: you can simply determine if a project is worth the dollar amount that the client has budgeted and inform the client of your decision to move forward or move out!

Remember, you do have options: bartering, for example, or billing your client over an extended period of time so the amount better fits his allotted budget (which might be set up for monthly or quarterly disbursements). Perhaps you can creatively scale the project itself so that certain phases can coincide with given budget time frames. For example, concept work, presentation, resourcing, and palette selection might be done in one quarter, finish and furnishings selection the next quarter, implementation of construction and finishes in the third quarter, and furniture/accessories purchase and installation in the fourth quarter.

My own feeling is that you *don't* compromise your fees unless one of two cases applies: either you must absolutely have the job for your portfolio, or else you're dealing with a long-term client who has a well-established history of giving you profitable assignment—and you're really doing him a favor.

Cost Control and Time Management

I hope I don't sound like a broken record, but once again, I'll tell you that the best strategy for cost control is *forms* (written-out figures and plans, as opposed to just an idea of what things should be). Forms are the key to controlling costs. Whether the forms are in the template of a project-management program or are developed to be used manually, they should show you at a glance how much time you have on a project, what your current costs are, and if you are on schedule for a project at any given date. The goal is for the system you establish to give you an instant status report on a job whenever you want it.

So, you say, you have the information at hand, now what do you do with it? Control and discipline! You should look at the project management side of your projects about as often as you look at them from your discerning, creative vantage point.

Before a project is started, share with your support staff how much time is budgeted for them to spend on each project task. Then, as the project progresses, update yourself on the *real* amount of time spent for various tasks. If more time than you allowed for in your estimate is being incurred, you need to immediately discern why and do something about it. There are several possibilities: someone is over-perfecting, someone is not sure what to do or how they should be doing something, you underestimated the time needed, or the client is slowing progress in some way. Whatever the reason, appropriate action should be taken to make a positive change.

Each of the scenarios given above has been dealt with elsewhere in this book, except for the issue of a staff member not being sure what to

do or how she should be doing it. Reality bites in this particular example, and you can probably blame it on being too busy and fragmented yourself—thus, the communication breakdown. Chalk it up to experience, and patiently take the time to explain the task more thoroughly.

If purchase orders have been properly submitted in great detail for all outside services and material objects you will require, overages on actual dollars spent should be obsolete. In the event that you are incurring rush charges from service bureaus that you did not allow for in your original estimate, expect these overages to come out of your profit margin—*ouch!* This either means that you're incredibly busy or you have incredible inefficiencies somewhere. Needless to say, you'll have to find the problem and deal with it.

Time sheets are really the only way to track hours spent on project tasks. It doesn't matter whether you record these manually or within a software program, but it is imperative to compare the actual time required to the estimated time allotted. Many firms only mandate the maintenance of time sheets for new employees; performance for established employees is measured more directly—by the amount of work produced and the profit generated by that work. Strategy for controlling total hours spent on projects may include a bonus incentive for your employees—the more work accomplished and the more profitable that work is, the more money there is for bonuses.

Unless you are working alone and have strictly placed a value price on a project, time sheets will be instrumental in your profitability. When I started my business, I was actually a freelancer and had a studio in my home for the first two years. I never kept time sheets and found myself floating from the studio out to the deck to get some sun, into the laundry room to do a load of whites, and then back to the studio! Consequently, I was working about eighteen hours a day. Fragmenting my studio time actually decreased my productivity level and doubled the amount of time I had originally budgeted for my projects. This became apparent to me only after I started keeping time sheets.

A larger staff requires an internal check system for hours logged to each project and for time sheets submitted on a timely basis. Delegate this check task to someone or do it yourself if you have to. It's the only way to bring balance and profitability into an otherwise timeless world that can quickly go careening out of control and into negative profitability. What work is and isn't billable to your client is reviewed in chapter 6.

However, there are a few unique situations I'd like to point out that pertain to project management. One fact of life is that the hours spent

on project-management tasks are all nonbillable hours. On pages 12–16 while we were determining your hourly rate, I noted that in no way are you or your staff members capable of billing a forty-hour week (unless you are actually working fifty-plus hours a week). We allowed ten hours a week for miscellaneous office tasks like cleaning up and backing up computer systems. Properly maintaining time sheets, filling out information on job jackets, and so on, also fall into this nonbillable category.

In order to get an accurate count of hours that are truly billable, you need to encourage respect for and the honest use of the time-sheet system within your business. Falsifying time-sheet hours is totally unacceptable, and you will see whether this is happening when you (or your designated staff member) review them. I've had great luck in obtaining accurate time sheets by personally discussing their importance with new staff members and instituting an overtime policy: No overtime hours are to be incurred without a simple overtime-approval form being authorized by me or my senior designers.

Nonbillable hours can also result from having an entry-level or inexperienced staff person performing a task that is not within his or her realm of expertise. In other words, someone who is less experienced may take twice as many hours to perform a task, but those additional hours can't fairly be charged to the unsuspecting client. On the other hand, it is important to give lower-level employees the opportunity to grow and learn. This will make them more efficient in what they do, and more of their hours will be billable. In the long run, having them spend more time now will benefit both of you.

The Quintessential Office Manager

Hiring a good office manager could be the most important accomplishment the owner of an interior design studio ever realizes with regard to staying on budget. Hovering above the design awards and industry-magazine features, behind the glory of obtaining the "perfect" account and hiring the best creative people to support you, lies the magical umbrella that keeps you and everybody else out of the storm, safe and dry—your office manager!

This wonderful person will organize everything regarding the administrative aspect of your business. She will communicate beautifully with clients and vendors. With the touch of a button or the wave of a hand, she will show you updated status reports regarding time and expenses logged per project. A reassuring smile will ensure you that she has indeed billed the project that was finished yesterday and that there *is* enough money in your checking account to cover payroll

Here are ten tips to finding and hiring the perfect office manager:

1. Network. Tell friends, family, and colleagues that you are looking for an office manager and explain the qualifications for the position.
2. First impressions count. If a candidate for your new position arrives at your office thirty minutes late, wearing her breakfast (I've seen someone actually do this), it's a good indication that she's not really who you're looking for.
3. Review the candidate's résumé and cover letter carefully for grammatical and spelling errors. If she is careless with these all-important documents, think how she will be with the responsibilities you've outlined for her.
4. During the interviewing process, be critical about articulation skills, eye contact, and levels of self-confidence that the candidate presents. These are three very crucial strengths that a good office manager must project.
5. Ask for references from prior jobs, and personally contact at least three of them. Ask previous employers about the candidate's promptness, English and math skills, and the levels of loyalty and trust the employer experienced with this person.
6. Ensure that the candidate is not overqualified for the position. There are a lot of college graduates and otherwise-overqualified people

tomorrow—and then some! She reminds staff that time sheets and purchase orders are necessary to complete the assigned tasks properly, and only screams at them if she gets absolutely no results otherwise.

People with these great dispositions and capabilities do exist, although they are truly a challenge to find. Without an office manager, you may find yourself totally bogged down with tasks like those I've described, and more than likely, those tasks are not what you do best. If you find yourself spending fifteen or more hours per week on administrative responsibilities, you really need to consider hiring an office manager. The amount of time you will regain and thus bill out at your own hourly rate will greatly supersede the moneys you will invest in the right office manager.

The Traffic Manager

Traffic managers (or contract managers, as some people call them) are a must when you find that there simply are not enough hours in the day to

who are desperate to find a job and think that they can get one in office management quite easily. These types will not last long in your organization unless they are challenged by growth opportunities. If growth realistically does not exist in the position you have to offer, don't hire them.

7. Don't hire a designer who can't find a design job and who appears to have office management skills (lots of us do). This person will become frustrated being part of a team where she cannot express or use her creative skills.

8. Offer a competitive salary and benefits that rival similar corporate positions in your area. You want this person to enjoy a long-term working relationship with you, so you must respect her long-term needs.

9. If you're horrible at math and can't decide whether the person you want to hire is the perfect candidate or not, have your CPA or tax accountant speak with him and ask pertinent questions regarding the person's technical capabilities.

10. Take your favorite candidate to lunch. It's amazing what you can learn over a meal. Observe manners and poise, and let the informal environment help you get acquainted.

perform tasks such as buying and coordinating subcontractor services, making punch-list and quality-control decisions with clients, and making sure your staff is staying on schedule. The traffic person acts as a liaison between you and your clients and between you and your other outside vendors to ensure that projects flow smoothly and proficiently. It is the traffic manager's responsibility to keep your staff within budgeted hours and to alert the sales or account person when a project is going over budget.

Acquiring the services of a seasoned traffic manager may be quite costly and will add a substantial amount to your fixed cost list, which will probably result in higher hourly rates for your firm. A traffic manager's time is only about 35 percent billable, but you can change that if you allow a certain amount of time for traffic tasks within your estimate. Obviously, this will cause your per-project rates to increase; however, if you've grown to need these services on a full-time basis, your clientele will probably not question you about the several hundred dollars extra that your current estimates reflect.

Announce your firm's growth and the addition of this important member to your team by sending out a mailing to all your clients and vendors. In your mailing, list the benefits your clients will immediately realize. Just like the office manager, the traffic specialist will really take the pressure off you and allow you to explore the opportunities of doing your best in the things you do best.

The Ten Key Tasks of a Traffic Manager

1. Buy all outside services that pertain to project implementation.
2. Assist or complete the estimate process by obtaining costs for all elements pertinent to projects.
3. Review final designs and finishes with all subcontractors.
4. Ensure that the staff stays on the given schedule.
5. Update and revise the schedule for staff, clients, and vendors.
6. Scrutinize for color and finish accuracy as soon as each color or finish is applied.
7. Punch list all projects before the client does.
8. Obtain delivery information from vendors and relay that information to the client and necessary installation people.
9. Update you daily on each project for which they are responsible.
10. Follow through with the client to ensure accurate delivery and satisfaction.

Successfully establishing and managing project budgets relies on several people working in tandem. It's difficult—especially for a solo designer—to let go of control and rely on others. The sidebar information in this chapter will be particularly helpful in propelling yourself into success mode. Even if you cannot afford an office or traffic manager, someone—probably you—will need to perform these responsibilities to ensure proficiency and profitability.

Negotiating 12

There are numerous books dedicated to the art of negotiating, but I wanted to include tips specific to interior designers in this book because I think our business is unique in its dynamics of negotiation. Negotiations are constantly and simultaneously taking place regarding almost every aspect of our projects. I cannot think of any other profession that incessantly finds its members whining more about losing the core value of their endeavors, and their complaints so often falling on deaf ears.

How to Show Them You're Worth It

I tell my students, interns, and entry-level designers over and over again that they are first and foremost salespeople. Not interior designers, artisans, environmental communicators, lovers of colors and words—none of these things; they're salespeople, every one of them. And effective salespeople—if they are going to make a profit—are good at negotiating. No one ever believes me until they show me their first finished project. Typically, any senior designer will ask his or her support staff questions, challenging them, "Why this blue, why that texture, why that style of furniture?" The replies given are all elements of negotiation. The client will ask the senior designer similar questions. We designers give answers in defense of our selections. There is usually rebuttal, more questioning, and more answering. A debate may ensue. Negotiation squads (you!) are brought in. Every time we show design solutions of any type, we go into the same territory. Better to have a diverse stash of thoughts, words, and actions, so we can rise above the ensuing stress and get the results we want.

The first place in a project where we have to negotiate is usually when we present the estimate, or shortly thereafter. This is your number-one opportunity to put your stars on the ceiling.

If it is a new client, or one who hasn't seen your work for quite a while, give her a dog and pony show. Before talking numbers, show your audience photos or a video (or create a CD) of completed work that is relevant to your proposed estimate. If you don't have any relevant work, show new clients the latest and greatest example of a project you've done for a client whose name they will recognize. If you don't have this either, have a brief discussion first about why your firm is the right choice for this specific project. Seek out definitive and qualitative reasons. For example, you received some generous press in the local newspaper for a project that originally had many challenges.

Obtain letters of recommendation for your firm's outstanding achievements—quantitative and qualitative information that will give you credibility in the eyes of this new client. Show them you're worth the pricing you're asking by never literally saying it. This is a competitive industry, and you need to find a reason and a way to distinguish yourself from either your competitors or, possibly, even your own history. Reinvent yourself every time you get the opportunity to present. Keep things fresh and new.

One of my fondest presentation memories is the time one of my graphic design partners and I presented an over-the-edge idea to a rather conservative client. The client had been our largest client for almost three years. We knew each other well; we had developed personal relationships and had great camaraderie. The staff had asked us to develop a totally new look for its national-print consumer advertising. We were not the biggest advertising experts; we did mostly business-to-business. But we knew the client's consumers intimately from having worked so closely with its collateral development for three years. I was growing fearful, however, having had the account so long, that perhaps the client was getting tired of us, and perhaps vice versa.

We had a blast designing the new ad formats, developing unique illustration styles and graphic design standards very new to the market. Prior to the presentation, we sent cheapie, rock 'n' roll band–style flyers to the client's entire advertising department, with some very cheesy graphics announcing "Ban" Jovi live and in concert in their conference room at our said meeting time in their city and state. This meeting was for the advertising department staff only. No big VPs or merchandising people. We knew we were dealing with a safe crowd.

The day of the presentation, we arrived with a banjo, in overalls and flannel shirts, complete with karaoke equipment and a script matching the tune of the *Beverly Hillbillies* theme song. The script announced our new ideas amidst the laughter and tears of our surprised friends and

colleagues. We had the guts to do something so strange and unheard-of to them that we couldn't even get finished because the roar in the conference room grew deafening. After the wildly successful presentation, we distributed souvenir Ban Jovi concert T-shirts. The noise was so loud that, fortunately or unfortunately, VPs and other senior execs were soon popping their heads into the conference room to see what was going on. Instead of waiting for the ad department to present the work to them, we got to do it firsthand, to our delight and victory. It was certainly the most fun I've ever had presenting *anything*. And it worked! Price became the low man on the totem pole because there were too many other diversions to sway our clients from their typical focus.

This isn't to say that silly gimmicks work every time. Remember, we knew every person at that eight-person table quite well. We knew their sense of humor and could take what we knew and mesh it into our script to establish personal connections and familiarities. Showing your own clients that you're worth it will come from your own individuality and creativity. The point I am trying to share with you is that being proactive and original can enhance your performance—in presentations, conversations, and negotiations. Because ultimately, negotiations are always lurking—whether it's to challenge price, particular design selections, or finished manufacturing decisions.

Discussing Rates and Fees

There will certainly be many occasions when you will need to justify the rates and fees that you propose in your estimates. About 50 percent of the time, clients will ask me how I arrived at my figures. It's interesting to note that they usually request an explanation on design fees, but not on the fees of subcontractors like painters and cabinetmakers. I think that, psychologically, clients understand that these artisans have ongoing equipment purchases to make, and since the results of their work are more tangible, their prices are justified somehow. They also know that there really aren't that many great subcontractors to choose from; and typically, industry standards require us to get bids from three equally qualified vendors and then use the best price we receive on our client estimate.

I have found that, more often than not, sharing an hourly rate with a client will totally freak them out. This is especially true of clients who need the aforementioned "education" and who are not particularly accustomed to purchasing design services. Usually, a simple explanation such as, "Well, this is a big project, and we will have it in our studio for over three weeks in the research and design stages alone," will suffice.

Clients tend not to envision things going on for several weeks or even months. I also refer to similar-in-scope projects that I may have shared with the client from our samples of completed work. It's helpful when you can say, "For example, the project we did for company X, which I showed you a photograph of last week, cost Y dollars to produce," and so on.

If your client wants a more itemized breakdown of expenses, give it to him. Sometimes, it is a lot easier to justify project expenses in incremental stages and costs than it is to justify (or even explain) a lump sum.

There can be that tendency to make projects bigger than what a client might be asking for. The general habit in the industry is to completely tear down and redo! Oh, the fun of it all, the succulent colors, the glorious textures, the crisp finishes. Even experienced clients who have been buying high-quality design services for years might need an education on the many design steps required for particular projects, especially those projects that have historic architectural standards that are relevant to updated design requiring more research. I was asked to work with an architect several years ago on a historic building renovation. I had worked with her before; she is known to be a really tough businesswoman, but a very good architect who (seemingly) can easily get zoning redefinitions and permit approvals. When I reviewed my estimate with her she literally went nuts, accusing me of over-inflated pricing. The fact that I had worked with her before on a low-budget project didn't work to my advantage here at all.

This was the architect who had reminded me years ago—after seeing renovation plans I had personally conceived for a historic building I myself owned—that I was a great designer but I was no architect. I realized this fact when she asked me where I was going to store my vacuum cleaner and where the kitty-litter box was going. I ended up hiring her to revise my plans to include proper storage areas and better organizational space. When I reminded *her* that she was no designer, while presenting her with an incredible list of justifiable hours needed to complete the historical research alone, she readily agreed to pay our fees and set up a meeting for us to get started, much to my relief. I had not worked very much with this client, and I wanted our professional relationship to grow. I certainly didn't want to blow it with a price that seemed out of line to her. On the other hand, I had researched my pricing carefully and felt my pricing was extremely fair for the scope of work required.

The important thing here is that I was also unwilling to let her questioning intimidate me into lowering my fees until I had properly explained them to her. In the long run, she received a beautiful, first-rate presentation, far beyond her original expectations. When I

explained that the project seemed more substantial after I got into the estimating process, I concluded with the fact that, in actuality, she was getting quite a lot of design for a modest rate. Her agreement gave us the encouragement to produce some great work without resentment for what we *weren't* being paid. Resentment resulting from lowering your pricing tends to build, instead of tapering off, once it has begun. It's not a desirable way to start a project.

Achieving the Win-Win

Frequently, fitting into a client's budget will oblige you to stand up to your subcontractors and/or vendors and ask for help. The easiest way to be in a position to negotiate with a vendor is first and foremost to be an important client to them. You can achieve this by paying your bills within the terms noted on your vendor's invoices, by referring your vendor to other colleagues and to clients buying their own outside services, and by sending a letter of thanks to your vendor when his exceptional services got you out of a jam or his great quality helped you look good to your client. It is just as important to have good communication with your vendors as it is with your clients.

Always compare apples to apples when comparing vendors' and sub-contractors' services. Don't expect a high-quality professional painter—with a clean, efficient work crew using the latest spraying equipment, who shows up on time and on budget, all the time—to be cost-competitive with Joe Painter, who just started his business with a couple of rollers and some paint pans. Just as you want your clients to compare you and your company's pricing and quality to someone who charges similar fees for similar quality, your vendors deserve the same treatment.

Ask your vendors and subcontractors to itemize their estimates. If one pillow manufacturer charges more for down forms than another, you can at least ask him why if the charges are itemized. Compare similar itemized quotes from at least two, if not three, similar suppliers. This is an industry standard, and many of your clients will ask you who you quoted to do what. Don't shortchange yourself or your client. Complacent vendors who realize you're not taking the time to do comparison-shopping may begin to take you for granted and not offer you their best pricing.

If you are trying to fit into a client's budget and you know that it is very tight, tell your vendors up front where their price needs to be. Instead of going to the trouble to research your project from the usual standpoint, they have the option (like you do) of taking the project for the budgeted amount or turning it down because it doesn't fit their fee structure. Estimates take a substantial amount of time to produce

properly, as you know. By sharing a tight budget as soon as you are aware of it, getting the information out on the table for review, you save yourself and your vendors a lot of valuable time and frustration.

It is considered unethical to share a vendor's name with other vendors involved in the same estimating process. Even if you tend to favor certain suppliers, for whatever reasons, there may be a time when you want to expand your vendor list, or maybe a client will ask you to try to work with a certain vendor, and this will be difficult to achieve because of your lack of confidentiality. After a job has been awarded to a certain vendor or subcontractor, you may discuss it with other vendors as necessary to justify your selection process.

No matter how big or how small your town is, it is very important to build partnerships with vendors—in much the same way you build them with clients. Word will travel fast about your work ethics, and these ethics can (and will) work for or against you.

Here are some of my famous tips for negotiating with vendors:

■ Treat your vendors exactly like you want your clients to treat you. Don't nickel-and-dime them to death, don't ask a lot of production-pertinent questions before you make a commitment to using their services (thus taking up nonbillable time—remember, they need to make a profit, too), and don't pass the buck to them if you start having problems that are really not their fault.

■ If you do have a problem to resolve, don't make threats or give ultimatums. If you are absolutely certain that you are right, make sure that you are negotiating with the right person—probably not the job foreman, but perhaps the administrative manager or even the owner.

■ Always have suppliers give you their estimates in writing while referencing the job number you gave them. Make certain that all items you specified are on their written estimates. If they forgot to include something, it is your job to ask them to revise their quote before you commit a project to them.

■ Don't shop for the lowest price when you don't have to. Remember, you get what you pay for!

■ Choose several subcontractors and manufacturers to work with consistently so that you can build a healthy rapport together. The stronger your relationships and the longer they last, the easier it will be to communicate your needs and resolve issues, especially when you need help saving money for lower-budget jobs.

The most important attribute of my win-win philosophy is letting go of your fear of risk. It took me well over ten years of being in business for myself to realize the confidence required to engage my clients directly, squarely, in face-to-face confrontation. I have learned that confrontation is not a bad word at all; it's actually very healthy, especially in long-term relationships. Any of those popular, bestselling self-help books will validate this theory. I now actually enjoy the risk of potentially giving in to the client's demands, the risk of possibly losing some money, the risk of angering—and even perhaps losing—a client.

By embracing these risks, I can readily see the worst-case scenarios of a problem that lies before me. I am now free to approach a resolution with complete and total honesty, combined with a genuine willingness to hear and identify with the client's point of view. It is important for me not to drink a lot of caffeine before I enter any sessions that require me to be smooth and easygoing. This may sound silly but it's true; know your own tolerances to caffeine, sleep deprivation, and other stresses and situations prior to any potentially challenging negotiating meetings. You want to be fresh and focused solely on the issue at hand, as though it were the most important moment of your career.

I always like to be proactive by opening a negotiating session first. I thank clients for their time and endeavor to outline the exact issues on which we have a disagreement. It is a great idea to present these issues in writing, in an outlined, bulleted format. This will keep you from diverting to other issues not pertinent to the subject at hand. Ask your client to help keep you firmly focused on the list, and announce that you will do the same for your client. Acknowledge that you want to leave the room on a high note together, that your goal is win-win. Say it out loud, with a smile. Smiles work wonders. Relax, have a cookie. Sweets at the table are a great way to add an informal element to the event —who doesn't like a little Toll House in the afternoon? Drink hot chocolate, not coffee. Be endearing, not abrasive.

The fairest, quickest way to obtain win-win resolution is to split fifty-fifty any financial differences you are having. Seldom will any reasonable person disagree with this suggestion. If you have followed some of the ideas previously presented in this book, gotten proper sign-off on estimates before getting started, properly documented and presented changes, and gotten the most important sign-off of all—at the end of a project, prior to construction or manufacturing—your negotiation tasks will be much easier. Most of us know deep down who's right and who's wrong. It's simply a matter of listening, confirming, and then creatively, jointly deciding what's right.

You can validate without agreeing. You can smile and say no. You can look out the window and wish your mother were there to lighten the moment. You can listen and learn more about yourself and your business practices. You can ask questions that might help you avoid this situation in the future. The important thing to know in negotiating is that yes, you can.

Providing win–win solutions is very rewarding and shows your emotional intelligence. It invariably results in huge relief for both parties and is sometimes cause for celebration over lunch. You buy. It shows your client that you care about more than simply getting your way, and are committed to longevity as a business owner.

Rewards and Repeat Clients

I remember sitting at the most beautiful conference table I had ever seen in my life, early on in my years as a design-firm owner, talking to a prestigious architectural and engineering firm about a liaison relationship. Awards spilled from its display cases. Photos of international projects lined the corridors. The building smelled better than a new car, stuffed ceiling to floor with the coolest office furniture money can design. I coveted this camaraderie.

The man reviewing our portfolio was engaging and interesting—and interested. The meeting was going very well. I had founded my firm just two years earlier and wanted this project, perhaps just a little too much, as a portfolio showpiece. With the portfolio closed, we sat and discussed some aptitudes of both of our businesses. The final question he asked me was, "Why should we enter into this relationship?" My reply was, "Because we can win awards and recognition for this work." I got the first project, and it did win a fair number of rewards and notoriety. But I will never forget my client's reply.

He leaned forward in his chair, looked me straight in the eyes, and said, "Theo, I could care less how many awards or how much press this project gets you. That doesn't mean anything to me. If I don't get this redesigned space leased within a reasonable timeframe, we will never use your services again, and I will consider the project a huge failure no matter how beautiful it is." I cowered and quivered. At that time, I did not know the average length of time for leasing a Class A commercial space in my area. Was he being unreasonable? How much did the success of the design solution actually have to do with leasing the space? Years later, this same firm is one of our biggest clients. The man who was my client at that time has gone on to found his own prosperous architectural firm. He taught me volumes.

Now, I always tell my staff that our biggest rewards are repeat clients, and I truly mean it. Let this be the mantra of our industry, and interior designers will go from wearing rose-colored glasses to owning the most profitable businesses of our times. Real, ongoing profitability relies on continuity, cohesiveness, and reliability. Clients who know that your rates are perhaps higher than Bob's down the street won't mind paying more if they know that, beyond your originality, you are going to provide fair and honest delivery of more than just interior design with good environmental functionality.

Your role as an industry expert is to rise above the typical flash-in-the-pan trends. You can present the differences by being a savvy negotiator. Learn to enjoy the entire negotiating process, and it will be evident to your peers. Rising above will result in your ability to be somewhat intimidating—but in a good way—at the tables of future sessions. Clients will learn to trust what you say and not question your authority over and over into infinity.

Case Study Interview

Negotiating—A Story That Ends Win-Win: Kimberly France, House of France, Montgomery, Ohio

Kimberly France is a graduate of the Peddie School and has a bachelor of science degree from Bucknell University. In 1994, when she and her family were moving from New Jersey to North Carolina, a train struck her moving van and all of her family's possessions were destroyed. As a young mother, she took it upon herself to rebuild the household and took full advantage of her proximity to High Point, North Carolina, the furniture/accessory capital of the world. Her research and study of the furniture industry paid off when friends and neighbors began hiring her to decorate their homes as well. In 1999, Kimberly joined Design Works Studio in Raleigh, North Carolina, a full-service interior design house. During her time with Design Works, she was hired to design a multimillion-dollar model home, several Dream Home Showcases, a cosmetic dentistry office, as well as many residential design projects. In 2002, Kimberly moved to Cincinnati, Ohio, where she and her husband opened a furnishings and interior design boutique aptly named House of France. They employ four full-time designers, a project manager, an office manager, and an intern. She and her husband reside in Indian Hill, Ohio, with their seven children.

Q. How do you present your fees and policies with new customers?

A. We have a unique situation in that we are a furnishings and interior design boutique—our team works within our store meeting customers all day long, so we have an ability to discuss our fees with potential clients face to face. We also publish an interior design pamphlet that the customers can take with them and outline three different ways we price projects. Many times customers—especially younger couples in a first-home situation—are reluctant to ask questions about fees, so our brochure works wonderfully for them.

We have two levels of designers. Senior designers bill out at $100 an hour, and junior designers bill out at $75 an hour, and this is the first fee policy we have: straight hourly rates. The second fee structure we have is that for every $2,000 in furniture and/or accessories purchased we erase an hour from the customer's bill. We are extremely lenient with this billing program as we try to develop a working relationship with our clients. A cohesive, finished look is our goal, and

the more items we sell from our showroom the more profitability we can share with our staff and the customer with regard to hourly design consultation.

The third pricing structure—which is decidedly the best win-win for our staff designers—is an incentive fee program. This works by motivating the designers working the showroom floor to sell the customer on a design contract. In this fee structure, they develop a budget together and 10 percent of the entire budget is paid to our business, which is nonrefundable but which of course counts toward all purchases. Then the designers go off of their internal hourly salary (which is minimal, plus only 3 percent of customer purchases) and begin to do a lot of non-revenue-generating work—floor plans, selecting wall coverings, furnishings, etc. They make all of their purchase orders through our store and set the pricing themselves. The designers are in complete control driving the project—free to set pricing, do whatever it takes. These are the only things that get deducted from the total amount of purchases. So once the contract is signed, we have very little invested in the actual overhead of the employee; and the designer has the freedom to design [read: sell!] as much as she can for a much more generous cut of the profits. Our office manager even handles the numbers for the project manager/designer.

Most retail outlets in Cincinnati don't pay designers hourly; everything is commission-based in our area. I want the opportunity to hire young hungry designers. My profit-sharing program gives them a sense of independence. If they want to reduce the price of something for a customer that is buying a lot—if someone spends $100,000 for example—they can drive it. This method really teaches them to become businesspeople, project managers, and full-service designers, all at a much larger salary than they would typically make anywhere else starting out.

The only time this has not worked was very recently when a brand-new designer reeled in a 27,000-square-foot house project. This is the largest home ever to be sold in Cincinnati and it is owned by a very big name in town. There was no way she could handle this project alone, so the hourly salary plus 3-percent customer purchase commission is a huge blessing to her, and it will certainly pay off with the best experience and education she could dream of in this stage of her career. She has already flown to New York in a private jet to buy rugs.

Q. How do you show clients that you are worth the fees you charge?

A. We quote verbally and the pamphlet really works great. Plus, since our designers often create the contract situation I described earlier, they develop a more intimate relationship with our clients and it becomes easier to present the information.

Q. Have you ever had someone challenge your fee structure, and if so, what was the outcome?

A. Yes, I have had them say things such as, "Well, if I'm buying furniture through you, why do I have to pay extra for design services?" Or, "No one else makes me pay for design service." My reply is that we have to make sure that the designers get paid for their time and usually, with the generosity of our complimentary hourly design service at certain purchase levels, our clients are sophisticated enough to understand that our people would not get paid if we didn't structure fees for services over and above what we initially offer to them.

Q. Will you share with us an occurrence where you had to do some negotiating with a client, vendor, or subcontractor? What transpired for you and how did you resolve it?

A. The most interesting one is just now occurring, with the 27,000-square-foot home I mentioned earlier. A couple owns the home—she's a federal court judge and he is a big-name class-action lawyer. I didn't know him and he didn't know of us, particularly; they just came into the store and he met one of my junior designers and told her he wanted one designer to do his entire project. He was adamant about not paying full retail from the showroom and negotiated with me, challenging me to come up with a pricing structure for him if he bought $100,000, $200,000, or $300,000 worth of items. I spent several crazy days and sleepless nights, realizing the scope of the project of this size, yet not wanting to sink my entire business into this one client. I wondered how taxing this was going to be on the support staff, even with the junior designer assisting; it is a big, big load on everyone—on top of the other projects we have. I finally came up with a sliding scale based on a per-item purchase. On items up to $3,000 (and he sees all my invoices), I use a 1.6-percent markup. Items between $3,000 and $10,000 take the markup down to 1.2 percent. I knew he was going to have expensive taste; for example, a $50,000 desk instead of a $5,000 desk is the same amount of work for my staff to resource. So I think I am still making a fair amount of money, and so far things are going very well.

We're all in the business of creating design solutions for spaces—that's a given. But we've come to an age of sophistication in our society when I believe it's time for interior designers to step up and be gratefully acknowledged. Never before has environmental design been so prominent in our everyday activities. People rely on good interior design without even knowing it, as it relates to their physiological comfort with regard to ergonomics and good lighting, and to their emotional energy, as demonstrated by feng shui. The significance of what you do is at the very center of many people's daily lives, both personally and professionally.

Standing on a Soapbox

Make it a point to take nothing for granted. You have known all along the values that permeate our world because of effective interior design. I have advised my staff since day one not to create a firm style, but rather to create a multitude, an endless array of styles that are relative to each client's needs. The result is what we market as "the smart firm."

It became apparent to me several years ago that big interior design firms were losing market share to boutique firms like my own. Articles were written in national news magazines and newspapers around the country profiling new, smaller, maverick firms that were obtaining big-name, international clients. I wanted a piece of that action for my firm too. I love to travel, and as I traveled more—even within the United States—I began to see prominent subcultures in attitude and lifestyle emerging that differed not only from coast to coast but also from city to city within the same state. This fascinated me and continues to do so today. My firm does not only reside in my hometown. I feel it resides around the world. After all, we do work for clients who have offices, collectively, on all continents, so we needed to

adapt our own mentality and raise the bar on how we look at projects both from an aesthetic perspective and, more importantly, from a content perspective.

Playing It Smart

The "smart firm" concept evolved in synchronicity with our hiring a sales-development person who is well known in our region—a one-time television personality who transcended her own career as weather-person to become a strategic marketer and planner. Hiring this person taught me that we would never again go without someone with her talents and perceptions. Our large clients who have in-house strategic marketing can now appreciate the fact that we are creating more than "pretty spaces." Even though we pride ourselves in appropriately researching projects before we start designing, the residual benefit of having a full-time strategic marketing person on staff elevated us in our larger clients' minds by a generous proportion. Our smaller clients benefit from her endeavors because each of our design solutions is presented with strategic reasoning. Suddenly, fewer questions are asked about why we chose orange or why we used photographs on the wall instead of paintings. It's all in the research!

Having a strategic marketing person on staff also made me realize that we had no actual marketing *plan* for our firm. Here we were, fifteen years old, with no plan other than to try to be as progressive as possible, react to ever-increasing changes within our industry, and enjoy ourselves along the way. Our process within this new (to us) realm was still in its infancy, but some interesting issues soon developed. First and foremost, the hiring of this person was so effective, we needed to hire an assistant for her, only one year after her hiring. Things we see our clients do—press releases, attending community events, and getting more involved in regional business endeavors—get our name into the public domain quickly and effectively, which results in our phones ringing more with requests for projects.

One of the first things I asked our strategic marketing planner to do was to begin thinking of a structure with which we could present our firm on paper. Her first action was to write a business review for my critique. Within that review, she identified our mission as a design firm with regard to our history, our future responsibilities, and professional ethics. She identified a myriad of services we provided, while ranking the types of clients we had attracted by overall sales revenues.

Next, she outlined attributes of the firm relative to our current size and comparatively with other similarly sized firms around the country.

She then did some informal research to check how our own new "brand definition" stood up—were people familiar with our company? Did our location help, hinder, or matter? How did our deliverables stand up to what was being done in the industry? What types of brand loyalties did our customers have, if any?

She then provided me with a chart detailing the "sales by user group" for the last three years. This chart showed me trends that I had not realized were evident within our revenue paradigm. From this information, we derived segmentation information, showing a percentage of revenues coming from repeat business, extension business (cross-selling additional services with existing or recent clients), private label business (revenues coming from intermediaries or recommendations from existing clients), and new business derived from cold-calling efforts or networking.

This information gave us a very clear picture of who we were at one time and of who we are today, and it set the groundwork for questioning who we want to be tomorrow. Some strategies were devised to increase awareness among our potential customer base. Our annual holiday gift giving was revamped to include content material featuring our latest creative achievements. "Due diligence before design" has become our motto.

The result is a more energized firm. About a year after hiring our strategic marketing planner, our most creative (at that time) senior director left for an equity position at a competitor firm. It could have been a blow to our staff, and I believe it was, temporarily. We decided to empower some of the younger people who had been loyal employees to the firm, embracing their enthusiasm for design and complimenting them for their acceptance of this higher system of knowledge application. Now, this "new and improved" group—having its foundation in being the same core of people—has literally reinvented itself with regard to self-esteem, presentation to the outside world, and professional culture. Sure, they still have rubber-band fights and silly grilling contests on the George Foreman Grill. But they also have instituted things like creative brainstorming retreats for the purpose of creating promotion for the firm itself. Encouraging everyone to take personal pride and ownership of the smart-firm concept has proven successful in morale, productivity, and creativity.

A personal selling strategy for the firm was then created and detailed with regard to presentation styles, proposal content, our Web site, and various other revenue-enhancing operations, with an overall effort to reduce selling costs while increasing selling content.

Getting Out in the Press

Generating publicity for your firm through the media, both regional and national, is integral to business growth. Brainstorming ideas for newsworthy press releases relative to your firm's success stories and capabilities should be done at least quarterly. If you do not have a marketing person, your office manager can source distribution channels for articles written by you as the principal "expert." A public relations or marketing consultant might also be retained for resourcefulness (and article writing). There should be a constant effort to step up the quality of design competitions you enter, with a special focus on national possibilities. One goal you might consider is creating a foundation for interior design students, with the goal of awarding an annual scholarship in your firm's name. Creating your own nonprofit entity can be an excellent way to permeate your community with goodwill, resulting in some new interest.

Strategic marketing makes a lot of sense for you at this stage in your game. I'm only sorry that I didn't recognize its value from day one. It has put us into a much more proactive position to think ahead, dream, and evolve from a plan instead of only reacting to economic and internal situations. I do honestly look at my business as a big, funky chess game, if you will. The moves must be well thought out, creativity reigns in the end, and it doesn't happen all that quickly.

The ongoing growth of our firm requires us to review our plan annually, with adjustments made continually. Just having a plan at all is a step in the right direction to committing to your firm's development. Our industry is especially chained to the concept of change and flexibility. Grasping for answers in a world economy that requires us to react quickly or get lost in someone else's feather duster is a lost cause. Having a vision for possibilities and a plan to build the roads to the foreseeable plain puts you up on the flight deck.

Communicating Successfully

We take communications for granted, with e-mail, cell phones, pagers, voicemail, and who knows what's next? Effective communication in our industry lies in three very different arenas, which we usually rank this way: communicating with our clients, communicating with our support network (i.e., bankers and suppliers), and, usually last by default, communicating with our employees and ourselves. I encourage everyone in the industry to reverse the order of his or her communications priorities.

First, our employees are our biggest assets. And if you're a one-person shop, then you're indisputably your biggest super-plus. Show your understanding of this value every day, and never take it anything else but seriously. By understanding your process, you can go to the next level, which is that of being good to yourself and your staff. If you know you're a perfectionist, take a day off work every time you complete a big job. If you know you're a procrastinator, set up an incentive for yourself to take a day off if you get the job finished by noon on Tuesday. A happy you is a happy staff, and vice versa.

One of the most difficult things about growing my firm was hiring the first employee. She was incredibly talented, and I was very lucky. This was not her first job out of college, so I was even luckier. Still, though, she required maintenance. And soon after, there was another employee, then another. Suddenly, I became a human resources manager. Design classes never prepared me for this at all. I had to rely on my instincts and my own personal motivations.

Many days went by when my own billable design time went down the drain. I seldom closed my door and always encouraged staff to come and talk to me. I still do. Now, if I really need or want to get something done, I just don't go into the office! Really—communicating with creative people is something I enjoy and am motivated to do, because through listening to them—and listening in turn to my own responses—I always learn something about myself and about managing a design firm.

The biggest challenge in communicating successfully with creatives is to listen, and listen as long as it takes. I typically find that designers are their worst critics. They are very hard on themselves and have a difficult time communicating. From a personality profile at my firm, most of us are introverts. Introverts find it hard to be open with information. You have to ask them questions. I always try to put myself in their position and then tell them a story about myself—or another person with whom I've had experience working—and make an attempt to adapt my story to their situation. By doing this, I do not put them on the defensive, which is the very last place you want them to go.

I tell analogous stories so that they can then visualize themselves in the scenario of the narrative. Creatives have a wonderful sense of intuition and relational thinking. The stories help them by showing them what I did, or what the person in my story said, without telling them what I think they should do. I always say, "My experience with this type of situation is . . ." before moving into the analogy. Without fail, the response is a solution coming from them, not me. Role-playing might

ensue between us, where we have a lively discussion about possible scenarios. It becomes fun, and a once-serious situation suddenly has gone from a square box to an open continuum.

Having you and your staff in synchronicity is like changing the oil in your automobile on a regular basis. We look forward to annual staff retreats, using a Myers-Briggs–trained facilitator to discuss our personality preferences and how those preferences make us communicate the way we do. This helps us all to have a greater understanding of each other. Introverts can appear cold and unapproachable when, in actuality, they need to feel safe before they can have open discussions. Extroverts might seem obnoxious and arrogant, when they are simply thinking out loud and need validation and feedback.

Using and understanding Myers-Briggs personality types helps us to better understand and communicate with our vendors and clients. Years of studying and comparing personality preferences among our staff have trained us to readily observe preferences in communication styles of other people whom we see often. It's enjoyable to realize that we all are who we are because of things we simply prefer rather than because of a superficial compulsion to torture our colleagues! To anyone who wants to be a better communicator, I highly recommend attending a Myers-Briggs workshop or reading books from the organization. The organization's long history and available case studies far outweigh other trendy self-help concepts. Visit the official site (*www.myersbriggs.org*) for more information. Also visit *www.typelogic.com*, another good Web site.

Our support network of vendors, from bankers to builders, is too often ignored with regard to how we treat them. Vendors are almost as important (and sometimes even more important) than our staff. They can make or break you in more ways than one. Doing something nice for these folks every once in a while is one of the smartest things you can do. Most of the time, these people are hearing about problems with a project, frustration with accounts payable or accounts receivable, carryover complaints from your clients, and so on. Treat them to some good news for a change! Send them a letter of thanks when things go well. Don't forget them during the holidays. Talk to them with the highest respect.

Think of your vendors as your counselors. They give advice on a plethora of subjects. You need them. You need to delegate complex and often personal situations to them. We make great client presentations in our sleep; why not make a great visual presentation to our bankers when we're asking for a bigger line of credit? Just as designers love colors and patterns, bankers love financial information. Designing creative charts

supporting your request will work wonders and sometimes even get you a banker for a client. Put your professional skills to work when you need to prove a point. Show your favorite contractor how much business you've given him over the last year when you're asking for some help on numbers. Design him a personal thank-you card relative to the presented information.

Good client rapport begins with a simple yet seldom-thought-of action. I always ask new clients how I should stay in contact with them. Phone? Voicemail? E-mail? Photos of project examples and case scenarios on occasion? Monthly meetings? Then, I make a note of their reply and follow their suggestions. Funny, I have a client who always wants me to fax her, yet she always complains that she never receives the faxes. So, whenever we fax her, our office manager voicemails *and* e-mails her to tell her she needs to look for her fax. Outdated, yes, but this is what the client asks for, so we steadfastly adhere to her request.

Here are some other pertinent client-communication tips:

- For ongoing clients, e-mail or fax (ask for their preference) them a weekly status report.
- Make quarterly meetings with existing and potential clients to show them your most recent work. It's so easy to forget your existing client list relative to your latest and greatest.
- Don't be reluctant to toot your own horn. Many younger people in our business tend to shy away from talking about their successes and think by simply showing their work, it should speak for itself. Not true. Learning how to talk about your work in relation to qualitative and quantitative performance is quite necessary in obtaining clients at the next level.
- Realize that your client has a life. Respect it. Don't call clients on Mondays if you can help it. Mondays are hectic, do-everything-you-didn't-get-done-on-Friday kinds of days. Don't call them between 11:45 A.M. and 2 P.M. unless you have a lunch appointment together. Don't call them after 4:45 P.M., when they're trying to wrap up their day. The best time to make calls is between 9 and 11 A.M.
- If you have bad news, try to hold it until Friday afternoon. Fridays are usually happy days, and then you both have the weekend to think about problem solving.

Learning Some Hard Lessons

I have had the misfortune to be the whipping post for lots of clients throughout my years as a business owner. It's so strange to have a psychotic client who loves you one minute and then berates you the next with unreasonable ultimatums, sarcasm, demands, and tones of voice that could curdle blue cheese. I hate to admit that, in my firm's case, most of these attitudes come from middle managers. When I am confronted with this type of client, I try to listen to the wrath and remove myself from them as soon as possible.

There is absolutely no way to win a conversation with someone who is in this frame of mind. She wants to beat you up because it makes her feel superior and strong. After the bullying, and after a safe amount of time has passed, hopefully after a remedy to whatever caused the stress, I try to schedule some offsite time with her. This meeting is the foundation for whether or not this client has longevity with me. Life is too sweet to surround oneself with unhappiness. I am quick to validate these clients' anger and be sorry they were angry. Remember, I can validate without agreeing whether or not it was right. But then, I must have a compassionate, direct conversation with them about their communication style. You get what you want by being nice, simple as that. You can demand with gentle firmness. It is an art, but it can be accomplished through practice.

Getting Down to Basics

A review of somewhat generic communication tips follows, with specific correlations to the interior design profession. I like to share these subjects openly at lectures I am asked to give in our industry and open the floor for case studies and feedback. Think of your own experiences at the end of every week, and, if you are of the mindset, start an informal journal of communication occurrences, good and bad. This will help you to start your own log of stories for future discussions with employees.

The basics begin with what I call the handshake versus the Hollywood hug. I come from the Midwest, where people are basically conservative—it's cold in the wintertime and hugs are for family. When I arrived in Hollywood, I was surprised to find that a lot of my clients actually hug or do the chic cheek thing—men and women alike!

When I speak to an audience, large or small, I like to introduce myself and explain my lecture by walking around the room (with a microphone), shaking as many people's hands as I can. Then, I introduce the concept of first impressions. Whether your subculture shakes hands (it's always the safest way to get started) or hugs (these usually come

after the first job or two), it's important to do so with warmth and sincerity. Too many men loosely shake women's hands like fragile noodles. They need to learn to sincerely shake with firm (yet not bone-splitting) simplicity. On the other hand, too many ladies want to make a statement that they're strong and have their guns loaded, and they shake too hard. Learning to shake hands well might sound extremely elementary, but try it objectively within your circle of close friends. Ask for honest critiques, and get it all out in the open. Everyone might learn something surprising.

Nonverbal communication says volumes. Posture, eye contact, vocal cues, personal space allowance, and your appearance tell the world about who you are, where you've been, and where you're going to go. Think of celebrities within our American culture and even your regional political figures, and you'll see what I mean. There's definitely something we say with our body language. For example, sitting at a conference table with your arms folded tightly across your chest in a negotiating session is likely to get you out the door a failure.

Learn to exert your professional influence without being overpowering. In most cases, in-person, face-to-face communication is best for clarifying, explaining, and resolving issues, uncertainties, or any misunderstandings. Environment and context can also influence the success of your dominance. Choose a light, airy location for your important conferences. Be on time. Showing up late gives an appearance of arrogance and of letting something else that is more important take precedence. Even if this is truly the case, you don't want the person waiting to have this impression.

E-mailing can be a very good and, just as quickly, a very bad means of communicating effectively. I suggest using e-mail for information delivery only. I also make it a point to request a return receipt on all dated, important messages. Cyberspace has its delivery glitches. If you're going to use e-mail, commit to using it proficiently. This means you or your secretary will need to follow up on your sent messages and make sure that you received replies to time-sensitive material. Never share emotions or concerns via e-mail. Too often, our personalities cause us to write either too much or too little, too bluntly or too enticingly. Having others reading between our lines can really get us into lots of trouble, especially when what they're reading is not what we intended. Better to play it safe and stick to the facts where e-mail is concerned.

Some Ideas for Improvement

Learn to role-play as a means for better communication. If you have a client who constantly befuddles you, practice the possible conversational

scenarios that might arise. I like to do this in the car with a mini-recorder. It's fun to talk into a voice-activated box and pretend you're having a conversation with the other guy; all while you're cruising to your next appointment or picking up dinner at the drive-through. It's even more fun to listen to the "conversation" later. Go ahead and amuse yourself. You're an imaginative person; that's why you're in this business. You will get better at guessing what your client is going to say the more you play this game. Just think, you're always the winner in this one!

Politics play a huge role in how well we communicate with our clients. I'm not talking about your registered voting party; I'm talking about intra-personal issues within your clients' companies. Be a listener. Remember, you can validate someone without agreeing with him or her. Don't get involved with who said what or who did what on that weekend, last month, or next year. Keep your knowledge of so-called political agendas within your clients' domain to yourself. This is the safest way to maintain professional integrity and client loyalty to your firm.

I have a "me versus we" theory that reminds my staff and me that, by signing a contract with a client, we are agreeing to collaborate. We are now a team. It is our challenge, therefore, to deem ourselves collectivist versus individualist without selling our souls. Questioning and answering what we want and what we can give in return helps to establish priorities at the onset of a new project even when a relation-ship has been well identified with a client. New projects mean new ways of thinking and exploring our flexibility. This is not always easy, and we need to remind ourselves of our commitment to collaboration.

Why You Charge What You Do

We charge what we do as interior designers because we are experts. Being experts requires us to look at ourselves as much more than artists of visual communications. We are ultimately experts at communication of all varieties, at all levels. Making excuses for our pricing structure will only undermine our own authority. Being proficient in communication can come naturally to us when we embrace these concepts, resulting in better self-confidence and stability.

The roles that you play as initiator, contributor, information seeker, opinion maker, information giver, elaborator, coordinator, orienter, mediator, evaluator, energizer, technician, lawyer, accountant, moti-vator, harmonizer, compromiser, and expediter all tie into the ultimate reasons for writing this book. Pricing, estimating, and budgeting in our industry have their place in Maslow's hierarchy of needs theory. Self-actualization, followed by esteem, belongingness, safety, and psychologi-cal aptitude, all tie into our ability to communicate well, and ultimately to our profitability.

Appendix: Business Forms

The use of business forms is crucial for the smooth running of any business. The forms gathered in this appendix are intended to help in implementing the business steps and strategies discussed in this book. No form can fit all situations, but they can at least offer a starting point for the creation of customized forms that will best suit your company's needs.

- The *Estimating Worksheet* is designed to allow you to understand all the costs you are likely to incur, so you can prepare an accurate estimate to give to your client.
- The *Estimate/Confirmation of Assignment* serves both to present your estimate to the client and, if the job goes forward, as the contract for the project.
- The *Project Mission Statement* is used internally to clarify how the design team will act individually and together to meet the defined goals of the project.
- The *Weekly Time Sheet* allows the tracking of time spent on the project, which can then be related back to the Estimating Worksheet to see if the project is on target.
- The *Project Expense Ledger* details all expenditures for the project and can also be reviewed against the Estimating Worksheet.
- The *Change-Order Form* makes certain that the client has approved and will pay for any changes.
- The *Invoice* is used to bill the client and incorporates by reference the terms of the Estimate/Confirmation of Assignment.

The best resource for the designer to develop business forms is *Business and Legal Forms for Interior Designers* by Tad Crawford and Eva Doman Bruck. It offers a wide variety of forms, an in-depth discussion of and negotiation checklist for each form, and includes a CD-ROM with the forms for ease of customization. Another excellent resource is the *Graphic Artists Guild's Pricing and Ethical Guidelines*.

This appendix and the forms contained herein have been created for this book by Tad Crawford (© Tad Crawford 2001) and are published here with his permission.

Project Plan and Budget

<div>

CLIENT

Name _____

Address (Meetings) _____

Phone _____

Address (Billing) _____

Phone _____

Cell _____

Fax _____

Other Contact Information _____

</div>

ESTIMATING FORMAT ASSUMPTION: RATES ARE PER ☐ HOUR ☐ DAY ☐ WEEK

	LABOR			
	Principal	Lead Designer	Designer	Design Assistant
RATES	$	$	$	$
Program Development				
Client Intake Meetings				
Site Conditions: Measurements and Notes				
Research				
Schematics				
Preliminary Color/Materials ("Mood") Boards				
Preliminary Budget/Schedule Estimates				
Program Presentation				
Revisions				
Miscellaneous				
Subtotal				
Design Development—Phase One—Schematics				
Site Plan Base Drawings				
Traffic Patterns				
Space/Layout Plans				
Schematic Plans and Preliminary Selections				
Walls				
Floors				
Ceilings				
Window Treatments				
Millwork				
Fixtures and Hardware				
Furniture				
Audio/Video				
Spa/Exercise Furnishings				
Linens, Rugs, Decorative Items				
Presentation/Sample Boards				
Budget/Schedule Estimates				
Schematics Presentation				
Revisions				
Miscellaneous				
Subtotal				

☐ Estimate Form for Client
☐ Preliminary Budget and Schedule
☐ Budget and Schedule Status Review

Date —————————————
By —————————————

PROJECT
Job Number —————————————
Job Name —————————————
Location —————————————
Description —————————————

ESTIMATE FACTORS			COST			SCHEDULE		
Total Labor	Materials	Misc.	Budget	To-Date	Balance	Allocated	To-Date	Balance

ESTIMATING FORMAT ASSUMPTION: RATES ARE PER ☐ HOUR ☐ DAY ☐ WEEK

	Principal	Lead Designer	Designer	Design Assistant
RATES	$	$	$	$
Design Development—Phase Two—Final				
Final Site Plan Base Drawings				
Final Traffic Patterns				
Final Space/Layout Plans				
Final Plans and Selections				
Walls				
Floors				
Ceilings				
Window Treatments				
Millwork				
Fixtures and Hardware				
Furniture				
Audio/Video				
Spa/Exercise Furnishings				
Linens, Rugs, Decorative Items				
Final Presentation/Sample Boards				
Final Budget/Schedule				
Final Design Development Presentation				
Revisions				
Miscellaneous				
Subtotal				
Contract Documents and Bids				
Bid Drawings and Specs				
Bid Review				
Client Review of Bids				
Revisions				
Vendor Selection and Contracts				
Miscellaneous				
Subtotal				
Project Implementation				
Purchasing—Stock Items				
Wall Fabrics/Finishes				
Flooring Material				
Ceiling Materials				
Window Treatments				
Fixtures and Hardware				
Furniture				
Audio/Video				
Spa/Exercise Furnishings				
Linens, Rugs, Decorative Items				
Storage/Shipping/Handling				
Miscellaneous				
Subtotal				

LABOR

ESTIMATE FACTORS			COST			SCHEDULE		
Total Labor	Materials	Misc.	Budget	To-Date	Balance	Allocated	To-Date	Balance

ESTIMATING FORMAT ASSUMPTION: RATES ARE PER ☐ HOUR ☐ DAY ☐ WEEK

	LABOR			
RATES	Principal	Lead Designer	Designer	Design Assistant
	$	$	$	$
Fabrication—Custom Orders				
Wall Fabrics/Finishes				
Flooring Material				
Ceiling Materials				
Window Treatments				
Millwork				
Fixtures and Hardware				
Furniture				
Audio/Video/Security/Other Electronic				
Linens, Rugs, Decorative Items				
Storage/Shipping/Handling				
Miscellaneous				
Subtotal				
Construction—Site Supervision				
Scheduling				
Walls				
Floors				
Ceilings				
Miscellaneous				
Subtotal				
Installation—Site Supervision				
Wall Painting/Coverings				
Floor Treatments				
Ceiling Treatments				
Window Treatments				
Millwork				
Fixtures and Hardware				
Furniture				
Audio/Video/Security/Other Electronic				
Spa/Exercise Furnishings				
Linens, Rugs, Decorative Items				
Miscellaneous				
Subtotal				
Final Project Completion Items				
Walk Through and Punch List				
Supervision of Punch List Completion				
Miscellaneous				
Subtotal				
Project Total				

| Total Labor | ESTIMATE FACTORS | | | COST | | | SCHEDULE | | |
	Materials	Misc.	Budget	To-Date	Balance	Allocated	To-Date	Balance	

SUMMARY FORMAT ASSUMPTION: FOR SCHEDULING, TIME SHOWN IS IN ☐ HOURS ☐ DAYS ☐ WEEKS

	Program Development	DD/1— Schematics	DD/2— Final	Contract Docu and Bids
Project Details				
Walls/Ceilings				
Paint				
Wall Coverings				
Mouldings				
Other				
Floors/Stairways				
Wood				
Ceramic				
Stone				
Carpeting				
Mouldings				
Other				
Window Treatments				
Shades/Blinds				
Louvers				
Drapery				
Valances				
Other				
Millwork				
Fixtures and Hardware				
Bath				
Kitchen				
Lighting				
Wall/Door				
Other				
Furniture				
Furniture—Purchase				
Furniture—Commission				
Furniture—Recondition/Special Finish				
Furniture—(Re)upholstery				
Audio/Video/Security/Other Electronic				
Spa/Exercise Furnishings				
Other Furnishings				
Linens				
Rugs				
Decorative Items (Objets d'art)				
Miscellaneous				
Travel				
Messengers				
Insurance				
Storage				
Shipping and Handling				
Project Total				

Purchasing Stock Items	Fabrication Custom Orders	Construction Site Supervision	Installation Site Supervision	Final Project Completion	Total

Proposal Form

Date _____

By _____

CLIENT INFORMATION

Name _____

Address (Meetings) _____

Phone _____

Address (Billing) _____

Phone _____

Cell _____

Fax _____

Other Contact Information _____

PROJECT

Name _____

Location _____

FEE INFORMATION

Flat Fee _____

Percentage (Square Feet) (Price of Goods) _____

Hourly Rates _____

SCOPE OF WORK

WORK PLAN SCHEDULE

	START-END DATES	BUDGET	TOTAL TIME
Program Development			
Design Development—Phase One—Schematics			
Design Development—Phase Two—Final			
Contract Documents and Bids			
Project Implementation			
Construction—Site Supervision			
Installation—Site Supervision			
Final Project Completion Items			

WORK PLAN—DETAIL

	NOTES	BUDGET	TOTAL TIME
Walls/Ceilings			
Painting			
Painting—Special			
Wall Coverings			
Mouldings			
Other			
Floors/Stairways			
Wood			
Ceramic			
Stone			
Carpeting			
Mouldings			
Other			
Window Treatments			
Shades/Blinds			
Louvers			
Drapery			
Valances			
Other			
Millwork			
Fixtures and Hardware			
Bath			
Kitchen			
Lighting			
Wall/Door			
Other			
Furniture			
Furniture—Purchase			
Furniture—Commission			
Furniture—Recondition/Special Finish			
Furniture—(Re)upholstery			
Audio/Video/Security/Other Electronic			
Spa/Exercise Furnishings			
Other Furnishings			
Linens			
Rugs			
Decorative Items			

	NOTES	BUDGET	TOTAL TIME
Miscellaneous			
Travel			
Messengers			
Insurance			
Storage			
Shipping and Handling			
Other			
TOTAL			

All information in this proposal is subject to the Terms and Conditions listed below.

TERMS AND CONDITIONS

Change Orders Work change orders will be issued for additional work and changes requested after approval of plans or commencement of work. WCOs include a description of the change/addition requested, estimated additional costs, and changes to work schedules/project completion. The client's signature is required on WCOs to proceed with changes/additions.

Billable Items In addition to the fees and costs estimated herein, costs incurred for insurance, storage, messengers, and shipping and handling are billable (at cost, with a markup of ____%). Wherever applicable, state and local sales taxes will be included in billable items.

Purchasing All purchases made on client's behalf will be billed to the client. In all cases, such prices will reflect a (discount) (markup) of ____%. Charges for sales tax, insurance, storage, and shipping and handling are additional to the price of each purchase. In the event the client purchases materials, services, or any items other than those specified by the designer, the designer is not liable for the cost, quality, workmanship, condition, or appearance of such items.

Deposits A 50 percent deposit is required on all orders made on behalf of the client, prior to the placement of such orders. The balance is due upon delivery. Any items canceled by the client more than 5 business days after designer has received the client's approval to purchase will be billed at ____ percent of the price of the item.

Custom Orders The client is fully responsible for paying all costs for custom orders canceled by the client once manufacturing has started. The cost of special orders that are canceled by the client following approval to purchase is fully dependent upon the terms and conditions put forth by the manufacturer, supplier, or vendor of the item(s).

Warranty The designer makes no additional warranty, guarantee, or any other assurances, other than those provided by the manufacturers, suppliers, or vendors of products and/or services.

Other Contracts The designer is not responsible for any contracts that the client enters into directly with contractors, suppliers, manufacturers, or vendors for goods and/or services, whether or not such sources are recommended by the designer.

Purchase Orders The designer is responsible for those purchase orders issued directly by the designer. The client is fully responsible for all purchase orders issued by the client. Responsibility includes, but is not limited to, errors, omissions, pricing, and scheduling.

Schedule of Payment Hourly Rate: Regular billing periods (bimonthly, monthly) based on hours consumed or periodic approval points. Square Footage: Billing may be ____ percent upon project commencement, ____ percent following completion of design development, ____ percent upon completion of punch list items. Flat Fee: ____ percent of fee payable upon signing of contract, ____ percent upon approval of final design development phase, ____ percent upon completion of punch list items.

Termination Policy The client and the designer may terminate project based upon mutually agreeable terms to be determined in writing, either prior to signing of this proposal or within the final Client-Designer Contract.

Terms of Proposal The information contained in this proposal is valid for 30 days. Proposals approved and signed by the client are binding upon the designer and the client beginning on the date of the client's signature.

If the information in this proposal meets with the client's approval, the client's signature below authorizes the designer to begin work. Kindly return a signed copy of this proposal/agreement to the designer's office.

Designer Signature _____ Print Designer Name _____ Date _____

Client Signature _____ Print Client Name _____ Date _____

Comprehensive Production Schedule

ALL PROJECTS

Job Name	Phase	Key Dates	Staff	Sources	Notes

INDIVIDUAL PROJECTS

CLIENT

Name _____

PROJECT

Job Name _____

Location _____

Job Number _____

Phase/Item	Schedule	Due Dates	By	To	Completed
Program Development					
Client Intake Meetings					
Site Conditions: Measurements and Notes					
Research					
Preliminary Color/Materials ("Mood") Boards					
Preliminary Budget/Schedule Estimates					
Program Presentation					
Revisions					
Client Sign-Off					
Design Development—Phase One—Schematics					
Site Plan Base Drawings					
Traffic Patterns					
Space/Layout Plans					
Preliminary Plans and Selections					
Walls					
Floors					
Ceilings					
Window Treatments					
Millwork					
Fixtures and Hardware					
Furniture					
Audio/Video					
Spa/Exercise Furnishings					
Linens, Rugs, Decorative Items					
Presentation/Sample Boards					
Budget/Schedule Estimates					
Design Development Presentation					
Revisions					
Client Sign-Off					

Phase/Item	Schedule	Due Dates	By	To	Completed
Design Development—Phase Two—Final					
Final Site Plan Base Drawings					
Final Traffic Patterns					
Final Space/Layout Plans					
Final Plans and Selections					
Walls					
Floors					
Ceilings					
Window Treatments					
Millwork					
Fixtures and Hardware					
Furniture					
Audio/Video					
Spa/Exercise Furnishings					
Linens, Rugs, Decorative Items					
Final Presentation/Sample Boards					
Final Budget/Schedule					
Final Design Development Presentation					
Revisions					
Client Sign-Off					
Contract Documents and Bids					
Bid Drawings and Specs					
Bid Review					
Client Review of Bids					
Revisions					
Client Sign-Off					
Vendor Selection and Contract Documents					
Project Implementation					
Purchasing—Stock Items					
Wall Fabrics/Finishes					
Flooring Material					
Ceiling Materials					
Window Treatments					
Fixtures and Hardware					
Furniture					
Audio/Video					
Spa/Exercise Furnishings					
Linens, Rugs, Decorative Items					
Storage/Shipping/Handling					
Miscellaneous					

Phase/Item	Schedule	Due Dates	By	To	Completed
Fabrication—Custom Orders					
Wall Fabrics/Finishes					
Flooring Material					
Ceiling Materials					
Window Treatments					
Millwork					
Fixtures and Hardware					
Furniture					
Audio/Video/Security/Other Electronic					
Linens, Rugs, Decorative Items					
Storage/Shipping/Handling					
Miscellaneous					
Construction—Site Supervision					
Scheduling					
Walls					
Floors					
Ceilings					
Miscellaneous					
Installation—Site Supervision					
Custom Wall Painting/Coverings					
Custom Floor Treatments					
Custom Ceiling Treatments					
Custom Window Treatments					
Millwork					
Fixtures and Hardware					
Furniture					
Audio/Video/Security/Other Electronic					
Spa/Exercise Furnishings					
Linens, Rugs, Decorative Items					
Miscellaneous					
Final Project Completion Items					
Walk-Through and Punch List					
Supervision of Punch List Completion					
Client Sign-Off					

Sample Time Sheet

Name Natalie Jaye
Month 12
Dates 1–7
Year 2002

Phase Codes	Phases	Activity Codes	Activities	Detail Codes	Detail Items
1	Program Development	C	Client Relations (Meetings/ Presentations)	00	Not a Detail Item
2	Design Development— Phase One (Schematic)	T	Travel	01	Walls/Ceilings
3	Design Development— Phase Two (Final)	B	Budget/Schedule/ Proposal	02	Floors/Stairways
4	Contract Documents and Bids	S	Site Visit/Inspection/ Supervision	03	Window Treatments
5	Project Implementation	R	Research	04	Millwork
6	Project Completion	D	Designing/Drawing	05	Fixtures and Hardware
		P	Presentation Drawing	06	Furniture
		M	Model Building	07	Audio/Video/Security/ Other Electronic
		W	Spec Writing and Drawing	08	Spa/Exercise Furnishings
		X	Spec Review and Selection	09	Other Furnishings
		Y	Shopping/Purchasing	10	Meetings
		Z	Coordination/Administration/ Meetings		

Project Number	Project Name	Date	Phase Code	Activity Code	Detail Code	Time Reg	OT	Total Billable	Notes
C01-TCN-1A	Blue Oyster Restaurant—Bar	Mon	1	C	00	2		0	
C01-TCN-1A	Blue Oyster Restaurant—Bar		1	C	10	3		3	
C01-TCN-1A	Blue Oyster Restaurant—Bar		1	B	00	2		0	
C01-BGS-1	Appleby's Farm Store		PM	C	10	1	1	0	Internal Meeting— Plan Presentation
	Subtotal					8	1	3	
C01-TCN-1B	Blue Oyster Restaurant—Dining Room	Tues	3	D	01	2		2	
C01-TCN-1B	Blue Oyster Restaurant—Dining Room				02	2		2	
C01-TCN-1B	Blue Oyster Restaurant—Dining Room				03	1		1	
C01-TCN-1B	Blue Oyster Restaurant—Dining Room				04	3		3	
	Subtotal					8	0	8	
C01-TCN-1A	Blue Oyster Restaurant—Bar	Wed	1	S	00	2		2	
C01-BGS-1	Appleby's Farm Store		PM	P	00	3		0	
	Nonbillable		EA			3		0	Dentist Appointment
	Subtotal					8	0	2	
	Nonbillable	Thurs	SK			8	0	0	
C01-TCN-1A	Blue Oyster Restaurant—Bar	Fri	2	D	01	4		4	
C01-TCN-1A	Blue Oyster Restaurant—Bar				02	4		4	
	Subtotal					8	0	8	
		Sat							
		Sun							
	Totals					32	1	21 131%	

Approved _____

Date Posted _____

Nonbillable Codes	
General Administration	GA
Maintenance	MN
Promotion/Marketing	PM
Holidays	HD
Sick Days	SK
Excused Absences (Jury Duty, Bereavement, etc.)	EA

Time Sheet

Name _____

Month _____

Dates _____

Year _____

Project Number	Project Name	Date	Phase Code	Activity Code	Detail Code	Time Reg	OT	Total Billable	Notes
___	___	___	___	___	___	___	___	___	___
___	___	___	___	___	___	___	___	___	___
___	___	___	___	___	___	___	___	___	___
___	___	___	___	___	___	___	___	___	___
___	___	___	___	___	___	___	___	___	___
___	___	___	___	___	___	___	___	___	___
___	___	___	___	___	___	___	___	___	___
___	___	___	___	___	___	___	___	___	___
___	___	___	___	___	___	___	___	___	___
___	___	___	___	___	___	___	___	___	___
___	___	___	___	___	___	___	___	___	___
___	___	___	___	___	___	___	___	___	___
___	___	___	___	___	___	___	___	___	___
___	___	___	___	___	___	___	___	___	___
Totals									

Approved _____

Date Posted _____

Purchase Log

CLIENT

Name

PROJECT

Job Name

Location

Job Number

			Bid Documents						Pri
Item	Vendor	Order Contact Info.	Specs	Drawings	Catalog Info.	Swatches/ Samples	P.O. Number	P.O. Total	Chan Orde

Schedule				Storage			
Invoice Total	Order Date	Delivery/ Due	Received/ Completed	Location	Ticket Number	In	Out

Purchase Order

Job Number _____ P.O. Number _____

To: Date _____

Vendor _____ Phone_____

Address_____ Fax_____

Contact_____ E-mail_____

Schedule Delivery Due: Installation Completed:

SPECIFICATIONS

Item Number	Description	Quantity	Unit Price	Other	Total

NOTES _____ Subtotal _____
_____ Shipping/Handling _____
_____ Tax _____
_____ Total _____
_____ Deposit _____
_____ Balance Due _____

Ship to: _____

Bill to: _____

Ordered by

Signature _____ Phone_____

Print name _____ Fax_____

Work Change Order

Client _____ Change Order Number _____

Project _____ Date _____

Work Change Requested By _____ Job Number _____

Phase

Program Development ❏

Design Development—Schematics ❏

Design Development—Final ❏

Contract Documents and Bids ❏

Implementation ❏

__Work Change Description__	__Cost Change__	__Schedule Change__

This is not an invoice. Revised specifications on work in progress represents information that is either different from that which the original project budget and schedule were based upon, or follows after client's approval to the stage of work in which this (these) item(s) appear(s). Changes in time and cost quoted here may be approximate, unless otherwise noted. Your signature below will constitute authorization to proceed with the change(s) noted above. Kindly return a signed and dated copy of this form to:

Authorized Signature _____

Print Name _____

Date _____

Designer-Client Agreement for Residential Project

[Designer's Letterhead]

Date

Ms. Alice Client
123 Main Street
Greenwich, CT 06830

Dear Ms. Client:

We are delighted to have been selected by you for your interior design project (the "Project"). This letter is to set forth the terms under which we will work together.

1. Description. We agree to design the Project in accordance with ❏ the following plan ❏ the plan attached hereto as Schedule A and made part of this agreement.

Project location, including identification of areas, square footage, and likely number of occupants:

Scope of work to be performed:

Scope of work set forth in project phases:

Program plan. We shall consult with you to ascertain your goals, interview the people who will use the space, visit the premises and make measurements, prepare designs and renderings, and offer recommendations for purchases of merchandise and construction (including sample materials, when helpful). Other services we will render during this phase include:

❏ If this box is checked, Designer shall prepare an estimated budget to include in the presentation, but you acknowledge that this budget is subject to change and is not a guarantee on our part with respect to the prices contained therein.

Design documents. After your approval of the presentation, we shall prepare interior architectural drawings for the following areas _____
_____, which, after your further approval, shall be submitted for competitive

bids to contractors selected by you after consultation with us. In addition, we shall prepare purchase orders for merchandise and construction for your approval. Other services we will render during this phase include:

Design implementation. We shall visit the Project with the following frequency _____,
discuss the status of the work with you, and be available to consult with you with respect to whether what is being delivered or constructed is in conformity with specifications and of suitable quality. However, the quality and supervision of merchandise or construction shall be the responsibility of the suppliers or contractors. Other services we will render during this phase include:

Services to be rendered by us in addition to those described above:

2. Schedule. We agree to make our presentation within _____ days after the later of the signing of this Agreement or, if you are to provide reference, layouts, measurements, or other materials specified here_____,

after you have provided this to us.

After approval of the presentation, we shall ❏ make reasonable efforts to progress the Project; or ❏ shall conform to the following schedule: _____

based on an intended occupancy date of _____.

You understand that delays by you, suppliers, or contractors may delay performance of our duties, and our time to perform shall be extended if such delays occur. In addition, if we or you are unable to perform any obligations hereunder because of fire or other casualty, strike, act or order of a public authority, act of God, or other cause beyond our or your control, then performance shall be excused during the pendency of such cause.

3. Purchases of merchandise and construction shall be handled in the following manner:
❏ We shall pay for purchases of merchandise, and you shall pay for construction.
❏ We shall commit to purchases of merchandise and construction as your agent, but you shall make payment directly to the suppliers or contractors.
❏ You shall pay for purchases of merchandise and construction.
❏ We shall pay for purchases of merchandise and construction.
❏ Other arrangement _____

If we are paying for either merchandise or construction, you shall give advance approvals by signing written authorizations. You shall pay us in full for lighting fixtures, fabrics, wallpaper, plants, flatware, crystal, linen, china, and other household items, pay a deposit of ____ percent for other merchandise; and pay a deposit of ____ percent for construction. You understand that we shall not place any order until after receipt of the signed approval with appropriate payment. Once we place such an order, it cannot be cancelled by you. If a deposit has been made, the full balance due shall be paid by you prior to delivery, installation, or completion of construction.

If we are acting as your agent, you shall approve all purchases of merchandise or construction by signing a written authorization.

We shall prepare purchase orders for purchases of merchandise or construction and shall advise you as to acceptability, but shall have no liability for the lateness, malfeasance, negligence, or failure of suppliers or contractors to perform their responsibilities and duties. In the event that, after your approval for purchases of merchandise or construction, changed circumstances cause an increase in price or other change with respect to any such purchases of merchandise or construction, we shall notify you in writing, but shall bear no liability with respect to the changed circumstances, and you shall be fully responsible with respect to the purchases of merchandise or construction. We make no warranties or guarantees as to merchandise or construction, including but not limited to fading, wear, or latent defects, but will assign to you any rights we may have against suppliers or contractors, and you may pursue claims against such suppliers or contractors at your expense.

If you pay directly for purchases of merchandise or construction, you shall make certain that we receive copies of all invoices.

You shall be responsible for the payment of sales tax, packing, shipping, and any related charges on such purchases of merchandise or construction.

4. Approvals. On our request, you shall approve plans, drawings, renderings, purchase orders, and similar documents by returning a signed copy of each such document or a signed authorization referencing such documents to us.

5. Your Responsibilities. You shall cooperate throughout the Project by promptly providing us with necessary information; arranging any interviews that may be needed; making access available to the project site; giving prompt attention to documents to review and requested approvals; facilitating communications between us and other professionals, such as architects and engineers whom you have retained; and, if necessary, designating the following person _____ to act as liaison with us. If you are to provide specifications, floor plans, surveys, drawings, or related information, this shall be at your expense, and we shall be held harmless for relying on the accuracy of what you have provided. If at any time you have knowledge of a deviation from specifications or other problem with the Project, you shall promptly give notice in writing to us. You shall be responsible for receiving, inspecting, and storing all deliveries, except that we shall assist in this as follows:

6. Remuneration. You agree to pay us on the following basis, as selected by a check mark in the appropriate box or boxes:

❏ Retail/list price plus a percentage of construction costs. We shall purchase merchandise at retail/list price and shall be compensated through the discount customarily allowed designers from such retail/list prices. If construction

is required, we shall be paid a markup of _____ percent of construction expenditures. You shall pay us a non-refundable retainer of $_____ on the signing of this Agreement, which retainer shall be applied to reduce the last payments due to us from you or, if insufficient purchases of merchandise and construction are made for the retainer to be so applied, shall be retained as a design fee.

❏ Flat fee plus a percentage of costs. Our compensation shall be a nonrefundable design fee of $_____, paid by you on the signing of this Agreement, plus an additional markup of _____ percent of the expenditures for merchandise and _____ percent of the expenditures for construction, except that the following budget items shall not be included in this calculation:

Regardless of whether payment is made by us or you, all purchases of merchandise and construction for the Project shall be included for the purpose of computing remuneration due us, except for the following exclusions:

In addition, you may append to this Agreement a list of items owned by you prior to commencement of the Project and use these items without any additional fee being charged by us.

❏ If an Estimated Budget is required by you, an additional fee of $_____ shall be charged for its preparation.

In the event that design services beyond the scope of work for this Project are requested by you and we are able to accommodate your request, we shall bill for such additional services as follows:

7. Revisions. During the development of the Project, we shall make a reasonable amount of revisions requested by you without additional charge, but if the revisions are requested after approvals by you, an additional fee shall be charged as follows:

8. Expenses. In addition to the payments pursuant to Paragraphs 6 and 7, you agree to reimburse us for all expenses connected to the Project, including but not limited to messengers, long-distance telephone calls, overnight deliveries, and local travel expenses. These expenses shall be marked up _____ percent by us when billed to you. In the event that travel beyond the local area is required, the expenses for this travel shall be billed as follows:

At the time of signing this agreement, you shall pay us $_____ as a nonrefundable advance against expenses. If the advance exceeds expenses incurred, the credit balance shall be used to reduce the fee payable or, if the fee has been fully paid, shall be reimbursed to you. Expenses shall in no event include any portion of our overhead.

9. Payment. You agree to pay us within ____ days of receipt of our billings for remuneration, expenses, or purchases of merchandise or construction. Overdue payments shall be subject to interest charges of ____ percent monthly. In the event that we are the winning party in a lawsuit brought pursuant to this agreement, you shall reimburse us for the costs of the lawsuit, including attorney's fees.

10. Term and Termination. This agreement shall have a term that expires on _____, 20__ The term shall automatically renew for additional _____ periods unless notice of termination is given either by us or you thirty (30) calendar days in advance of the renewal commencement. In addition, this agreement may be terminated at any time for cause by either party notifying the other party in writing of that party's breach of the Agreement and giving ten (10) business days for a cure, after which the notifying party may terminate if there has been no cure of the breach. Causes for termination shall include, but not be limited to, failure to perform any duty pursuant to this agreement in a timely manner and postponements of the Project for more than ____ business days in total. While reserving all other rights under this Agreement, in the event that the Project is terminated, we shall have the right to be paid by you through the date of termination for our work, for any purchases by us of merchandise and construction pursuant to purchase orders approved by you, and for our expenses.

11. Ownership of Design. We shall retain ownership of the design, including any drawings, renderings, sketches, samples, or other materials prepared by us during the course of the Project. Our ownership shall include any copyrights, trademarks, patents, or other proprietary rights existing in the design. You shall not use the design for additions to this Project or for any other project without obtaining our permission and paying appropriate compensation.

12. Consultants. If outside consultants, including but not limited to architects, structural engineers, mechanical engineers, acoustical engineers, and lighting designers, are needed for the Project, they shall be retained and paid for by you, and we shall cooperate fully with these consultants. Such consultants shall be responsible for code compliance in the various areas of their expertise.

13. Publicity. We shall have the right to document the Project in progress and when completed, by photography or other means, which we may use for portfolio, brochure, public display, and similar publicity purposes. Your name and the location of the Project may be used in connection with the documentation, unless specified to the contrary _____. If we choose to document the Project, we shall pay the costs of documentation. In addition, if you document the Project, we shall be given credit as the designer for the Project if your documentation is released to the public.

14. Relationship of Parties. We and you are both independent contractors. This agreement is not an employment agreement, nor does it constitute a joint venture or partnership between us and you. Nothing contained herein shall be construed to be inconsistent with this independent contractor relationship.

15. Assignment. Neither our nor your rights and duties may be assigned by either party without the written consent of the other party, except that we may assign payments due hereunder.

16. Arbitration. All disputes arising under this Agreement shall be submitted to binding arbitration before _____ in the following location _____ and settled in accordance with the rules of the American Arbitration Association. Judgment upon the arbitration award may be entered in any court having jurisdiction thereof. Disputes in which the amount at issue is less than $_____ shall not be subject to this arbitration provision.

17. Miscellany. This agreement shall be binding on both us and you, as well as heirs, successors, assigns, and personal representatives. This agreement constitutes the entire understanding. Its terms can be modified only by an instrument in writing signed by both us and you. Notices shall be sent by certified mail or traceable overnight delivery to us or you at our present addresses, and notification of any change of address shall be given prior to that change of address taking effect. A waiver of a breach of any of the provisions of this agreement shall not be construed as a continuing waiver of other breaches of the same or other provisions hereof. This agreement shall be governed by the laws of the State of _____.

If this agreement meets with your approval, please sign beneath the words "Agreed to" to make this a binding agreement between us and you. Please sign both copies and return one copy for our files. We look forward to working with you.

AGREED TO

Sincerely yours,
XYZ Interior Design, Inc.

By: _____ By: _____
　　　　　Alice Client　　　　　　　　　　　　　Authorized Signatory, Title

Designer-Client Agreement for Commercial Project

Agreement as of the ＿＿ day of ＿＿＿＿＿, 20＿＿, between ＿＿＿＿＿＿＿＿＿＿＿＿＿＿＿＿＿,
located at ＿＿＿＿＿＿＿＿＿＿＿＿＿＿＿＿＿＿＿＿＿＿ (hereinafter referred to as the "Client") and
＿＿＿＿＿＿＿＿＿＿＿＿＿＿＿, located at ＿＿＿＿＿＿＿＿＿＿＿＿＿＿ (hereinafter referred
to as the "Designer") with respect to an interior design project (hereinafter referred to as the "Project").

Whereas, the Designer is a professional interior designer of good standing;

Whereas, the Client wishes the Designer to design the Project described more fully herein; and

Whereas, the Designer wishes to design this Project;

Now, therefore, in consideration of the foregoing premises and the mutual covenants hereinafter set forth and other valuable considerations, the parties hereto agree as follows:

1. Description. The Designer agrees to design the Project in accordance with ❑ the following plan ❑ the plan attached hereto as Schedule A and made part of this agreement.

Project location, including identification of areas, square footage, and likely number of occupants:

＿＿
＿＿

Scope of work to be performed by Designer: ＿＿＿＿＿＿＿＿＿＿＿＿＿＿＿＿＿＿＿＿＿
＿＿
＿＿

Designer's scope of work set forth in project phases:

Programming ＿＿＿＿＿＿＿＿＿＿＿＿＿＿＿＿＿＿＿＿＿＿＿＿＿＿＿＿＿＿＿＿＿＿＿＿＿＿
＿＿
＿＿

Design Concept ＿＿＿＿＿＿＿＿＿＿＿＿＿＿＿＿＿＿＿＿＿＿＿＿＿＿＿＿＿＿＿＿＿＿＿＿
＿＿
＿＿

Decoration ＿＿＿＿＿＿＿＿＿＿＿＿＿＿＿＿＿＿＿＿＿＿＿＿＿＿＿＿＿＿＿＿＿＿＿＿＿＿＿
＿＿
＿＿

Contract Documentation ＿＿＿＿＿＿＿＿＿＿＿＿＿＿＿＿＿＿＿＿＿＿＿＿＿＿＿＿＿＿＿
＿＿
＿＿

Contract Administration ＿＿＿＿＿＿＿＿＿＿＿＿＿＿＿＿＿＿＿＿＿＿＿＿＿＿＿＿＿＿＿＿
＿＿
＿＿

❑ If this box is checked, the Designer shall prepare an estimated budget to include with the Design Concept for presentation to the Client, but the Client acknowledges that this budget is subject to change and is not a guarantee on the part of the Designer with respect to the prices contained therein.

As the work is in progress, the Designer shall visit the Project with the following frequency _____, discuss the status of the work with the Client, and be available to consult with the Client with respect to whether what is being delivered or constructed is in conformity with specifications and of suitable quality. However, the quality and supervision of merchandise or construction shall be the responsibility of the suppliers or contractors.

Services to be rendered by the Designer in addition to those described above: _____

2. Schedule. The Designer agrees to make its presentation within _____ days after the later of the signing of this Agreement or, if the Client is to provide reference, layouts, measurements, or other materials specified here _____ _____, after the Client has provided same to the Designer. After approval of the presentation, the Designer shall ❑ make reasonable efforts to progress the Project; or ❑ shall conform to the following schedule _____

based on an intended occupancy date of _____.

The Client understands that delays on the part of the Client or suppliers may delay performance of the Designer's duties, and the Designer's time to perform shall be extended if such delays occur. In addition, if either party hereto is unable to perform any of its obligations hereunder by reason of fire or other casualty, strike, act or order of a public authority, act of God, or other cause beyond the control of such party, then such party shall be excused from such performance during the pendency of such cause.

3. Purchases shall be handled in the following manner:
 ❑ The Client shall pay for purchases of merchandise and construction.
 ❑ The Designer shall commit to purchases of merchandise and construction as the agent of the Client, who shall make payment directly to the suppliers or contractors.
 ❑ Other arrangement _____

If the Designer is acting as agent for the Client, the Client shall approve all purchases by signing a written authorization.

The Designer ❑ shall ❑ shall not prepare purchase orders for purchases of merchandise or construction and shall advise the Client as to acceptability, but shall have no liability for the lateness, malfeasance, negligence, or failure of suppliers or contractors to perform their responsibilities and duties. In the event that, after the Client's approval for purchases of merchandise or construction, changed circumstances cause an increase in price or other change with respect to any such purchases of merchandise or construction, the Designer shall notify the Client in writing, but shall bear no liability with respect to the changed circumstances, and the Client shall be fully responsible with respect to the purchases of merchandise or construction. The Designer makes no warranties or guarantees as to merchandise or construction, including but not limited to fading, wear, or latent defects, but will assign to the Client any rights the Designer may have against suppliers or contractors, and the Client may pursue claims against such suppliers or contractors at its own expense.

The Client shall make certain that the Designer receives copies of all purchase orders and invoices.

The Client shall be responsible for the payment of sales tax, packing, shipping, and any related charges on such purchases.

4. Approvals by Client. On the Designer's request, the Client shall approve plans, drawings, renderings, purchase orders, and similar documents by returning a signed copy of each such document or a signed authorization referencing such documents to the Designer.

5. Client Responsibilities. The Client shall cooperate throughout the Project by promptly providing the Designer with necessary information; arranging any interviews that may be needed; making access available to the project site; giving prompt attention to documents to review and requested approvals; facilitating communications between the Designer and other professionals, such as architects and engineers whom the Client has retained; and, if necessary, designating the following person _____ to act as liaison with the Designer. If the Client is to provide specifications, floor plans, surveys, drawings, or related information, this shall be at the Client's expense, and the Designer shall be held harmless for relying on the accuracy of what the Client has provided. If at any time the Client has knowledge of a deviation from specifications or other problem with the Project, the Client shall promptly give notice in writing to the Designer. The Client shall be responsible for receiving, inspecting, and storing all deliveries, except that the Designer shall assist in this as follows:

6. Remuneration. The Client agrees to pay the Designer on the following basis, as selected by a check mark in the appropriate box or boxes:

❏ Hourly or per diem rate. The Designer shall bill its usual hourly or per diem rates. The Client shall pay a nonrefundable design fee of $_____ on the signing of this Agreement. Thereafter, the Client shall pay a monthly retainer on the first day of each month in the amount of $_____ until _____. The Designer shall render billings on a _____ basis, applying the design fee and retainer payments thereto, and the Client shall pay any balance due on the billings within _____ days of receipt.

❏ Flat fee plus a percentage of costs. The Designer's compensation shall be a nonrefundable design fee of $_____ paid by the Client on the signing of this Agreement, plus an additional markup of ___ percent of the expenditures for merchandise and ___ percent of the expenditures for construction, except that the following budget items shall not be included in this calculation: _____

❏ Flat fee. The Designer's compensation shall be a design fee of $_____, which shall start with a nonrefundable payment of $_____ by the Client, with the balance paid in installments of $_____ on the following schedule:

If the Project continues beyond _____, an additional fee of $_____ shall be paid each month until completion.

In the event that the Designer's remuneration is based, in whole or in part, on the amount expended for the Project, all purchases of merchandise and construction for the Project shall be included for the purpose of computing

remuneration due the Designer, except for the following exclusions: _____

In addition, the Client may append to this Agreement a list of items owned by the Client prior to commencement of the Project and use these items without any additional fee being charged by the Designer.

❑ If an Estimated Budget is required by the Client, an additional fee of $____ shall be charged for its preparation.

In the event that design services beyond the scope of work for this Project are requested by the Client and the Designer is able to accommodate Client's request, the Designer shall bill for such additional services as follows:

7. Revisions. During the development of the Project, the Designer shall make a reasonable amount of revisions requested by the Client without additional charge, but if the revisions are requested after approvals by the Client, an additional fee shall be charged as follows: _____
_____.

8. Expenses. In addition to the payments pursuant to Paragraphs 6 and 7, the Client agrees to reimburse the Designer for all expenses connected to the Project, including but not limited to messengers, long-distance telephone calls, overnight deliveries, and local travel expenses. These expenses shall be marked up ____ percent by the Designer when billed to the Client. In the event that travel beyond the local area is required, the expenses for this travel shall be billed as follows: _____.

At the time of signing this Agreement, the Client shall pay the Designer $____ as a nonrefundable advance against expenses. If the advance exceeds expenses incurred, the credit balance shall be used to reduce the fee payable or, if the fee has been fully paid, shall be reimbursed to the Client. Expenses shall in no event include any portion of the Designer's overhead.

9. Payment. The Client agrees to pay the Designer within ____ days of receipt of the Designer's billings for purchases, remuneration, or expenses. Overdue payments shall be subject to interest charges of ____ percent monthly. In the event that the Designer is the winning party in a lawsuit brought pursuant to this Agreement, the Client shall reimburse the Designer for the costs of the lawsuit, including attorney's fees.

10. Term and Termination. This Agreement shall have a term that expires on _____, 20___. The term shall automatically renew for additional _____ periods unless notice of termination is given by either party thirty (30) calendar days in advance of the renewal commencement. In addition, this Agreement may be terminated at any time for cause by either party notifying the other party in writing of that party's breach of the Agreement and giving ten (10) business days for a cure, after which the notifying party may terminate if there has been no cure of the breach. Causes for termination shall include, but not be limited to, failure to perform any duty pursuant to this Agreement in a timely manner and postponements of the Project for more than ____ business days in total. While reserving all other rights under this Agreement, in the event that the Project is terminated, the Designer shall have the right to be paid by the Client through the date of termination for the Designer's work, for any purchases by the Designer of merchandise and construction pursuant to purchase orders approved by the Client, and for the Designer's expenses.

11. Ownership of Design. The Designer shall retain ownership of the design, including any drawings, renderings, sketches, samples, or other materials prepared by the Designer during the course of the Project. The Designer's ownership shall include any copyrights, trademarks, patents, or other proprietary rights existing in the design. The Client shall not use the design for additions to this Project or for any other project without the permission of the Designer and appropriate compensation.

12. Consultants. If outside consultants, including but not limited to architects, structural engineers, mechanical engineers, acoustical engineers, and lighting designers, are needed for the Project, they shall be retained and paid for by the Client, and the Designer shall cooperate fully with these consultants. Such consultants shall be responsible for code compliance in the various areas of their expertise.

13. Publicity. The Designer shall have the right to document the Project in progress and when completed, by photography or other means, which the Designer may use for portfolio, brochure, public display, and similar publicity purposes. The name of the Client and location of the Project may be used in connection with the documentation, unless specified to the contrary _____. If the Designer chooses to document the Project, the Designer shall pay the costs of documentation. In addition, if the Client documents the Project, the Designer shall be given credit as the designer for the Project if the Client's documentation is released to the public.

14. Relationship of Parties. Both parties agree that the Designer is an independent contractor. This Agreement is not an employment agreement, nor does it constitute a joint venture or partnership between the Designer and the Client. Nothing contained herein shall be construed to be inconsistent with this independent contractor relationship.

15. Assignment. This Agreement may not be assigned by either party without the written consent of the other party hereto, except that the Designer may assign payments due hereunder to other parties.

16. Arbitration. All disputes arising under this Agreement shall be submitted to binding arbitration before _____ in the following location _____ and settled in accordance with the rules of the American Arbitration Association. Judgment upon the arbitration award may be entered in any court having jurisdiction thereof. Disputes in which the amount at issue is less than $_____ shall not be subject to this arbitration provision.

17. Miscellany. This Agreement shall be binding upon the parties hereto, their heirs, successors, assigns, and personal representatives. This Agreement constitutes the entire understanding between the parties. Its terms can be modified only by an instrument in writing signed by both parties. Notices shall be sent by certified mail or traceable overnight delivery to the parties at the addresses shown herein, and notification of any change of address shall be given prior to that change of address taking effect. A waiver of a breach of any of the provisions of this Agreement shall not be construed as a continuing waiver of other breaches of the same or other provisions hereof. This Agreement shall be governed by the laws of the State of _____.

In Witness Whereof, the parties hereto have signed this Agreement as of the date first set forth above.

Designer _____ Client _____
 Company Name Company Name

By _____ By _____
 Authorized Signatory, Title Authorized Signatory, Title

Contract Summary Sheet

Client _____

Address _____

Telephone _____ Fax _____
Cell phone _____ E-mail _____

Contact at Client _____

Representative for Designer _____

Description of Project _____

Full description appears in ❑ the agreement, or ❑ schedule attached to the agreement

When does the agreement commence? _____

What is the schedule for the Project? _____

Is there a projected occupancy date? _____

How will purchases of merchandise or construction be handled in terms of which party is paying, which party is
preparing purchase orders, substitutions, exclusions, and what deposits or working funds will be made available?

How will remuneration be handled, including requests for work beyond the scope of the Project?

Has an estimated budget been requested for inclusion with the presentation of the design concept? ❑ Yes ❑ No

If such estimated budget has been requested, will an additional fee be charged and, if so, how will it be computed?

When will revisions be billable? _____

What expenses are billable? _____

How long does the Client have to pay billings after receipt of invoices? _____

What interest rate can be charged on overdue invoices? _____

What is the term of the agreement? _____

Has the Client placed any restrictions on publicizing the project? _____

What is the position of the person signing the agreement for the Client? _____

Does the agreement include the Designer's standard provisions as follows:

That the quality and supervision of merchandise or construction shall be the responsibility of the suppliers or contractors? ❑ Yes ❑ No

That delays caused by the Client, suppliers, contractors, or acts of God, etc. shall extend the Designer's time to perform? ❑ Yes ❑ No

That the Designer shall have no liability for the lateness, malfeasance, negligence, or failure of suppliers or contractors to perform their responsibilities and duties? ❑ Yes ❑ No

That the Designer shall have no liability if changed circumstances cause a change in price or other change after the Client's approval for purchases of merchandise or construction? ❑ Yes ❑ No

That the Designer makes no warranties or guarantees as to merchandise or construction, including but not limited to fading, wear, or latent defects, but will assign to the Client any rights the Designer may have? ❑ Yes ❑ No

That the Client shall be responsible for the payment of sales tax, packing, shipping, and any related charges on such purchases? ❑ Yes ❑ No

That the Client must sign approvals on the Designer's request? ❑ Yes ❑ No

That the Client must meet the usual client responsibilities? ❑ Yes ❑ No

Does the Designer own all rights in the designs? ❑ Yes ❑ No

Is the Client responsible for retaining and paying other professional consultants? ❑ Yes ❑ No

Is there an arbitration provision? ❑ Yes ❑ No

Is there a standard "Miscellany" provision? ❑ Yes ❑ No

Has any standard provision been altered, and have any provisions been added to the agreement at the request of the Client?

Person completing this Contract Summary Sheet _____

Date completed _____

Client Approval

CLIENT
Name _____
PROJECT
Job Name _____
Location _____
Job Number _____

Phase	Item	Initials	Date
Program Development			
Preliminary Color/Materials ("Mood") Boards			
Preliminary Budget/Schedule Estimates			
Revisions			
Approval to Proceed to Next Phase			
Design Development—Phase One—Schematics			
Site Plan Base Drawings			
Traffic Patterns			
Space/Layout Plans			
Preliminary Plans and Selections			
Walls			
Floors			
Ceilings			
Window Treatments			
Millwork			
Fixtures and Hardware			
Furniture			
Audio/Video			
Spa/Exercise Furnishings			
Linens, Rugs, Decorative Items			
Presentation/Sample Boards			
Budget/Schedule Estimates			
Revisions			
Approval to Proceed to Next Phase			
Design Development—Phase Two—Final			
Final Site Plan Base Drawings			
Final Traffic Patterns			
Final Space/Layout Plans			
Final Plans and Selections			
Walls			
Floors			
Ceilings			
Window Treatments			
Millwork			
Fixtures and Hardware			
Furniture			
Audio/Video			

Phase	Item	Initials	Date
Spa/Exercise Furnishings			
Linens, Rugs, Decorative Items			
Final Presentation/Sample Boards			
Final Budget/Schedule			
Revisions			
Approval to Proceed to Next Phase			
Contract Documents and Bids			
Bid Drawings and Specs			
Client Review of Bids			
Revisions			
Approval to Proceed to Next Phase			
Project Implementation			
Purchasing—Stock Items			
Wall Fabrics/Finishes			
Flooring Material			
Ceiling Materials			
Window Treatments			
Fixtures and Hardware			
Furniture			
Audio/Video			
Spa/Exercise Furnishings			
Linens, Rugs, Decorative Items			
Storage/Shipping/Handling			
Miscellaneous			
Fabrication—Custom Orders			
Wall Fabrics/Finishes			
Flooring Material			
Ceiling Materials			
Window Treatments			
Millwork			
Fixtures and Hardware			
Furniture			
Audio/Video/Security/Other Electronic			
Linens, Rugs, Decorative Items			
Storage/Shipping/Handling			
Miscellaneous			
Construction—Site Supervision			
Walls			
Floors			
Ceilings			
Miscellaneous			

Phase	Item	Initials	Date
Installation—Site Supervision			
Custom Wall Painting/Coverings	_____	_____	_____
Custom Floor Treatments	_____	_____	_____
Custom Ceiling Treatments	_____	_____	_____
Custom Window Treatments	_____	_____	_____
Millwork	_____	_____	_____
Fixtures and Hardware	_____	_____	_____
Furniture	_____	_____	_____
Audio/Video/Security/Other Electronic	_____	_____	_____
Spa/Exercise Furnishings	_____	_____	_____
Linens, Rugs, Decorative Items	_____	_____	_____
Miscellaneous	_____	_____	_____
Final Project Completion Items			
Final Client Sign-Off	_____	_____	_____

Selected Bibliography

Berens, Linda V., and Dario Nardi. *The Sixteen Personality Types, Descriptions for Self-Discovery*. New York: Telos Publications, 1999.

Crawford, Tad, and Eva Doman Bruck. *Business and Legal Forms for Interior Designers*. Rev. ed. New York: Allworth Press, 2001.

DuBoff, Leonard D. *The Law (in Plain English) for Small Businesses*. New York: Allworth Press, 1998.

Feldman, Franklin, Stephen E. Weil, and Susan Duke Biederman. *Art Law: Rights and Liabilities of Creators and Collectors*. 2 vols. Boston: Little, Brown and Company, 1986. Supp. 1993.

Foote, Cameron. *The Business Side of Creativity: The Complete Guide for Running a Graphic Design or Communications Business*. New York: W. W. Norton & Company, 1999.

Goleman, Daniel P. *Emotional Intelligence: Why It Can Matter More Than IQ*. New York: Bantam Books, 1995.

Gray, John. *Men Are from Mars, Women Are from Venus: A Practical Guide for Improving Communication and Getting What You Want in Relationships*. New York: HarperCollins, 1992.

Keirsey, David, and Marilyn Bates. *Please Understand Me: Character and Temperament Types*. 5th ed. Amherst, New York: Prometheus Book Co., 1984

Knackstedt, Mary V. *The Interior Design Business Handbook*. 3rd ed., New York: John Wiley & Sons, Inc., 2002

Lynch, Sarah. *77 Habits of Highly Creative Interior Designers: Insider Secrets From the World's Top Design Professionals*. Gloucester, Mass.: Rockport Publishers, 2003

Ries, Al, and Jack Trout. *Positioning the Battle for Your Mind*. 2nd ed. New York: McGraw-Hill, 2001.

Siegel, Harry. *A Guide to Business Principles and Practices for Interior Designers.* New York: Watson-Guptill, 1982

Shim, Jae K., and Joel G. Siegel. *Budgeting Basics and Beyond: A Complete Step-by-Step Guide for Nonfinancial Managers.* Upper Saddle River, New Jersey: Prentice Hall, 1994.

Stearns, David. *Opportunities in Interior Design and Decorating Careers.* 2nd ed. New York: McGraw-Hill, 2001

Weisinger, Hendrie. *Emotional Intelligence at Work.* San Francisco: Jossey-Bass, 1997.

Williams, Theo Stephan. *Creative Utopia: 12 Ways to Realize Total Creativity.* Cincinnati: F&W Publications, 2002

United States Department of Labor. *Occupational Outlook Handbook.* 2004-05 ed. Lincolnwood, Illinois: NTC/Contemporary Publishing Co., published annually.

About the Author

Theo Stephan Williams is the founder of Real Art Design Group, Inc., an award-winning, full-service graphic design firm whose international client base includes Universal Studios Hollywood, the Walt Disney Company, and General Motors. The author of *The Streetwise Guide to Freelance Graphic Design and Illustration, Pricing, Estimating & Budgeting for Graphic Designers* and *Creative Utopia: 12 Ways To Realize Total Creativity*, she has taught many college courses in design theory. After founding an organic ranch and specialty-food company with her husband Joel, her career has transcended to interior design, creating original patterns that are being manufactured into carpets and other textiles in Nepal. Contact her at *theo@globalgardensgifts.com*.

Index

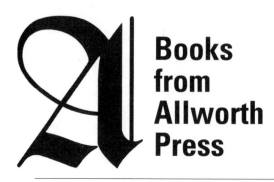

Books from Allworth Press

Allworth Press is an imprint of Allworth Communications, Inc. Selected titles are listed below.

Business and Legal Forms for Interior Designers
by Tad Crawford and Eva Doman Bruck (paperback, with CD-ROM, 8½ × 11, 240 pages, $29.95)

The Graphic Designer's Guide to Pricing, Estimating, and Budgeting
by Theo Stephan Williams (paperback, 6¾ × 9⅞, 208 pages, $19.95)

Licensing Art and Design, Revised Edition
by Caryn R. Leland (paperback, 6 × 9, 128 pages, $16.95)

The Real Business of Web Design
by John Waters (paperback, 6 × 9, 256 pages, $19.95)

Creating the Perfect Design Brief: How to Manage Design for Strategic Advantage
by Peter L. Phillips (paperback, 6 × 9, 208 pages, $29.95)

Starting Your Career As a Freelance Illustrator or Graphic Designer, Revised Edition
by Michael Fleishman (paperback, 6 × 9, 272 pages, $19.95)

How to Grow as a Graphic Designer
by Catharine Fishel (paperback, 6 × 9, 256 pages, $19.95)

The Graphic Designer's and Illustrator's Guide to Marketing and Promotion
by Maria Piscopo (paperback, 6 × 9, 224 pages, $19.95)

Careers by Design: A Business Guide for Graphic Designers, Third Edition
by Roz Goldfarb (paperback, 6 × 9, 240 pages, $19.95)

AIGA Professional Practices in Graphic Design: The American Institute of Graphic Arts
edited by Tad Crawford (paperback, 6¾ × 9⅞, 320 pages, $24.95)